Coney Island Tattoo Festival poster, from the author's collection.

THE TOTAL TATTOO BOOK

AMY KRAKOW

WARNER BOOKS

A Time Warner Company

Copyright © 1994 by Amy Krakow
All rights reserved.

Warner Books, Inc., 1271 Avenue of the Americas, New York, NY 10020
W A Time Warner Company

Printed in the United States of America
First Printing: June 1994
10 9 8 7 6 5 4 3 2 1

Library of Congress Cataloging-in-Publication Data

Krakow, Amy.
 The total tattoo book / Amy Krakow.
 p. cm.
 ISBN 0-446-67001-4 :
 1. Tattooing. I. Title. II. Title: Total tattoo book.
GN419.3.K73 1994
391'.65—dc20
 93-41322
 CIP

Book design by Giorgetta Bell McRee
Cover design by Diane Luger
Cover photograph by Seiji Kakizaki
Logo design by Tom Nikos
Photo color retouch by Christine Rodin

This book is dedicated to the people who made it possible: men and women who have tattoos, men and women who want tattoos and men and women who give tattoos.

CONTENTS

ACKNOWLEDGMENTS

The tattoo family truly became my family when I started work on this book. No longer am I the unadorned black sheep. Now I am part of a global tribe that is ever expanding. My thanks go to everyone who has helped me along the path. These include the tattooists who welcomed me into their shops—and their lives, especially Shotsie Gorman of Wayne, New Jersey. He granted me carte blanche at his studio, he regaled me with tattoo tales, he welcomed me into his home. His staff, too, offered generous advice, leads and information. They were always kind, helpful and funny. Scotty Lowe, Michele Breen, Lisa Bernabe, Eric Newman, Cathy Wheeler gave of their time, their knowledge and their hearts. Thanks as well go to the clients at Shotsie's, who endured cameras, lights and questions. In Connecticut and New York, many thanks go to Spider Webb, and to Mike and Mehai Bakaty, who let me hang around, and hang around, and hang around. On the West Coast, my thanks go to the men most responsible for shaping the recent past, present and future of tattooing: Lyle Tuttle and Ed Hardy.

This book has also given me new friendships: Mick Beasley, the founder of the Alliance of Professional Tattooists. Her indefatigable efforts on behalf of the tattoo community are extraordinary. I am pleased to be able to assist her. Sheila May has created a new classification of tattooing in the form of permanent makeup. She is a joy to know. Bill De Michele turned his obsession into an art form. His introductions and counsel are always welcome.

The archivists who steered me in the right direction and provided advice, information, great pictures and stories deserve mention: Chuck Eldridge of the Tattoo Archive in Berkeley and Bill Funk of the National Tattoo Museum in Philadelphia. Flo Makof-

ske of the National Tattoo Association in Allentown was always there for me with a prompt answer.

The people at Warner Books deserve special mention for supporting this offbeat project and for helping with some of my more bizarre requests: Dennis Dalrymple, Diane Stockwell, Anne Douglas Millburn, Brian McCafferty and, of course, my editor, Karen Kelly.

On a personal level, thanks to Steve Bonge, who is the personification of "good people." He is also a great photographer. Plus, he introduced me to Donna Gaines. Do I say thanks or what? Chris Pfouts offered insight, observations and lots of laughs. Photographer Jim Salzano and Suk Choi of Box Graphics proved that people in advertising are some of the best in the world in every aspect. Ruth Marten was a superb tattooist. She is now a superb illustrator and designer. Her advice, input and inspiration have added immeasurably to this book.

I thank my friends who put up with my obsession, read, commented and in some way helped to make my work better: Bert Berdis for Marina del Rey, Brooke Berdis for her California photography and insights, Kay Blumenthal, Bob Maxwell, Craig Nelson, Elisa Petrini, Anne Winn and especially Melanie Mintz, whose insightful comments made all the difference.

My photo researcher/editor and all-around assistant, Sima Davis, put up with an enormous work load and endured outrageous pressure. She is a magician. Helen Rees knows exactly what she did . . . and I'm most grateful.

Finally, thanks to my husband, Gary Krakow. "Hey, honey, when are you going to get that Froggy the Gremlin tattoo?"

PROLOGUE

Every year I'd get up at the Coney Island Tattoo Festival and greet the crowd. This has been going on for some ten years. Every year, the assembled multitudes (okay, the guys) would yell at me to show off my tat. By the third year of the festival, I was making jokes about my tattoo-less body.

I didn't have a tattoo, but I did have overwhelming guilt. For several years I donated back any and all of my meager profits to the not-for-profit boardwalk theater where I originally held the festival.

Then I started to work on his book. I couldn't very well continue as an undecorated person. That would be considered rude. Bad form. Lousy karma. So I set out to get tattooed. And my odyssey became a celebration of the art of the tattoo.

The only difference between a tattooed person and a person who isn't tattooed is that a tattooed person doesn't care if you're tattooed or not.

—Posted in a tattoo shop

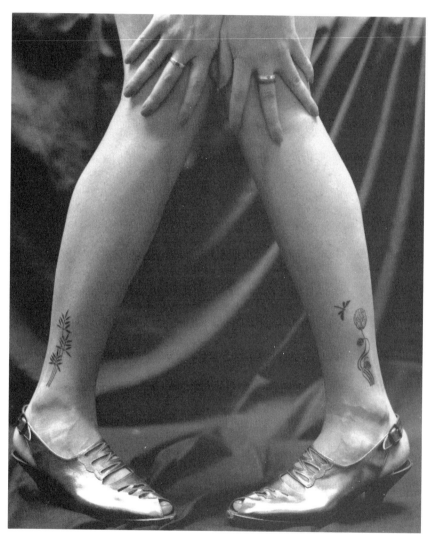

Tattoos are fun, artistic, and ubiquitous. Tattoo artists unknown.
(Photo by Dara © 1991 Seth Gurvitz)

WHAT IS A TATTOO?

I fell in love with pictures on skin when I was five. I would sit in the backseat of my parent's big old gray Dodge, licking cockamamies onto my arms. I'd start jumping up and down with excitement as we'd drive past the tattoo parlors on Flatbush Avenue in Brooklyn. Every so often my folks would give in to my demands and stop the car. I'd happily skip out, run over to the window and gaze at the flash on the walls. My parents always used the word "bums" whenever I'd beg and plead with them to stop and let me look. Now, years later, like my friend Donna I'm a "tattooed Jew" (her expression)! I no longer fantasize about what picture I'm going to get. I've got more than one.

These days, those little pictures are really ubiquitous. Madonna uses them to shock in her film *Truth or Dare* (fakes) and in her book *Sex* (real). *Vogue* and *Elle* magazine models flaunt them in photo shoots (Carre Otis's tattoos are real, Naomi Campbell's are temporary). Cher collects them. Roseanne Arnold featured her favorite tattoo artist on her television program. She and husband, Tom Arnold, pledge their eternal love through them (as did

Johnny Depp and Winona Ryder, and Mark Gastineau and Brigitte Nielsen). Queen Victoria, George Shultz and Barry Goldwater did their best to hide theirs (it was titillating when the press discovered *their* decorations). Janis Joplin's heart (on her chest) and wrist bracelet tattoos ignited a fad some twenty-five years ago. When I worked at *Reader's Digest* I was too embarrassed to tell anyone about my avocation. I still find people who will turn up their noses when they learn that for the past ten years, I've produced New York City's longest-running tattoo festival.

Tattoos have appeared throughout history as ritual art, pagan decoration, art to mark a rite of passage, art to inform, forbidden art, blue-collar art, popular art and erotic art.

A tattoo is a permanent coloration of the second layer of the dermis. It's produced by puncturing the skin and inserting indelible inks. The word *tattoo* has two major derivations. The Tahitian word *tatu* means "to make a mark." The Dutch expression "*Doe het tap toe*" was the signal for closing public houses, given by continuous drum beating or rapping; this rapping or tapping was close to the sound made by early tattooers as they tapped a needle with a small hammer in the process of punc-

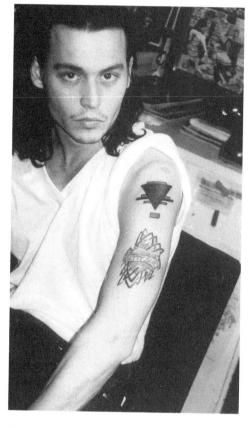

Johnny Depp in tattoo artist Jonathan Shaw's New York studio. Tattoos by Jonathan Shaw. (PHOTO © JONATHAN SHAW, FUN CITY STUDIOS, NEW YORK CITY)

turing the skin. (The hand process is still very much alive today in several cultures around the world, including Samoa, Japan and Thailand.)

Anthropologists generally don't study tattoos. In fact, one Columbia University master's degree candidate had his thesis

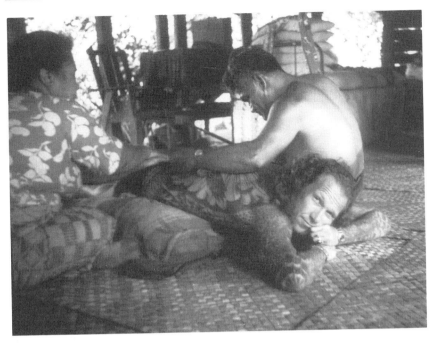

Tattoo artist Lyle Tuttle being tattooed by hand in Samoa. The Samoan style and process of tattooing has remained the same for centuries. (PHOTOS FROM LYLE TUTTLE'S COLLECTION)

on maritime tattoos challenged five times. Some folklorists consider tattooing to be a unique cross-cultural folk art and craft. Those who love it get to exercise their fascination and prurient interest in the name of academia. Lenny Bruce related in one of his routines how his tattoo would prevent him from being buried in a Jewish cemetery unless he cut off the offending arm. Reginald Marsh, the WPA painter and chronicler of downtown New York in the 1930s and 1940s took a gritty and real-istic look at one aspect of the scene in his painting *Tattoo and Haircut.* The work is in the Art Institute of Chicago, and in good company; it hangs next to Grant Wood's well-known *American Gothic.*

From the eighteenth century on, men and women of Western cultures have collected tattoos to show they're different, to thumb their noses at the establishment. Bikers wear their club colors along with mottos like FTW (which stands for "F**k the World"), politically active

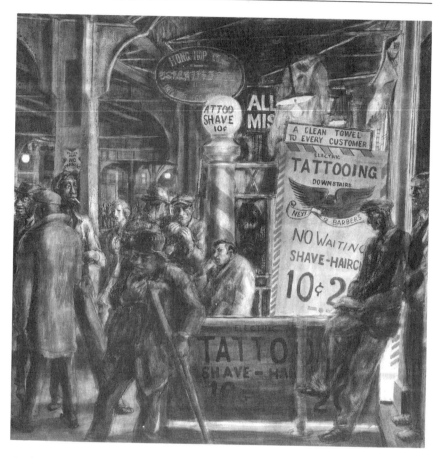

Artist Reginald Marsh captures the essence of tattooing in Depression-era New York City in his painting Tattoo and Haircut. *You could get both in the same place in those days. This painting is in the permanent collection of the Art Institute of Chicago. Reginald Marsh, American, 1898–1954,* Tattoo and Haircut, *egg tempera on masonite, 1932, 118.2 x 121.6 cm, gift of Mr. and Mrs. Earle Ludgin.* (PHOTO COURTESY OF THE ART INSTITUTE OF CHICAGO)

gay men tattoo the pink triangle, lots of people tattoo skulls and grim reapers to thumb their collective noses at death. Then there's the yuppie with a sense of humor who tattooed the Izod Lacoste alligator on his chest.

In 1936 *Life* magazine created a stir with an article that

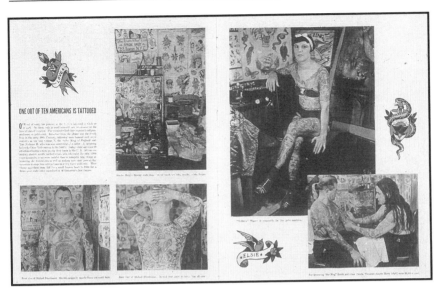

A photo essay from a 1936 issue of Life *magazine.* (COURTESY OF *LIFE* MAGAZINE © TIME WARNER)

Kids are fascinated by tattoos. They generally don't have any preconceived notions or prejudices about either the body art or the wearer of the artwork. Tattoos by Spider Webb. (PHOTO © MARTHA COOPER)

claimed: "One in ten Americans is tattooed."

Tattoos are provocative. But today they're very popular and quite chic. Watch a child touch a tattoo. The bewilderment, the fascination, the joy—kids love the pictures, the art, the images, just as they love the fact that these images are right there in the skin. They go with the owner, and they don't come off! So why—and how—have people gotten this notion that tattoos are forbidden?

It's right there in the Bible: "You shall not make any cuttings in your flesh . . . or tattoo any marks upon you" (Leviticus 19:28). In the late 1960s, if you wanted to show you were part of the counterculture you did something that was considered different—or deviant. Not only did permanent tattooing flourish, so did temporary body painting. And then as we got more in touch with our bodies, we became prouder. Looser and freer. Less rigid. More inclined to show off. And the Bible's sanctions against permanent body art started to fade from people's minds, as more and more people collected more and more tattoos.

San Francisco tattoo artist Lyle Tuttle, who takes well-deserved credit for helping to popularize the art form among the counterculture, declared

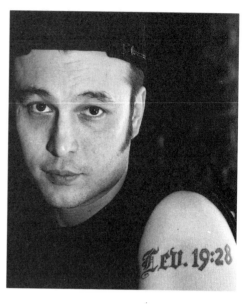

Leviticus 19:28. The biblical tattoo taboo, worn here by T. Sixtus (Six). Tattoo by Darren Rosa. (Photo © Lynne Burns)

back in 1970: "Tattoos are merely another physical form of expression. A way to say something intimately with your body." What began as another part of the be-ins and love-ins among hippies, flower children, hip intellectuals and drugged-out street people became more and more acceptable to the masses. NBC brought us *Laugh-In. Laugh-In* gave us Goldie Hawn. And Goldie let all of America see her great painted body every Monday night.

The more adventurous went for the real thing. Tattoos be-

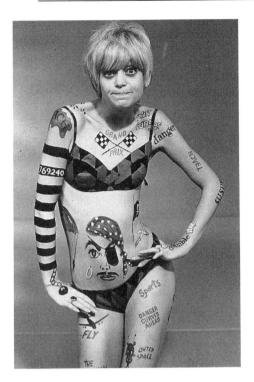

Goldie Hawn sported lots of hand-painted body art during her days on the popular television program Laugh-In. (PHOTO © EVERETT COLLECTION)

came quite popular among hippies and hipsters, especially in San Francisco, where Lyle Tuttle tattooed Janis Joplin. Long unkempt hair, loose clothing, laid-back looks and casual attitudes that said rebellion. Whatever it took to show you were a part of US and not THEM showed class. Tattoos were *real* class: the ideal way to indelibly declare yourself *not* a part of the establishment.

In New York, hippies had to travel outside the city for their permanent means of expression. Or they could truly thumb their collective noses at the establishment by getting tattooed illegally inside city limits. Due to a series of hepatitis outbreaks in the late 1950s, as well as pressure from the Catholic Church, in 1961 the city fathers declared tattooing illegal and a violation of the city's health code. Tattooing went underground in the Big Apple, and in all of Massachusetts, too. Ten years later, Spider Webb became the art's lone crusader. He took up his needles and tattooed on city streets, gaining exposure and calling attention to the arcane and bizarre tattooing laws. Webb, the master tattoo promoter, had a shop in Mount Vernon, New York, just a few miles outside of the city limits. He advertised in the *Village Voice*. Like Tuttle, he understood the value of reaching a young, hip population.

It took a select group of artists in the early 1970s to bring a new world of tattoos to the public. San Francisco–based Ed Hardy and Mike Malone understood that the body could serve as a unique canvas. Tattoos became a powerful, personal means of expression, a physical manifestation of how the collector views various as-

pects of his or her life, the world or, simply, art.

In early times, cave drawings and petroglyphs served the dual purpose of chronicling day-to-day life and calling the spirits—the gods and goddesses—to the service of the people who drew them. Tattoos served the same ritual purpose: to call the spirits and to mark a rite of passage. They still do. Ask a tattooed person about a specific image on his or her body. Invariably he or she will tell you what in their life was worth noting when they got that tattoo. Most owners will even tell you it was done to mark a certain point in time, or a specific occasion. One woman got a tattoo when she was divorced. Another recovered from serious surgery, and then went off to be tattooed. One of my friends marked the death of her mother with a tattoo. Another has the names of his children tattooed on his body.

Many of us are intrigued by pagan rites—spiritual rituals performed before the days of organized religion. Tattooing embodies the spiritual made secular. Or maybe it's the Judeo-Christian edict against tattooing: Many pagan rites and rituals such as harvest festivals and spring celebration holidays were co-opted by organized religions; other rites were

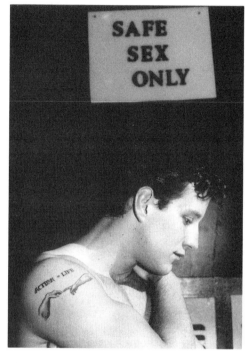

Gay rights activist Brad Lamm has his sensibilities and sensitivities elegantly inscribed. Tattoo by Darren Rosa. (PHOTO AT NEW YORK'S LIMELIGHT © LYNNE BURNS)

shunned. Tattooing, as ritual and as art, has gotten a bad rap for centuries. But attitudes are changing. Tattoos combine an interest in ancient and primitive cultures and their rites, along with an easier, less rigid way of dealing with (and looking at) our bodies. There's also the modern notion that tattoos no longer have to be a few stan-

dard images. They can be anything.

There's also an element of sexual backlash: Tattoos can be hidden under clothes, making them a perfect—and permanent—rebellion against sexual repression in the AIDS generation.

Mix in some new technology: brighter pigments, better sterilization methods and waste disposal.

And don't forget women's liberation. Women now account for at least 40 percent of work done in tattoo studios, not the old-fashioned tattoo parlors. They account for 35 to 40 percent of tattooists, as well. Most women request custom work, even when having a popular image tattooed. For women, the most popular tattoos are flowers and butterflies. But anything goes. Recently, a young woman showed me a lizard tattooed on her stomach. "It's to protect me from appendicitis. That's what killed my best friend." These days, when it comes to a tattoo, no one in the business even considers gender an issue anymore.

"Every time I visit a new chiropractor, I know that I'm going to hear the whoosh—that sucking in of his breath when he sees my tattoos," said a college-educated, heavily tattooed writer in New York. And that brings up the issue of discrimination. Tattoos bring out prejudice in many people—people who have bought into the long-held myths that tattoos were the marks of lower-class people, mentally and morally deficient people, or criminals. Times have changed. With movie stars, rock stars and models saying it's okay to decorate the body permanently, and with a new look at ancient forms of art and expression, tattooing is becoming a terrific topic of conversation at cocktail parties. It's an acceptable art form.

An aging population seeks out cosmetic tattooing. One forty-eight-year-old woman said to me: "I've worn the same eye makeup for the past ten years. And I'm farsighted. Having my eyeliner tattooed saves me all the squinting, the hassles of trying to apply this makeup."

I knew that the stigma was beginning to crack, and that tattooing was more than simply a fad when my sixty-eight-year-old mother called from Miami Beach. She asked for the name of a cosmetic tattooist. She and three of her Jewish grandmother friends wanted to do their eyebrows. But with this acceptance comes a downside. Cosmetic tattooing has opened up a legal can of worms, as hairdressers, manicurists and cosmeticians apply what they call

Permanent makeup: dark eyeliner on Rosemary, applied by Sheila May.
(PHOTO © SHEILA MAY)

permanent makeup. They'll call it anything and everything except what it actually is—a tattoo, but the issue is raised: Who would you like to tattoo your eyebrow, eyeliner or lip-liner? I know who's done my permanent makeup. Not a cosmetician. Instead, I chose a tattooist who's been working for years and can speak at length about the how-to's of needle sterilization.

Tattooers today are concerned with ambiance, aesthetics and cleanliness. Through their associations they exchange information about topics such as the spread of infectious diseases, pigment migration and bio-hazardous waste disposal.

Tattooing has changed remarkably, and not only as an art form. Tattooing is big business. One estimate cites 30,000 tattooers working in the United States today. In very general financial terms, some tattoo artists do extremely well, making in excess of $200,000 a year, employing three or four other tattooists in their shops, along with assistants or receptionists. I get a kick out of taking unsuspecting friends to some of these studios. The aesthetics are just not what they've been led to expect.

Since I've become involved in this world, my friends think I'm the repository for all things tattoo. A couple of years ago, I'd

When Steve Allen was host of his own nighttime television program, he liked to do things that were silly, shocking, bizarre and funny. Allen did this not only because it made for good television, but because he was (and still is) genuinely interested in popular culture and the icons of our times. So one evening, he decided to get a tattoo. On the air. In fact, Allen got three tattoos (they're minuscule dots, but they're tattoos).

get a clipping or two sent to me every other month, plus a phone call about a documentary once a year (always the same program). Now I get at least one call a day—"Did you see the article . . . TV show . . . book . . . cover of the *New Yorker* . . . that ad?" I can't keep up with it all. The tattooed masses have arrived. We're mainstream.

Think about it. If one in ten Americans was tattooed in 1936, the odds are good that the person sitting opposite you on the bus is tattooed. Did you

Tattoo by D. E. Hardy, 1992, from a childhood drawing done by the client. (PHOTO © D. E. HARDY)

Bernie Moeller holds the title of "Most Tattoos" in the *Guinness Book of Records*. He has 9,860 individual tattoos covering virtually every inch of his body, except for his face, neck and head. "I'll never do anything past my neck. I promised my family I wouldn't." What happened when Bernie just had to have one more tattoo so that he could retain his world title? He sort of stuck to his promise to his family—he got the tattoo inside his mouth.

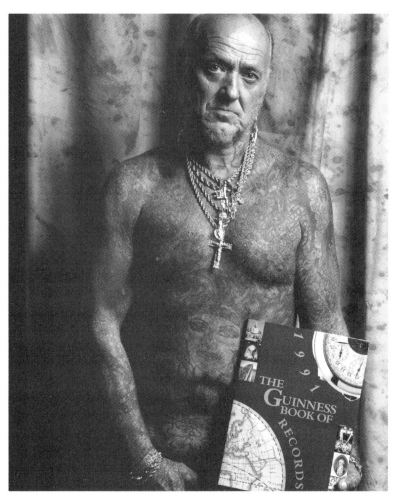

Bernie Moeller. (PHOTO © TOM SANTELLI)

know that a Pulitzer Prize–winning journalist for *New York Newsday*, whose articles keep you riveted, is tattooed? Or how about several well-known NBA players? Or members of a medal-winning Canadian sports team (they all have a Canadian maple leaf tattoo). Their names don't matter. What matters is the fact that you're probably surprised that these people would have tattoos. Why? Some people have lots of tattoos. Some people have just one. The interesting thing about us is that we're just like any—and everybody—else.

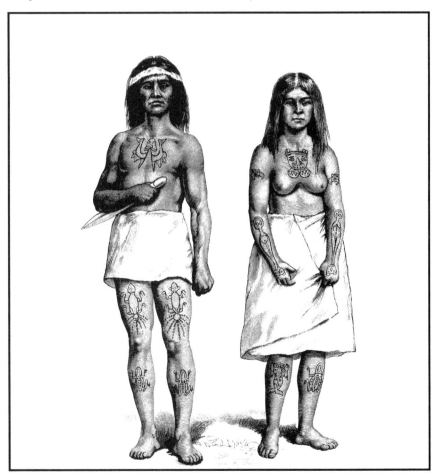

Haida tattoos, North America, 18th and 19th centuries. (Fourth Annual Report of the Bureau of Ethnology to the Secretary of the Smithsonian Institution, 1882–1883)

As an art, they have been traced back 4,000 years to the Egyptians. They appear in the culture of the Polynesians, the Maoris of New Zealand, the Mayas and the Incas. King George V, Czar Nicholas II and King Frederik IX of Denmark wore them. For years they have adorned the arms and chests of sailors, roustabouts and construction workers. Now, after a decade or two of decline, tattoos are enjoying a renaissance. They have become the vogue of the counterculture.

—*Time*, December 21, 1970

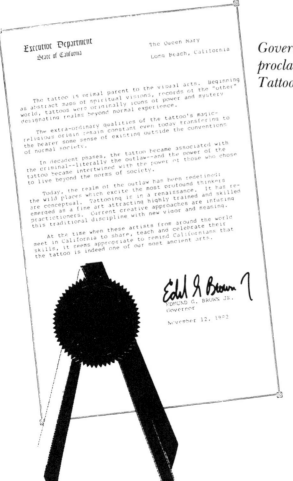

Governor Jerry Brown's proclamation:
Tattoos ARE *art.*

C H A P T E R

THE TATTOO IN HISTORY

When I told my mother I was writing a book, she was thrilled. To a Jewish mother, an author in the family is almost as good as a doctor.

"It's a book on tattoos, Mom."

"That's great. I'm so happy."

A couple of months later, during Passover, my folks were visiting me. Walking to the car after the first seder, my mother glanced down at my leg. "What's that on your leg?"

"A tattoo."

"Oh, a fake tattoo. That's nice."

"No Mom. It's not fake. It's real. It doesn't come off."

She started bellowing: "You got a *tattoo*? How could you?"

"Mom! It's okay to write a book about tattoos, but it's not okay to have one? That's hypocritical."

Here, then, is the tattoo pride chapter. Validation and vindication. The tattoo-centric view. Something to show to my mother and prove that tattoos have a long, fascinating, reputable history. If your mother, like mine, is resistant to even the *idea* of a tattoo,

here are a few facts to wow her with.

Tattoos existed 12,000 years before Christ. Proof has been found in archaeological and anthropological digs.

The tattoo was developed for nonaesthetic purposes, yet at its highest levels it served a purely aesthetic calling.

Tattoos combine art and craft. As in any applied art, technical skill, along with creativity and vision, is required of the artist.

Tattoos are an art form both spiritual and secular. Cultural anthropologists believe that tattoos actually serve society by bringing ritual to cultures that lack communal rites. That's just one of the reasons why tattooing is so popular in America today. Our culture suffers from a decided lack of traditions, combined with a latent desire for both spiritual and secular rites that bind people to each other or to a larger group. A tattoo *is* a committment. And it's been that way for centuries. In the past, for example in Borneo, certain tattoo patterns on a woman's forearm indicated her skill as a weaver, and accomplished weavers were highly prized "marriageable material." Finger or wrist tattoos on both sexes kept away illness. Other tattoos memorialized battles, journeys, vi-

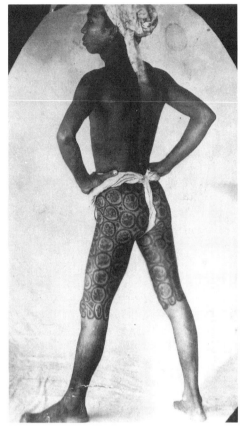

Tattooing from Papua, New Guinea. (PHOTO COURTESY OF PHILADELPHIA EDDIE FUNK AND THE NATIONAL TATTOO MUSEUM, WITH SPECIAL THANKS TO BILL FUNK FOR HIS ASSISTANCE)

sions or membership in a special society, or status as part of a clan or caste. Still other images called the spirits of that particular image to the wearer. The spirit of a tattooed animal, it's ferocity or fierceness, for example, would belong to the tattooed person.

Today in America the tattoo ritual serves many of the same purposes, as you'll see, for members of the military and members of certain clubs. When men and women want to memorialize a certain point or a certain event in their lives, or want a sign or symbol to ward off evil or be a guardian angel, a tattoo is the permanent manifestation of that desire. Getting a tattoo is a ritual, with the tattooist as a "shaman" who offers the "magic." Rituals, whether personal or societal, bond a person to the heritage and traditions of the past, while carrying them into the present and future. Tattoos clearly do that.

Through the ages, tattooing has had well-defined roles: marking a rite of passage at a stage of life, calling the spirits, proudly, defiantly or sneakily showing who you are via body art. That's pretty much how the tattoo tradition evolved, and it's pretty much the way it remains.

After induction, members of motorcycle clubs become tattooed with the club's "colors," or logo. A few years ago, the Yale Crew Team made a preseason visit to Spider Webb for matching crossed oars. They posted an undefeated season. Three team members who chickened out of the original ritual showed up at Spider's after the season. They wanted it known that they were part of the team. Devotion tattoos are ever popular: A couple declares eternal love through permanent body art. In postindustrial society, our tattoos are a link to the past. Tattoos do for us the things they did for our ancestors: They create an indelible bond with the universe, mark a special place and time in our lives, show status or stature in our community. Then tell a story or paint a picture.

Tattooing traveled the globe, beginning in Egypt during the Third and Fourth Dynasties, when the great pyramids of Giza were being built. Tattoos communicated various symbolisms. They were made by puncturing the skin with a sharp needle. Clay dolls with little tattoo-like pictures on them are the evidence. The Egyptians expanded their empire, and they passed along their culture. Tattoos traveled to Crete, Greece, Persia and Arabia. By 2000 B.C., the art of the tattoo had spread to China.

In the Mediterranean, Greek spies communicated via their tattoos. The markings indicated who the spies were and how highly they were ranked. Romans marked criminals and slaves with tattoos. Gladiators, convicts who played out their sentences as violent sportsmen, were marked for easy identifi-

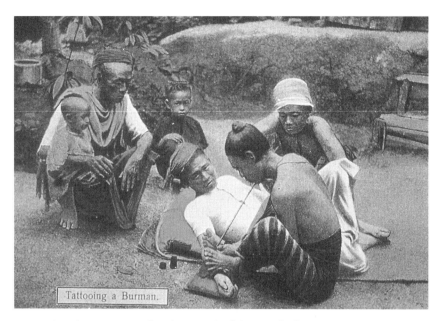

Tattooing a Burman.

Tattooing in Burma today is practiced in much the same ways as in the past. (PHOTO © TATTOO ARCHIVE)

cation. The notion that tattoos denote dangerous people is long-standing.

The Ainu of Western Asia used the art of tattoo to show social class and status. Married women had specific status markings visibly tattooed, as did girls coming of age. As the Ainu traveled, so did their tattoos, moving across Asia and into Japan. It was in Japan that tattooing developed into more than a religious or ceremonial rite. But it took many years for the art to move from the spiritual to the secular realm.

In Burma, tattoos were very much a part of religious and spiritual beliefs. In Borneo, women were the tattooists and the weavers; it was the cultural tradition. Like the women society-page writers of the 1950s and much like gossip columnists and journalists of today, these women were familiar with the social status of their subjects. The tattooists inscribed designs that reflected the owner's station in life—his tribe, his family, his social status. Different tribes had different designs, just as they had different dialects. Kayan women had delicate arm tattoos that resembled lacy gloves. Sea Dayak warriors who had "taken

a head" had fine-line tattoos on their hands. A man who had taken a head was well-respected, his status assured for life. Rosettes on the Sea Dayak's shoulders or back indicated tribal status or class. The tattoo wearer of Borneo had the burden of the afterlife. A tattoo that said the wearer was of a higher social class than what he or she had actually been born into was doomed to be labeled an impostor in the afterlife—a fate much worse than death.

People traveled and took their culture with them. Polynesians went to New Zealand, where they developed a facial style of tattooing, Moko, that is still being used on Maoris (and other people who like the style and the heritage). Moko tattoos showed warrior rank as well as bravery. Polynesian tattoos denoted tribal communities, families and ranks, with special patterns for young girls and married women. Mexicans and Peruvians practiced the art as ritual, according to evidence found in Mayan, Inca and Aztec cultures. Alaskan tattoos may have come from the Siberian Chukchee, who learned it from the Ainu.

In Western Europe, pre-Celtic Iberians in the British Isles tattooed ceremonially, and so did the Gauls. Teutonic peoples tattooed. The Danes,

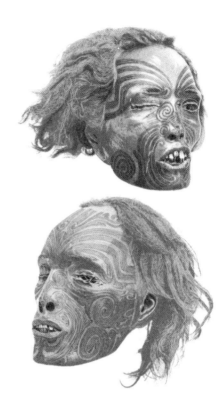

New Zealand Maori Moko tattoos. (Fourth Annual Report of the Bureau of Ethnology to the Secretary of the Smithsonian Institution, 1882–83.)

Norse and Saxons, being more cultured and artistic peoples, tattooed their family symbols and crests. Scots and other Anglo-Saxons still tattoo family crests—tattooist Lyle Tuttle is a well-known example of this practice!

The early history of Western tattooing ended in A.D. 787, when Pope Hadrian banned the

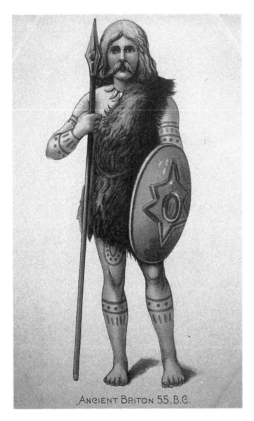

ANCIENT BRITON 55 B.C.

Early English tattooing. (PHOTO © TATTOO ARCHIVE)

art form. Tattooing survived in Britain until the Norman invasion of 1066. Normans scorned tattoos, but "like Anglo-Saxon kings before him, King Harold was heavily tattooed. When his body was recovered from the battlefield of Hastings, it was identified by the word 'Edith' tattooed over his heart."[1] After the Norman invasion, there's

little mention of tattooing in Western culture from the twelfth to the sixteenth centuries. But in Japan, tattooing was secretly flourishing.

As in other societies, tattooing at one time in Japan was used to mark criminals. First offenses were marked by a tattooed line across the forehead. A second crime added an arch, a third crime another line, with the three-mark tattoo forming the Japanese character meaning "dog." But it was also in Japan, later on, that the tattoo was elevated from ritual and religious symbolism to a true aesthetic art form.

"The Japanese body suit originated around 1700 as a reaction to presumptary laws regulating diet, dress and other forms of conspicuous consumption among the various social classes. Because only royalty were allowed to wear elaborately embroidered, ornate clothing, members of the merchant and other classes resorted to costly and beautiful tattooing, conforming to the shape of the body and requiring many years of work, by which to bypass the regulations. With the addition of a loincloth, a highly tattooed person could be considered well-dressed."[2] But only

[1] George Burchett, *Memoirs of a Tattooist*, edited by Peter Leighton, Oldbourne Book Company, London, 1958.
[2] Donald Richie, "The Japanese Art of Tattooing," *Natural History*, December 1973.

in the privacy of his home. Because tattooing came into practice to avoid class laws and sanctions, tattoos were hidden.

The Japanese did maintain some of tattooing's spiritual roots. Their ornate tattoos were meant to resemble kimonos, but since they had to hide their body art, they could only tattoo sleeves up to the elbow, and the front of the garment up to their chest or waist. To permit the escape of demons or bad spirits, they kept the tattooed kimono partially open, with a portion of skin remaining unadorned.

It was in 1691 that tattooing reemerged in Western Europe in "civilized" society. Sailor and explorer William Dampier brought the heavily tattooed Prince Giolo to London from the South Seas. Known as the Painted Prince, he was placed on exhibit and became the rage of London, a sure-fire, money-making attraction. His Polynesian tattoos covered his body, legs, and arms in the precursor to today's tribal tattoos. It had been just about six centuries since anyone in London had seen, let alone touched a tattoo. And it would be another hundred years before tattooing would truly make a mark on Western society.

In the late 1700s Captain Cook, another sailor and explorer, but much better known, made several trips to the South Pacific. London society reveled in his stories and embraced the art and artifacts he brought back with him. On his second journey, one of his artifacts was Omai, a heavily tattooed Polynesian male who created such a sensation in London among the upper classes that soon they were demanding small, discreetly placed tattoos of their own. The Great Omai was seen as a noble savage, and though his tour was clearly a more refined version of it, he was the first "sideshow" exhibit.

Tattooing became a fad among the men and women of

George Burchett, London tattooist and author of *Memoirs of a Tattooist*, died in 1953 at the age of eighty. He was trained by Britain's Professor Riley, who tattooed the Duke of York (King George V), King Oscar of Sweden, Jenny Randolph (Sir Winston Churchill's mom), Grand Duke Alexis of Russia and other European royals. Burchett tattooed the Great Omi and other notables.

The New York World *indicated that in August 1897 tattoo mania had arrived in New York City via France.* (PHOTO COURTESY OF PHILADELPHIA EDDIE FUNK AND THE NATIONAL MUSEUM, WITH SPECIAL THANKS TO BILL FUNK FOR HIS ASSISTANCE)

Cook's upper-class audience, but not a long-lasting one. Remember, during Cook's era in the late 1700s tattooing was done by hand. And that's a slow, painstaking procedure for both artist and canvas. Tattooing became a more mass art form with the invention of the electric tattoo machine. Since everyone could then have a reasonably priced and readily available tattoo, the upper classes quickly turned away from tattooing. In 1891 Samuel O'Reilly patented the first electric machine, and tattooing caught on among a wider Western audience. Competing New York City newspapers said in 1897 that tattooing came to the United States via either France or England. It was labeled a fad. And it was, for a brief period of time.

O'Reilly's tattoo machine was likely based on a Thomas Alva Edison invention—the electric pen, which was capable of puncturing paper with its needle-like point. The machine underwent several patented modifications, most of which were invented by working tattooists. The basics were always based on the original: moving coils, a tube and a needle bar.

At the beginning of this century, tattooists worked in seedy

sections of cities and towns, in areas frequented by sailors and in traveling sideshows and circuses. The tattoo community honors the people who toured with circuses, yet many of us hate it when the media turns any gathering of tattooed people into a "freak show."

The freak-show aspect of tattooing—tattooed men or women exhibiting their heavily decor-ated bodies for a fee—is a part of tattoo history that's difficult to deny. It began when tattoos reemerged in Europe during the 1800s and in the United States around the turn of the twentieth century. During the 1930s the Great Omi, a heavily tattooed man, toured the world. Betty Broadbent, who traveled with Ringling Brothers Circus, also in the 1930s, stated in an

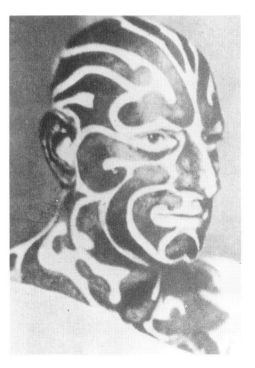

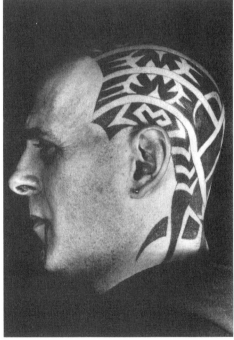

The Great Omi. (PHOTO COURTESY OF PHILADELPHIA EDDIE FUNK AND THE NATIONAL TATTOO MUSEUM, WITH SPECIAL THANKS TO BILL FUNK FOR HIS ASSISTANCE)

A modern-day masterpiece, featuring tattooing in the style of the Great Omi. Collector: Mr. Moko. Tattoos by Dan Thome (chin) and Pat Sinatra (head). (PHOTO © PULSATING PAULA)

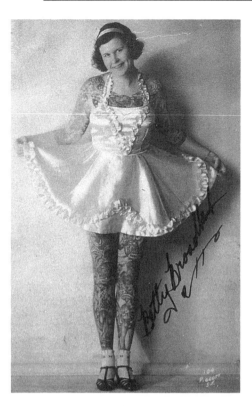

Circus and sideshow attraction Betty Broadbent. (PHOTO © TATTOO ARCHIVE)

interview with the *New York World-Telegram* that she was only one of two or three heavily tattooed women in the United States. Photographs, including those seen in *Life* magazine, dispute this claim, but in those days, who really was counting?

Perhaps the only people who were counting were the tattooists. With tattooing viewed so poorly by the cultural elite for much of this century, the art form went underground. Knowledge was passed on by tattooers. There weren't any real tattoo schools. Few people were invited to join this "secret society" of artists. There were no magazines or associations. Tattoo suppliers generally didn't advertise their products. You had to know where to go and who to go to if you were interested. Yet the art form survived and flourished in several locations across the country.

The birthplace of American-style tattooing (the tattoo images we grew up with, those familiar images of love and loyalty) was in Chatham Square, New York City, just before the turn of the twentieth century. It

Freaks are the much needed escape from the humdrum. They are poetry.

—ALBERT PARRY, *Tattoo*, 1933

was a seaport and entertainment center that attracted working-class people with money to spare. Samuel O'Reilly, the tattoo machine inventor, came to New York from Boston in the 1890s. Charlie Wagner apprenticed to him and then took over the shop when O'Reilly died in 1908. Wagner patented a second tattoo machine and opened a supply business with Lew "The Jew" Alberts, who, according to sources, deserves credit for redesigning a large portion of early American tattoo flash (the designs found on tattooists' walls). Alberts was well-trained for his new career: He had worked as a wallpaper designer. Like other tattooists, Alberts had a nickname that distinguished him in the subculture; unlike most of his tattoo contemporaries, he was Jewish.

Chatham Square flourished and so did tattooing. Husbands trained their wives to use the machine, but they made sure to tattoo them first with several quality examples of their most popular tattoo styles and designs. Walking advertisements! Wives were the perfect trusted partners who could help expand the business and wouldn't

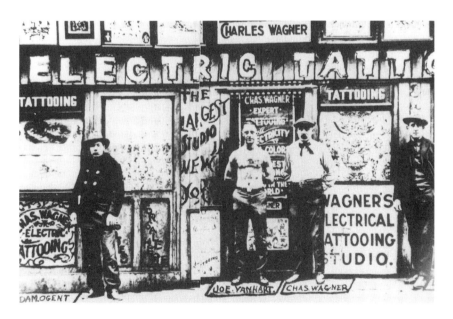

Charlie Wagner's tattoo shop in Chatham Square, New York City, approximately 1910. (PHOTO COURTESY OF PHILADELPHIA EDDIE FUNK AND THE NATIONAL TATTOO MUSEUM, WITH SPECIAL THANKS TO BILL FUNK FOR HIS ASSISTANCE)

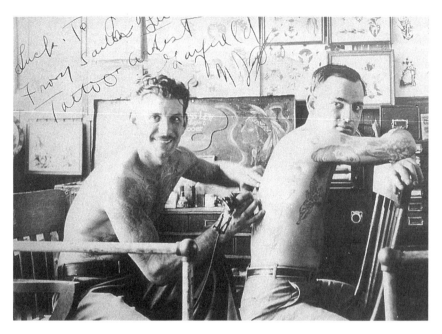

Lew "The Jew" Alberts on the left, with Bob Wicks. Alberts, a wallpaper designer turned tattoo artist, is credited with inventing the design sheets known as flash. Photo taken around 1930. (PHOTO © TATTOO ARCHIVE)

open up a competing shop across the street. Tattooists began to offer cosmetic tattooing—blushing cheeks, dark eyebrows, bright-red bowed lips. Then came World War I, and with it a demand for new tattoo flash, based on bravery and wartime images and icons.

Times changed. Chatham Square lost its luster, thanks to Prohibition and the Depression. Tattooing in New York moved to the seashore playground of the masses, Coney Island.

Other sections of the country had similar tales. Tattooists opened shops in areas that would support them: Norfolk, Virginia, and San Diego, California, with their naval bases; Boston, with its harbor; North and South Carolina towns near military bases. In those days, tattoos were known as "travel marks—you knew the guy had been over the horizon if he had tattoos," said Lyle Tuttle, who got his first in 1947.

Society changed rapidly after World War II. Some teenagers had a reputation of being wild:

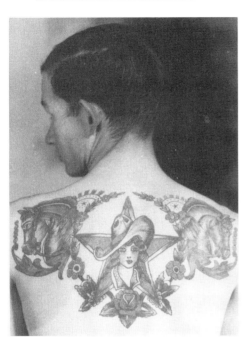

Before there were motorcycles there were horses. Before there were bikers, there were cowboys. This beautiful tattoo was done by tattoo artist Bert Grimm. (PHOTO COURTESY OF PHILADELPHIA EDDIE FUNK AND THE NATIONAL TATTOO MUSEUM, WITH SPECIAL THANKS TO BILL FUNK FOR HIS ASSISTANCE)

listening to loud rock and roll music and playing pinball machines. Hollywood made movies about juvenile delinquents. Inside suburban tract houses were the devices through which the global village began: radio and television. Senator Joe McCarthy and the Russian Red Menace loomed over our heads and out of our TV screens. Changing times made lots of Americans run scared. It was the stuff that fearful traditionalists could easily latch onto.

The newspapers of those times are filled with the stories. First the self-righteous types went after pinball. Then rock and roll. When those attempts failed, they chose an easier target. Tattoos. A hepatitis outbreak was all that was needed to ban tattooing, in various sections of the country, in 1961. There was reasonable cause for the fear.

In New York City, some tattooists worked "dirty." They had sterilization machines and autoclaves on display for show, yet didn't bother to use them. Juvenile delinquents and tough guys populated the shops. The *Daily News* reported stories of a young teenager who actually got blood poisoning from tattoing in the late 1950s. Church and city officials decried the "dirty, seedy" outrages of the tattoo shops. The general population tended to agree. But the city fathers weren't entirely "bad guys." Before tattooing was outlawed in New York City, government officials actually gave the tattooists the opportunity to form an association and self-regulate. The independent, feisty tattooists couldn't

*In 1961 tattoo shops were closed down by governments in New York
City and the state of Massachusetts.* (PHOTO © UPI/BETTMANN)

organize themselves. Instead,
the health code violation went
into effect.

The tattoo shops closed and
the tattooists moved from
Times Square and Coney Is-
land (among other locations) to
places where they could work
legally, like Philadelphia, Yon-
kers, New Jersey. The tattoo
strips in New York City disap-
peared, and along with them
went the "seedy" element that
tattoo parlors represented. For
a period of time it was difficult
to find anyone tattooing in New
York, even underground. Be-
sides the fact that it was illegal,
tattooing had a bad reputation.

Few people desired it; more, in
fact, were afraid of what tattoos
represented: illness, juvenile
deliquency, a bad element. Tat-
tooing's positive qualities, in-
cluding heroic and patriotic
wartime tattoos, were quickly
forgotten, lost amid the hyste-
ria.

Then came the summer of
peace, love, and hippies in
1967. What better way to say
you weren't part of the estab-
lishment than with a tattoo?
Lyle Tuttle helped fan the fad.
He was intelligent, well-spo-
ken, attractive, interesting and
charming. More than twenty
years later he remains all of

Today it's difficult to call the best tattooing anything but art. Following the lead of Chicago tattooer Cliff Raven (now retired in California), Californian Ed Hardy and Hawaiian/Texan Mike Malone, tattooers such as Shotsie Gorman of New Jersey, Leo Zulueta, Bob Roberts and Jack Rudy of southern California, Cynthia Witkin of New Mexico, and Vyvyn Lazonga of Seattle (among many others) have helped to change tattooing through their backgrounds as artists, through their knowl-

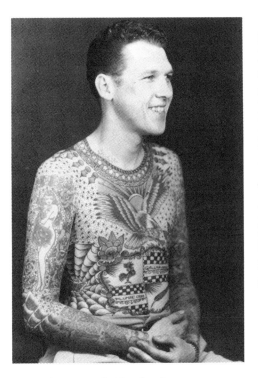

Young Lyle Tuttle. (PHOTO COURTESY OF PHILADELPHIA EDDIE FUNK AND THE NATIONAL TATTOO MUSEUM, WITH SPECIAL THANKS TO BILL FUNK FOR HIS ASSISTANCE)

those things and more (he's a tattoo elder statesman now). Lyle tattooed lots of celebrated women, among them Joan Baez. Most importantly, he knew how to use the media.

Magazines and television all went to Lyle when they wanted a feature on the rebirth of the ancient art form. "Travel marks" turned into sexy little designs, political statements, pretty pictures.

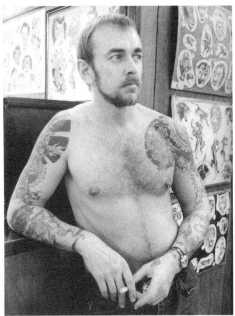

Cliff Raven, around 1974. Raven retired from tattooing in 1993. (PHOTO © MARTHA COOPER)

edge of tattoo art, craft and technology, and through their willingness to meld the traditional tattoo aesthetic with their own personal artistic visions. There's even a younger generation of artists. Watch out for Eddy Deutsch, Freddy Corbin, Filip Leu and Guy Aitchison, who blend different art styles to create dramatic new tattoo images.

New Age Totems

Historically certain venerated symbols have been ever present as totems. These totems may be carved, sculpted, painted, woven or tattooed—ours are pushed under our skins. Modern-day totems are personal symbols which have great meaning to the owner. They can be anything from lucky dice, medicine wheels, crystals, feathers, hearts, skulls to calligraphy. When we choose to have our totem tattooed, we obtain a powerful connection to the ancient world. On my own back I wear a totem which I call the Karmic Embrace. It is a tattooed woman, who is me. She-I-am embracing a skeleton. This signifies my coming to terms with my own mortality.

—CHINCHILLA, TATTOOER AND CURATOR
OF TRIANGLE TATTOO AND MUSEUM

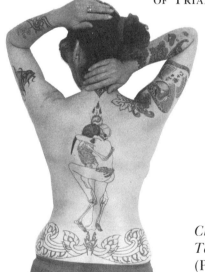

Chinchilla's back.
Tattoo by Mr. G.
(PHOTO © CAPT. GARBAGE)

CHAPTER 3

TRADITIONAL ART FORM, POST-MODERN EXPRESSION, MODERN METHODS: TATTOOING YESTERDAY AND TODAY

In the years before Stonewall (the violent incident on June 28, 1969, between cops and gays that marks the beginning of gay rights) owning and operating a bar that catered to the homosexual trade was illegal. I'm not quite sure what statute would have been violated, but I do know that my father owned and operated a lesbian bar in the middle to late 1950s. And that was in the days before it was "chic" to be a lesbian or be involved in the lesbian scene.

My father's experience taught him never to judge people by their lifestyle. He judged them by their values and passed that lesson on to me. I bring this up because I've been producing a tattoo festival for nearly ten years, in a city where tattooing is illegal—and before it was fashionable to have a tattoo.

Now that I'm tattooed, I've noticed a lot of unenlightened souls who make pruney faces when they see my design. They stare and point. And I've got just a small ankle and foot tattoo. There are the people who treat me as if I'm some kind of novelty act. Apparently, for these people being tattooed connotes a certain kind

of lifestyle. And then there are the questions. Always the same questions!

"Where is it?" "Why did you get that particular tattoo?" "What does it mean?" (Relatively reasonable questions.) "How long did you have to think about it?" "Did you always want one?" "Does it hurt? How bad?" (This question invariably carries visual or sound effects—people indicate their feelings by making a face or sucking in their breath.)

Of course, there are also people who are genuinely interested in tattoos. This is for them.

Visiting tattooists all across the country leads me to the conclusion that tattooing today is just not what people expect. There are at least 30,000 tattooists working in the United States now—and that's just a rough estimate of artists working in shops and studios. The actual total may be closer to 100,000. With all those tattooists working, tattooing has fast become at once a mainstream, kicky, fun form of body art and decoration that's also quite serious and stately. Tattooing is on the verge of becoming "legit." Lyle Tuttle, the man most responsible for bringing tattooing to the general public, says with amused cynicism, "I'm the man who ruined it."

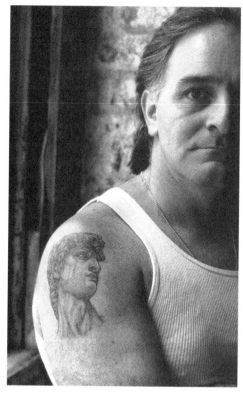

Michael Di Lauro displays Michelangelo's David. *Tattoo by Scotty Lowe.* (PHOTO © TOM GOERTEL)

Before Janis Joplin and the hippies, before New Age rites and rituals, there were people who said that tattoos and tattooists embodied seaminess and sleaze. Was it true? Well, that may have been the attraction for a few guys, especially the bad boy types. Tattooing *was* an underground practice.

The artists tried to keep tattooing to themselves. They were very secretive. The stories

the old-timers tell are all alike: Young kids would seek out the wisdom of the tattoo elders, looking for information, trying to break into the field, only to be sold broken-down equipment for lots of money. Apprenticeships were rare and usually reserved for family members. When tattooer Coney Island Freddy attempted to break in, half a century ago, he hit a brick wall. "The first tattoo machine I bought was from the Greco Brothers in Coney Island," related Freddy in an interview with tattooer and magazine editor Jonathan Shaw. "They charged me twelve dollars for the machine and laughed like bastards when they sold it. I stood there with the machine in my hand. No nothing. That was it. That was what I got. I took it home, put it on the table and says, 'Okay, how do you make it work?' "[1]

"Back then, you didn't ask a tattoo artist any questions. You walked in and told the guy you wanted to be a tattoo artist and you were thrown out of the shop. You wanted to buy things, they told you nothing. There was only a handful of suppliers. There was only one publicized ad for tattooing—that was Zeis, the School For Tattooing (by mail)—in the back of *Mechanix Illustrated*."[2]

[1] "Coney Island Freddy Remembers," *International Tattoo Art*, Volume 1, number 3, 1993, pp. 20–27.
[2] *Ibid.*

Coney Island Freddy's shop and George C. Tilyou's Steeplechase Park funny face. (REPRINTED COURTESY OF *INTERNATIONAL TATTOO ART* MAGAZINE)

Zeiss School of Tattooing. (PHOTO © TATTOO ARCHIVE)

Freddy learned the hard way—by himself. He did what kids had done for years before, just as there are still some kids today who do the same thing. A kid who's motivated will figure out how to make the machine work. He'll take it apart, put it back together again. He'll buy some india ink. And he'll practice. On potatoes. On himself. On his friends. In the old days, once a kid had gotten the basics down pat, he'd go back to the tattoo shop and hang around. If a kid showed he was serious enough—which meant cleaning, mopping up, doing the grunt work—he'd eventually get to apprentice to the master. That's where he'd learn about soldering needles to needle bars, and how to outline the tattoo and then shade it in. In the old days, lots of tattoo shops were in seedy parts of town. There were usually winos and derelicts close by. They were the perfect subjects. They'd generally let someone put a small tattoo on them for fifty cents. And once a kid had hung out long enough, paid some dues in the shop and practiced a bit, he was called an apprentice. And then *he'd* learn how to guard the trade secrets and keep the profession underground.

Tattooing was, to put it mildly, a unique business. Upstanding middle-class folks were afraid of it, while uptown swells were attracted to what they viewed as its lawless quality. Tattooists were fiercely independent. Artists threatened other artists, they threatened people who got too close and wanted to know too much, they even threatened people who didn't stroke their egos. Old habits die hard. Even I was threatened, back when I first started the Coney Island Tattoo Festival. And I wasn't even tattooing.

A well-known but unpopular tattooer, a scratcher from Brooklyn, called me. ("Scratcher" is a

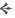
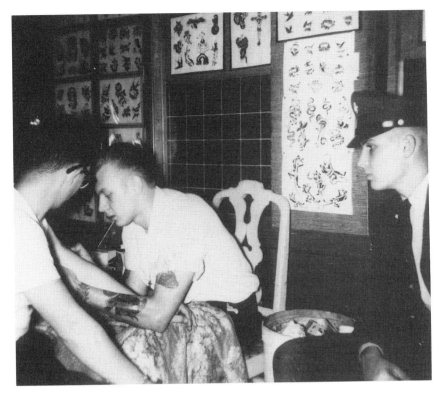

Philadelphia Eddie tattooed in New York's Times Square and in Coney Island before the 1961 ban. (Photo courtesy of Philadelphia Eddie Funk and the National Tattoo Museum, with Special thanks to Bill Funk for his assistance)

derogatory tattoo term.) "You know, you can get in trouble with that festival." I was so naive. "Why? We're not tattooing on the premises. I know it's illegal in New York." Then came his response. I still love its twisted simplicity. "Yeah, well, I know there are gonna be underage kids there who were tattooed. And I'm gonna have some off-duty cops there to check 'em out and bust 'em up."

At this point, the light bulb went off in my head. This guy was insulted that I didn't include him in the planning or put his name on the marquee. How could I? I was so green that I didn't know he existed.

The next year I called and acted as if nothing had happened. "Oh, I'd be delighted to be a part of the festival," he replied, sweetly.

Add it up. Threats, secrecy,

codes. Tattooing had image problems. Bad image problems. Tattooists were required to be tough because of the stereotype, or felt they should be to keep up the image. A lot of unsavory types would come in to be tattooed. Guys going in or coming out of jail, guys who were street tough or bike tough, and guys who just wanted to appear tough made up a good portion of the tattooist's clientele. The sensitive artist persona didn't quite seem to be the way to deal with these people.

Coney Island Freddy describes the scene in a New York shop owned by two brothers who just loved to fight: "One day, I walked into their shop and they said, 'You should have been here yesterday.' They pointed to the designs on the wall; there was blood all over the wall. They had a big fight in the shop. They beat the guys' asses and threw 'em out in the street."[3]

Tattooists were not only independent, they were jealous.

[3] *Ibid.*

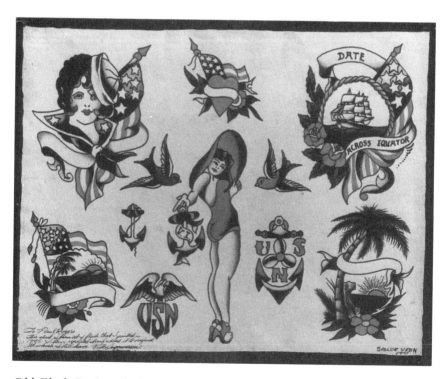

Old Flash Designs by Vern Ingemarson, Sailor Vern. (© TATTOO ARCHIVE)

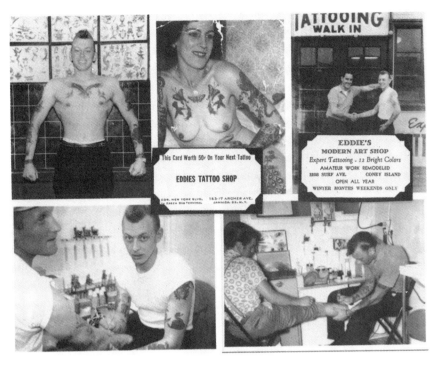

Photo montage and business cards. (PHOTO COURTESY OF PHILADELPHIA EDDIE FUNK AND THE NATIONAL TATTOO MUSEUM, WITH SPECIAL THANKS TO BILL FUNK FOR HIS ASSISTANCE)

They didn't want competition from some new guy who might open up down the block, across the street or, worse, next door. They didn't want anyone coming in, copying the flash off the wall or checking out the prices. They didn't want another tattooist looking over their shoulder to get a close-up view of the modifications they made to their tattoo machines. And they certainly didn't want anyone around who might have been an agent of the Internal Revenue Service—tattooing was very much a cash-only business.

Tattooing was a business with few written rules, and little legislation. You weren't taken seriously as a tattooist until you had been in it for several years—until you had paid your dues, showed you could cut it, showed you were part of the "family." Once it was apparent to the local trade that you were willing to keep the secrets, and willing to stand up for your brothers, only then would you be ac-

cepted into the fraternity. But since there were few rules, there were few standards. Dr. Samuel Steward, a college professor of English who was also known as Phil Sparrow, tattoo artist and author, wrote this about a tattoo hustle: "Unscrupulous tattoo artists . . . used to buy a bottle of Jergen's lotion and a box of empty half-ounce lead ointment tubes from a pharmaceutical house, have tiny labels printed with the words 'Magic Tattoo Salve,' fill each tube with the lotion and crimp the end, selling the tube for two dollars. The lotion faded the color, of course, although it did seem to promote faster healing. And then again there was an extra fee for recoloring."[4]

With few standards, the hustler types in the business helped tattooing earn a bum rap. Of course, there were many exceptions. Lots of tattooers across America had high standards for themselves and their employees. They offered a quality service at a fair price and maintained high standards of behavior and hygiene. A lot of them are still around. So what was it like to get a tattoo in New York City before 1961, when it was still legal?

[4]*Bad Boys and Tough Tattoos: A Social History of the Tattoo with Gangs, Sailors and Street-Corner Punks, 1950–1965*, Samuel M. Steward, Ph.D.

1957

First of all, you'd probably be a man. Or a boy verging on manhood. What better way to prove you're a man than with a tattoo?

There you were, with your friends in Coney Island. You'd probably be hanging out, taking a couple of rides on the Cyclone or the Thunderbolt. You'd be eating hot dogs, drinking beer, playing coin-toss games and winning stuffed animals for your girlfriend. You'd be talking about the biggest news in Brooklyn: The Dodgers would finish out the season, then move to Los Angeles.

You and the guys would see a tattoo parlor, so you'd go in and goof around. You'd check out the wall of flash, seeing if any of the designs said something to you. "Hey, look at this—I could get a big sailing ship, so that when I move my stomach it would look like the ship was moving on the water." Or maybe you'd see something a little smaller that really said how you felt about your mom.

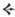

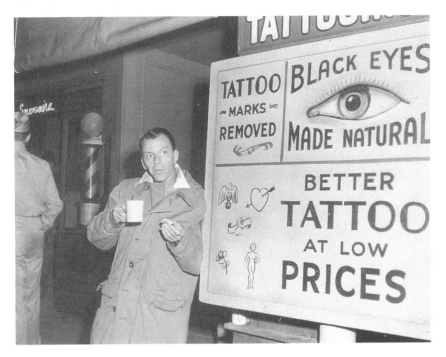

A period piece. A tattoo shop exterior was created to add realism to a film about WWII, From Here to Eternity. *Frank Sinatra leans up against the sign during filming in 1954.* (PHOTO © EVERETT COLLECTION)

Coney Island postcard. (COURTESY OF THE CHRIS PFOUTS COLLECTION)

Or your girl. Or your new status as a Marine. Or maybe you remembered that image your father had—the Lady Luck girl, that terrific, curvy pin-up girl that he got during the war.

"Does it hurt? Yeah, well, I can take it. Well, lemme go have a beer." Or two. Or three.

You study the wall some more and decide what you want. You hear the music on the radio. "Goodness, Gracious, Great Balls of Fire." Jerry Lee Lewis. You check the price underneath the picture and watch the tattooist work on an older guy. He sits beneath the wall of flash, behind a waist-high barrier. First he pulls out a razor— a straightedge. Your eyes widen, you swallow a little bit too hard, you hope no one sees you. The tattooist shaves the skin. Out comes a stencil—a template, actually—of the design. The tattooist looks up at you and smiles. Then he sprinkles something dark on the acetate stencil and presses the template against the skin. The dark powder forms an outline of the design. The tattooist picks up his machine. He's using what's called an outliner, a bundle of three to five needles, bound or soldered to a needle bar.

You watch the human canvas grimace slightly as the tattooist works. The machine buzzes,

hums. The man in the chair does not pass out, even though you're sure he will. He doesn't throw up, either, but you think that you might. Instead this guy is talking to the tattooist, he's talking to you. Of course, he's got lots of tattoos. You wonder if all those tattoos make your skin so thick and tough that you don't feel anything anymore!

The tattooist stops periodically and wipes off the tattoo he's just outlined. He looks, then he dips into the colored pigments. The needles don't hold ink, so the tattooist can't shoot out more or less color as he works. Instead, it's the number of needles used that give a specific look or line, just as the style of a painting can depend on the brushes. The tattooist keeps on working, but you're getting a little antsy. You want the tattooist to start work on you. Then it's over. The machine stops whirring. The tattooist wipes down the tattoo. He takes out a piece of brown wrapping paper, places it over the work, tapes it down and collects the money. In cash (remember, this is the '50s—there was nothing else). "Keep it covered for a day. And don't pick at the scabs," he advises.

Your turn. You make a bunch of nervous, dumb jokes. Your buddy, who got a tattoo a few years back, warns you,

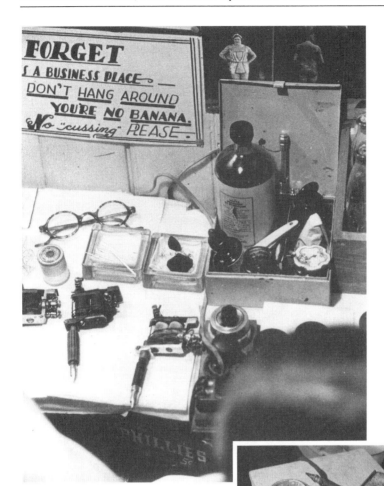

*Some of tattooist Millie Hull's
working tools, these from her New
York shop in the 1940's.* (PHOTO
© UPI/BETTMANN)

*More tools of the trade: pigment
pots, tattoo machine, razor.*
(PHOTO © THE BETTMANN
ARCHIVE)

"You'd better be prepared. You'll never have any pain like this in your life. Never. You'll see. Everyone who gets his first tattoo passes out. Right on the spot. And doesn't come to until the work is finished." The tattooist nods his head in grim agreement.

Wait a minute. That guy in the chair didn't pass out. He just made a couple of faces. And he was busy chatting. So it's probably not so bad after all. The tattooist begins to work, putting the black outline into the skin. You're pretty pleased with yourself. The pain is bearable. Sort of. You guess. The machine continues to whir and buzz away. You're getting tattooed.

Some things never change. A wall of flash in Buddy Mott's tattoo shop, Newport, Rhode Island, 1971. (PHOTO © MARTHA COOPER)

Now

I love mentioning tattoos because I never quite know the response I'm going to get. Bob Wiener, a producer at WNBC-TV in New York, rolled up his pants legs the minute I said "tattoo." He has two. One on each ankle. He got 'em from Brooklyn Blackie.

"It was right before the tattoo parlors closed down for good, and a bunch of guys from Rutgers University went to Coney Island one night to hang out and get tattooed. We all got similar images. I got a question mark and an arrow. One of the guys is now a CPA, another is a corporate attorney—he's always embarrassed about his tattoos at company picnics. And one of us won a Pulitzer Prize. It's amazing the memories I have of that night, they're so vivid. After he finished a tattoo, Blackie wiped it down with after-shave lotion—Aqua Velva. Then he put a Kleenex over the area and taped it with Scotch tape. Sanitary."

Sterilization wasn't on anyone's mind in a tattoo parlor in the 1950s. Customers didn't look around the shop for the autoclave, now used by dentists and tattoo artists alike to sterilize needles. No one cared if the tattooist used rubber gloves. Who thought about those things back then? It's doubtful that anyone at all thought or even knew about bio-hazardous waste material disposal. Tattooists now are concerned with health-related issues. It makes loads of sense, personally and professionally. You wouldn't go to a dentist or doctor who doesn't sterilize his or her equipment. Why go to a tattooist who uses unsanitary methods?

Artwork, health and hygiene, ethics and standards. Time has changed tattooing. Tattooists realize there's strength in numbers.

The Alliance of Professional Tattooists, Inc., (APT) was founded in June 1992 to deal

Body alteration is culture.

—CLINTON R. SANDERS, PROFESSOR OF SOCIOLOGY
AT THE UNIVERSITY OF CONNECTICUT,
IN *CUSTOMIZING THE BODY:*
THE ART AND CULTURE OF TATTOOING

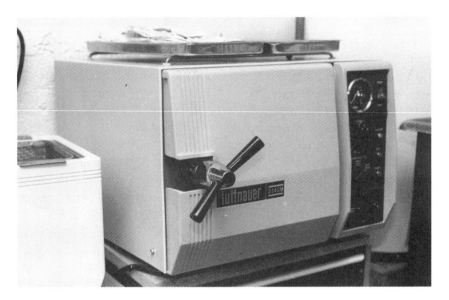

One of the tattooist's tools of the trade today: an autoclave. (PHOTO © LYNNE BURNS)

with the professional concerns of the artists and their clients. The Alliance works to protect the artist's right to tattoo and the client's right to receive quality tattoos in sanitary studios. With Bible-totin' fundamentalists, the threat of hepatitis and AIDS, along with Byzantine laws that are still prevalent in many states (in Fort Lauderdale, Florida, for example, an ordinance requires a tattooer to have a member of the medical profession on the premises), protecting the right to tattoo is not as silly as it sounds.

"Tattooers need something to bank on in their old age," explained the founder and president of APT, thirty-four-year-old Mick Beasley. "We're providing health insurance and retirement plans, and we also offer liability insurance at low rates. We believe there's a need to self-regulate, instead of having everyone else tell us how to run our businesses."

Mick is chatty and smart. She grew up in a large family with eight siblings. I should have asked if she organized family meetings, because she's doing a good job at organizing the tattoo family. And that takes some real politicking. Mick's trying to run the APT in a businesslike way. Some of the by-laws: Professional tattooers must show

three years of documentable tattoo experience, whether working for someone else or as a self-employed professional working alone; references are checked. Prospective members must use an autoclave, and within two years of joining the alliance, they must take a nine-hour seminar in microbiology and disease transmission that's given at conventions around the country. The course is taught by both Mick and Dr. Kris Sperry, deputy chief medical examiner of Fulton County (Atlanta), Georgia.

"During the seminar, we sug-

The Alliance of Professional Tattooists, Inc.

The APT has membership categories for tattooers, nontattooing professionals and collectors. Here is some of the information sent to prospective members:

The APT is a rapidly growing organization dedicated to the continuing education of tattooists on a global level.

The APT conducts seminars to provide you with up-to-date information on sterile procedures, offers a complete infection-control guideline for your studio/ employee use and factual information regarding the Federal Blood-borne Pathogens Rule (March, 1991— U.S. employers only) and what it means to you.

The A.P.T. is blind regarding age, race, creed, level of ability or studio affiliations. Our goal is to simply provide our members with accurate and credible information to maintain our livelihoods with minimal government interference and provide a support base for action against undue legislation aimed at severely restricting or banning the art of tattoo.

We are a self-regulating body of concerned professionals with a board of directors that include medical professionals who have pledged to facilitate our goals.

This is an organization with an open door policy that encourages members to participate on all levels and in all activities.

We sincerely hope you will join in our efforts to keep tattooing safe and legal.

—MICAELA MICHIELI-BEASLEY

gest items that people might want to use in their shops to secure a hygienic environment. And with OSHA (Occupational Safety and Health Adminstration) fines at $7,500 per day, it helps to keep a studio clean and safe." Money talks.

Tattooers who complete the course requirements receive a certificate to be posted in their shops. They're actually doing just that. The certificate states that the tattooer has received instruction in the control of infectious diseases and has sworn to follow the guidelines.

But this is the 1990s. We're all media and marketing savvy. Tattooers are smart. They understand image problems. And the APT is determined to do something about tattooing's image. Brian Everett, a tattoo artist from Albuquerque, New Mexico, explains: "When tattooing wasn't in the mainstream, people felt compelled to hide what they did. So there were few rules, or even no rules. Certain standards became the norm ... things that just weren't ethical evolved into acceptability. For example, there was a great deal of plagiarism— the stealing of flash and then copying it off and using it in a shop as your own. We like sharing our flash with others, but as artists we deserve to get paid for other people using our designs.

It's like computer software or illustrations. We need to set good examples.

"Then there's the issue of mud slinging. In an operating room, doctors don't bad-mouth other surgeons. Yet tattooers constantly tell their clients that other shops are dirty—or worse. Nothing good comes out of it, and the public is smart enough not to believe it all. For us, the tattooers, it had become like the Hatfields and the Mc-Coys. Bad infighting. With the Alliance, we have a means of es-

Alliance of Professional Tattooists decals, in the window of Shotsie's Tattoos in Wayne, New Jersey.
(PHOTO © LYNNE BURNS)

> What to charge? Ah, that's impossible to say. In the 1950s prices were a fifth of what they are today, when many artists will not wet a needle for less than twenty or thirty dollars, and the best workers make $150 or more an hour. In the '50s I was almost embarrassed to ask for $20 an hour.
>
> —SAMUEL M. STEWARD, PH.D., WHO TATTOOED
> AS PHIL SPARROW, FROM HIS BOOK
> *BAD BOYS AND TOUGH TATTOOS*

tablishing a set of positive standards, so that we behave professionally, both for our clients and ourselves. It's for the betterment of everyone."

Even though several attempts at organizing tattooists and providing a set of standards for the industry have previously failed, the last group didn't have the background of this one. Mick Beasley's father ran for the state senate in his native Colorado, then worked in Washington as a professional lobbyist.

The APT has additional goals: to educate the public about good tattooing. How can you tell what's good and what's not? If you hear the term "scratcher," run the other way. That's a nasty term. A bad "dis." Scratchers are just plain lousy at tattooing.

How to Choose a Good Tattooer

Here comes the service aspect of the book—*the advice column!*

Look before you leap. Literally. If you can develop your eye before you get a tattoo, you'll get a great tattoo. Take a look at some of the tattoo publications. Study photos of the work of several different artists, but make sure you see the work up close.

Attend some of the conventions held in your area, or travel to the large, national events. Ask your friends. Word of mouth is still a powerful form of advertising.

Visit the studios of several tattooers in your area. See if the shop meets your expectations. Consult with the tattooer.

For a listing of APT tattooers in your area, call or write the Alliance of Professional Tattooists, P.O. Box 1735, Glen Burnie, Maryland 21060; Telephone: (410) 768-1963.

The National Tattoo Association limits membership to 1,000. There is a waiting list, and prospective members may make application by subscribing to the association's newsletter. Members must be sponsored by one tattoo artist member to join. There are both artist and enthusiast categories.

Newsletters feature four-color photographs and stories about tattooers, along with articles and columns of interest to the tattoo community. Each issue covers a different health-related topic by Dr. Kris Sperry. Classifieds list businesses for sale. Most importantly, National runs well-organized and well-attended conventions. For more information, contact Flo Makofske at the National Tattoo Association, 465 Business Park Lane, Allentown, Pennsylvania 18103; Telephone: (215) 433-7261.

NATIONAL TATTOO ASSOCIATION

CHAPTER 4

DIFFERENT STROKES
FOR DIFFERENT FOLKS:
THERE'S A TATTOO FOR EVERYONE

Now that I'm growing older, I've developed an appreciation of my family—what it means to me and how it's informed who I am today.

And what I like most about tattoos is that once you get one, you automatically become part of a family. In this case, ink is thicker than water. The best part is that no one gets on your case if you don't show up at weddings, bar mitzvahs or Christmas dinners. Who knows if this family is dysfunctional or not? Who cares? If what *Life* magazine wrote in 1936 is still true—that one in ten people in the United States is tattooed—that's 25 million people. We're a big family.

Here are some branches of the tattoo family tree, the subcultures within the larger tattoo world.

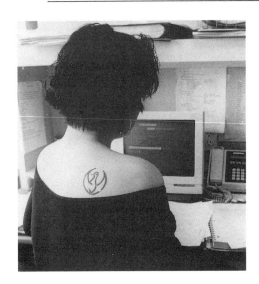

Beth Dunlin at her desk. A tattoo makes you a member of the family, no matter who you are or what you do. Tattoo by Mike Bakaty. (PHOTO © LYNNE BURNS)

Military

What was the first tattoo you ever saw? For me, it was a military tattoo—a patriotic exposure to tattoo art. These tattoos gave us a glimpse of what our fathers, uncles and brothers experienced in the service. I'd always get to laugh as my father's friend would make his sailing ship jump around on rough seas or float placidly on still stomach waters.

A serviceman's tattoo says something to himself and to other servicemen: Where he's been, where he served, what rank he attained, what job he had. Most importantly, these pictures suggest the genesis of tattoo's earliest roots in a modern-day setting: a picture to go along with the oral tradition of storytelling.

Wherever there was a military base, there were, and still are, numerous tattoo shops. Some of these shops, satellites of larger shops in larger towns, opened only on servicemen's payday. Others were there forever. In fact, the nation's oldest tattoo shop, Bert Grimm's, is in a naval town on the Pike in Long Beach, California.

During World War II, the Lady Luck image was particularly popular. There was Lady Luck nude and there was Lady Luck dressed. There was a form of the Lady who served as a warning: She was one of the things that made up Men's

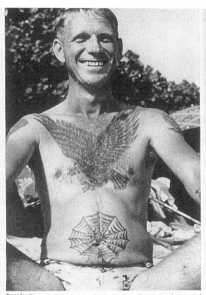

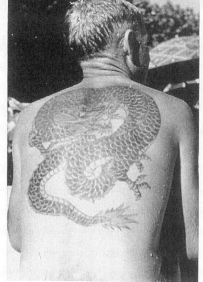

Spreadeagle on a sailor's chest is a heroic expression of patriotism that required several sittings to administer. The spider web expresses less exalted sentiments.

Japanese dragon shows fine execution of a Japanese tattooist. Lines are more finely drawn than those of Occidental practitioners, colors have range and subtlety.

TATTOOS COVER ACRES OF U. S. SAILOR SKIN

"Some birds get tattooed in Brooklyn
And I got my first one in Brest,
But Kelly was born on a December morn
With a square-rigger drawn on his chest."

Kelly, Chief Bosun's Mate and hero of an endless cycle of free-running quatrains, belongs to the older generation of sailors. His 20 years in the Navy were logged in eight colors on his skin. On a modern sailor a tattoo, costing from 25¢ to 85¢ is often a matter of deep remorse within a few weeks.

But the waterfront "professors" still find a living branding green sailors with the symbols of their profession—anchors and ships. Next most popular are girls, who, according to regulations, must be suitably clad. Chef d'oeuvre of the art is an unfortunate casualty of the Pacific crisis. It is the finely drawn dragon pricked on only by Japanese practitioners in Yokohama.

THIS TATTOO WAS SUPPOSED TO KEEP SAILORS FROM FALLING OFF YARDARM

Coat of arms combining anchor, battleship and flag is elaborate sailor's brand.

Sailor's Sweetheart, in uniform, ranks next in popularity to the coat of arms.

Clipper ship has not yet been replaced by modern warship as motif for decoration.

Hula girl, inscribed by Honolulu tattooist, dances when sailor flexes his biceps.

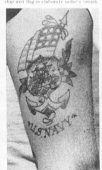

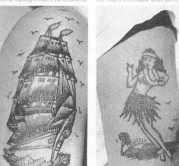

In October 1940, Life *magazine celebrated maritime tattoos.* (PHOTO BY CARL MYDANS, *LIFE* MAGAZINE, © TIME WARNER)

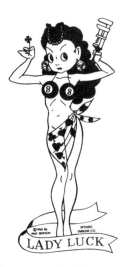

Lady Luck decals. (COURTESY OF
THE CHRIS PFOUTS
COLLECTION)

A classic Men's Ruin tattoo. (LEG
COURTESY OF RON C., TATTOO
BY TONY P., PHOTO © LYNNE
BURNS)

Ruin, the other two being drinking and gambling. There was the Pacific Theater Lady, who sometimes took the form of a Hula "girl." The Lady Luck tattoo wasn't all that different from those painted on planes and cannons and bombs. I like the Lady Luck images. They all point to one thing: the power of women (how's that for a post-feminist take?).

I think I would like a retro Lady Luck image to be my next tattoo. Where should I get it? Bicep? Forearm? I'm not quite sure. I've just started to see a resurgence of Lady Luck tattoos among both male and female collectors. I think the older Lady Luck images are absolutely spectacular. I'm partic-

ularly passionate about the ladies drawn by the late, legendary Sailor Jerry Collins, whose Honolulu shop, China Sea, is now owned by Mike Malone.

Military tattooing remains a powerful tradition, even in these times of a shrinking army. Right after Operation Desert Storm in the Middle East ended, tattooist J. D. Crowe, of Norfolk, Virginia, said that business was brisk for his specially designed Desert Storm tattoo. That was a generic "I was there, I served" banner/memo-

rial type of tattoo. The other image that has a universal military appeal is the Warner Brothers cartoon character, the Tasmanian Devil. Military base tattoo shops feature "The Taz" as soldier or sailor, holding an M-16 or swinging an anchor.

Generally each branch of the armed forces has its favorite tat-too image: Death before Dishonor, Semper Fi, USMC and the bulldog mascot are the Marines choices. Various ships, including old-fashioned sailing vessels, are obvious Navy selections, although sailors also go for naked women, bluebirds and Neptune, according to Crowe.

The Future of a Genderless, Tattooed Military May Be Upon Us

The *New York Times* reported the following in March 1979:

The Marine Corps discharged a twenty-three-year-old Long Island woman because of a tiny tattoo. Marine regulations permitted the tattoo on a man. "She shouldn't have got past the recruiting station; she will be discharged next week," Major William Paulson, a Marine Corps spokesman said from Parris Island, South Carolina. The marine was told she could complete her basic training if she had the tiny five-pointed star on her left wrist removed.

"The Marines are always talking about how women have as much opportunity as men; I'm glad I found out about it," said the woman. "It's my mind they want, my talents, not my wrist."

She did list the tattoo as an identifying mark during her induction physical. Major Paulson said the tattoo ban, as indicated in the *Marine Corps Personnel Procurement Manual*, does not apply to men.

In 1993 Captain Steve Manuel, Headquarters Marine Corps media officer, had this to say about tattoos and gender: "There is nothing about it in the current *Marine Corps Personnel Procurement Manual*. Ideally, you shouldn't be able to see a tattoo while the Marine is in uniform. But there is nothing in the regulations that addresses it at all."

There is no record of what happened to the Long Island woman.

Navy Tattoos

When a sailor had racked up 5,000 sea miles, he had a blue-bird tattooed on the side of his chest. When he had gone 10,000 miles, he had another one placed on the other side. A dragon showed he was on a ship that had crossed an international line. Often a sailor had the name of each port tattooed on the side of his leg. In the British navy, a crucifix tattooed on the back of a sailor spared him from a flogging. Who would strike such a revered image? That would be a sacrilegious act. Sailors in the "Windjammer days" had "Hold fast" tattooed on their knuckles as a safety reminder when aloft.

Tattoo by Chinchilla. (Photo © Capt. Garbage)

The local retired seaman who owns the tattoo pictured here said: "The propellers on my buttocks and the rooster and pig on my ankles are to keep me from drowning if the boat capsizes. Most of my tattoos are navy tattoos. I have two seagulls tattooed on my left ear. These seagulls are representative of sailors lost at sea. I feel these tattoos will always identify me with the sea I love and the service I gave to my country. I am proud to be wearing these tattoos."

—Chinchilla, tattooer and curator of Triangle
Tattoo and Museum

Wartime salvaged tattooing. Because there's a generational lag . . . tattoos don't go away. . . . The kid who was ten in 1955 wanted to get his first tattoo around 1963. Every morning that kid would be looking at Dad over the breakfast table. And seeing that tattoo. Since it was likely that Dad had a service tattoo, then the integrity of the imagery propped it up and helped tattooing to survive during the early 1960s.

—TATTOOER AND ANTHROPOLOGIST MICHAEL MCCABE

Prison Tattoos

I get a kick out of hearing people say a tattoo helps to provide an instantaneous image of "tough guy." It's really not the whole truth. Tattooing has been a means to mark the accused and the convicted for thousands of years. Prisoners in ancient cultures were tattooed, and so were the people who committed real or imagined crimes against Nazi Germany.

Today prisoners apply their own tattoos to pass time, not necessarily as an identification badge. Elaborate Russian convict tattoos, which the men apply to each other, relate the prisoner's life story in code. A spider in a web tattooed on a skull indicates that the person is a drug user. Other images tell of the owner's crimes, the sentences he's received and the wearer's position and status in convict hierarchy. The more tattoos he has, the more respect he gets, because the tattoos prove that the owner isn't afraid of pain.

American prison tattoos are generally crude, handmade images. They are meant to be noticed, running across hands and fingers. For many years, a very finely drawn type of picture/portrait tattoo has been prevalent among certain Latino prisoners on the West Coast; these single-needle, "fine-line" images have helped to inspire a tattoo genre: the fine-line portraits of tattooists such as Jack Rudy of California and Brian Everett of New Mexico. You can see an example of Everett's work in this style in Chapter Six.

Prisoners utilize various materials to make their tattoos. Needles, thread, syringes and

Allen Falkner. Stomach tattooed by Howard "Monty" Hayes while in the state pen for armed robbery ten years ago. Hayes used a cassette tape deck and a guitar string. Paraphernalia had to be cleaned up when they heard the warden coming.

Vada is Allen's grandmother's name; Virgo is his astrological sign. Tattoos on his right arm were done by Carlos of Woodland, California. Devil and "Born to raise hell" were done while on leave from the service, and the two lower portraits were done by Mr. G of Triangle Tattoo in Fort Bragg, California.

Allen's left arm was tattooed by Carlos. The names are Allen's immediate family members. Allen is planning to have an asterisk tattooed next to his brother Bryan's name, since Bryan died in a car accident two years ago. (© 1993 DEIRDRE LAMB PHOTOGRAPHY, FORT BRAGG, CA)

electric shavers all serve as parts in handmade tattoo equipment. An inmate may burn the heel of a shoe and utilize the ash, or let a lit candle burn against a ceiling, scraping off the soot and mixing in some water. The black carbon serves as the ink.

"I'm going to the can [jail]. I gotta get a tattoo before I go in."

—OVERHEARD IN A TATTOO SHOP

Rock and Roll, Rockabilly Tattoos

Rock and roll radio begat MTV and MTV begat music videos. Music videos begat lots and lots and lots of images of musicians with tattoos. Some wear their guitars on their skin. It seems to come with the turf. Back when it first began in the 1950s, rock and roll was the angry, angst-ridden music of the young. Tattoos were verboten, especially for teenagers. So, was rock and roll at its inception. Now rock and roll is probably the world's most popular style of music among young people. Does it follow that tattoos may soon be the most popular body art among teenagers?

Rockabilly tattoos are simply a way of letting everyone know that while rock and roll may be here to stay, rockabilly never went away at all. It's a different music and a different genre. Its roots are well into the '50s—hot rockabilly bands still have nonelectrified string basses! The style of the music lends itself to a different style of tattoo: Rockabilly tattoos are for people who are less angst-ridden than rock and roll kids. Although they take their cars (hot lead!) quite seriously, they take their rockabilly tattoos the same way as their music: fun, fun, fun.

Scott Kempner of the Del-Lords with his Bob Roberts tattoo. (PHOTO © LYNNE BURNS)

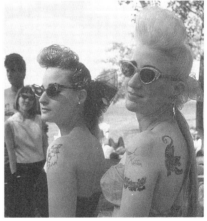

A rock and roll tattoo doesn't have to feature rock and roll symbols to look good. (PHOTO © STEVE BONGE, N.Y.C.)

Rockabilly gals and their tattoos. Tattoos by Brian Lilly and Shotsie Gorman. (PHOTO © STEVE BONGE, N.Y.C.)

Elvis I

While we cannot attest to the living or dead qualities of the king of rock and roll, we have seen lots of versions of the Elvis stamp tattooed on males and females all over the country. Which is particularly good since the stamp is now out of print.

Elvis II

In 1993 we called the White House to learn if Bill Clinton had ever been tattooed. The spokesperson made this statement: "To the best of our knowledge, the President is not tattooed." Is Hillary?

Tattoos in People's Lives

Tattoos provide meaning in people's lives. Here are two memorial tattoos.

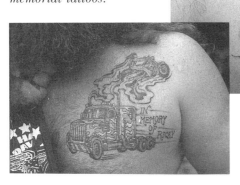

"In memory of Dad" tattoo on Crazy Larry by Jack Rudy. (PHOTO © STEVE BONGE, N.Y.C.)

"In memory of Ricky" tattoo on Stinky by Morbella. (PHOTO © STEVE BONGE, N.Y.C.)

Biker Tattoos

Nearly ten years ago, I produced the first of what has become the annual Coney Island Tattoo Festival. I did it to help raise money for the only not-for-profit arts organization in Coney Island which was dedicated to preserving Coney's rich history of popular culture. The "playground of the masses" had been a center of tattoo shops during the 1950s, so, in keeping with the theater's mission, I thought I'd rekindle the memories. I had a background in producing large events and festivals. When the rest of the board of directors said: "Hey, Amy, great idea, you wanna put on a tattoo festival, go do it," I did.

But what did I know? I knew tattooing was illegal in New York City and I knew how to find Spider Webb. He advertised in the *Village Voice*, the weekly newspaper that was my employer at the time.

Instead of hunting around in New York, I went to New Jersey—to Lola's Hot and Flying Tattoo Parlor in Cliffside Park. Lola is an earthy, bawdy, large, funny lady (I like Lola). Her clientele consisted mainly of young biker wanna-bes and working-class heroes and heroines. Her shop was more like an old-fashioned tattoo parlor than a modern-day studio. She took one look at me, spent several hours talking to me, then sent me to two New York City tattooists, both fine artists, both holders of college degrees in art. They listened to me, then put me in contact with a few of the tattooists working underground in New York.

I produced the event in a dumpy old theater on the Coney Island boardwalk. The place was a mess. Dark, old, very funky, decorated with an offbeat, "downtown" artsy-fartsy sensibility. The audience

Club colors are tattooed on oneself usually as a requirement to show you have achieved full membership. But as a biker I can also tell you that tattooing my colors is a sign of pride and commitment to my fellow brothers in the club.

—Biker

Tattooist and collectors. From left to right, Woody, Stinky, tattooist Jack Rudy and Flathead Ed on the boardwalk at the Coney Island Tattoo Festival. (PHOTO © STEVE BONGE, N.Y.C.)

was to be seated in a tier of bleachers that seemed in danger of collapse. The stage was raised up about 18 inches. To separate the crowd from the stage, there was a rickety half-rail. But the setting didn't matter. It was pure Coney Island. It was the history that counted. And the history was glorious. For a time in New York, throughout the '20s, '30s and '40s, when someone phoned information for the telephone number and address of a tattoo shop, the operator would simply advise the caller to visit Coney Island.

I staged a panel discussion, "Tattoo as an Art Aesthetic." I invited photographers to participate in a photo exhibit. The pictures added a nice decorative touch to the black walls. I had art videos showing on two screens, on each side of the stage, at all times.

Three days before the festival, I had a revelation: "Bikers have tattoos. Bikers will come to the festival. What's going to happen? What will I do?" I was absolutely panic-stricken. I called the local police precinct and we discussed the situation.

What situation? The day ar-

rived. The crowd was small. They all seemed to know each other, or they knew somebody who knew somebody who knew them. They all showed off their work and talked about it. They discussed the artists: who was working where, who had moved, who had stayed put. They mostly ignored the panel discussion. And they didn't fight or wreck the place, as I had mistakenly been led to believe would happen.

After that first festival, several bikers came up to me. "Whaddya have all those cops here for?" (Most of the cops were off-duty, in plain clothes and showing off their tattoos. They were scattered among the uniformed patrolmen, but we all knew they were cops.) "We just wanted to . . ." At this point in time, it doesn't matter what they wanted to do. What they wanted to do is still not legal, but it is not a felony offense. But I digress. What I thought would be a downtown art scene event, an acceptance of tattoo as a true art form among the Soho art crowd, turned into "a cross between a biker convention and a high school prom," according to a piece in the *New Yorker*. Each year since then, the crowd has grown larger, and the number of Harleys displayed on the Coney Island boardwalk becomes more impressive.

I hired a bike club as security. I no longer invited the cops. ("Remember that first year, Amy?" remarked one biker recently. "You had seventy-five cops and about eleven of us.") My audience had a great time. I had a great time. And I grew to respect, admire and really like the bikers. They're just like everyone else. Some are smart, some aren't. Some are good-looking, some aren't. Some are friendly, some aren't. Some are ambitious, some aren't. Some work, some don't. Where bikers are different is in their commitment to a lifestyle that is very

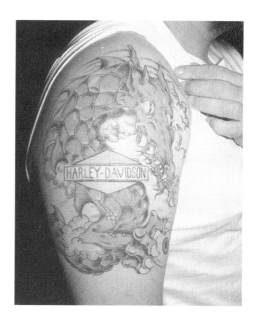

A dragon guards this Harley Davidson tattoo. Tattoo by Cindy of Hempstead. (PHOTO © STEVE BONGE, N.Y.C.)

FTW, taken during Bike Week at Daytona's Boot Hill Saloon. (PHOTO © STEVE BONGE, N.Y.C.)

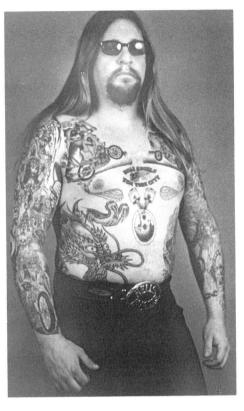

Artist and photographer Steve Bonge. Tattoos by various artists, including D. E. Hardy and dragon by Bob Roberts. (PHOTO © STEVE BONGE, N.Y.C.)

much their own. It's not for everyone; it's not meant to be. Where bikers are especially different is that they know how to throw a party better than anyone else. And bikers have some great tattoos.

If an outlaw biker lifestyle signifies an extraordinary sense of freedom, and a nonacceptance of other people's way of living, a biker's tattoos show his (or her) commitment to that life. Like all body art, biker tattoos are about life, ritual, symbols and icons. The motto bikers often tattoo reads "Live to Ride, Ride to Live," or "FTW." (For the uninitiated, FTW means "F**k the World." Nobody tattoos the words. The expression is FTW, therefore, the tattoo is FTW.) The motorcycles they tattoo on themselves

are their favorite brand. Many bikers proudly display their 1% tattoo. Ask a biker what it means, or check the tattoo lexicon in the Appendix.

Bikers who belong to motorcycle clubs not only wear their club colors on their jackets, they wear their colors permanently. I wanted to show a club tattoo in this book. But you don't just

go around snapping pictures of motorcycle club members. It's not proper etiquette. So I consider it a gift that Steve Bonge, a talented New York artist and the photographer who produced many of this book's photos, gave me his picture to be printed in the book. You can tell by the tattoo on his chest that he's a member of a renowned motorcycle club.

Like everyone else, bikers appreciate admiration of their tattoos. And why wouldn't they? Their carefully chosen images have a personal and special meaning.

Bikers kept tattooing alive in the 1960s, when the art was outlawed in so many states and cities.

—C. W. ELDRIDGE, TATTOOER AND CURATOR OF THE TATTOO ARCHIVE IN BERKELEY, CALIFORNIA

From "Sleazy Perversion" to "Self-Expression and Style"—The Serious Artists Take Over

The *Wall Street Journal* Leisure and Arts column of April 8, 1986 was a cheeky, irreverent piece written by Ed Ward. It was ostensibly about the National Tattoo Convention held in New Orleans. But it gave *Journal* readers something much more important: a very brief history of modern tattooing. "Tattooing, by the mid-'60s was in a rut: The same old designs that World War II had birthed were being chopped out in studios in every dingy port in the world. Artistry was not unknown, but mediocrity was rampant. Enter Norman Collins, known to the trade (most tattoo artists have a pseudonym . . .) as Sailor Jerry.

"Although Collins despised the Japanese for their role in Pearl Harbor, he knew that in the centuries-old tradition of full-body designs fitted to a person's contours they had us beat. We had superior technology—electric needles, brighter pigments—and we were blowing it

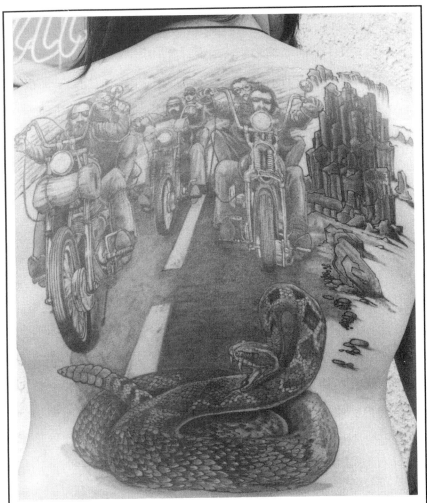

(PHOTO © LYNNE BURNS)

My tat, which artist Shotsie Gorman has captured so realistically, is an expression of the way of life that I've chosen. Riding my Harley solo or with my brothers is the closest thing to freedom I know. My hog is the most essential tool on the road to total fulfillment. The snake represents the fact that there's danger around every bend. But I have always been able to overcome the danger.

I live the life I love, and I love the life I live.

—TIM FALK, A BIKER FROM NEW JERSEY

on the aesthetic front, something he complained about in his frequent letters to such youngsters as Don Ed Hardy and Mike Malone. 'All we need is a "dream culture" of euphoric fantasia to work on,' he wrote in 1971, 'and I think we could crack the nut.'"

It was clear that the times were changing. Mike Malone and Ed Hardy were serious artists who chose to be tattooists. Skin was their medium. And Lyle Tuttle had already done an excellent job of giving tattoos a measure of respectibility. So, according to Ward's article in the *Wall Street Journal*, "what was formerly considered a sleazy perversion, a mistake made by drunken sailors on shore leave, became just another form of self-expression and style."

And there you have it in a nutshell. The genesis of the modern tattoo, the back story behind the book. But what exactly is this new tattoo art and how does it differ from old tattoos?

If a tattoo makes you stop and look and think, the odds are good it's a modern tattoo. Dr. Kris Sperry, deputy chief medical examiner of Fulton County, Georgia, the man who now teaches tattooists about blood-borne pathogens, had seen lots of tattoos back in the days when he performed autopsies in New Mexico. Some were bad, some terrific. But they inspired him to learn more. He found *Tattootime*, the publication created by Ed Hardy to serve as a vehicle to get the word—and the pictures—out about modern tattoos; the platform to get people to reconsider their preconceived notions about tattoos and tattooers. "When I saw the art that was possible, it was as if the curtains had pulled, the waves had parted. Before this I had never been concerned with tattoos. But now it was obvious. I'd have to get one." You can see Dr. Sperry's tattoo in the accompanying photograph.

Modern tattoos are very much about making a statement. That's why we get them.

What Is the Most Popular Tattoo Image in America?

According to an unscientific poll of tattooists in every section of the country, the number-one tattoo image, depending upon whom you ask, is one of the following: Jesus, eagles, lions, tigers, panthers.

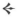
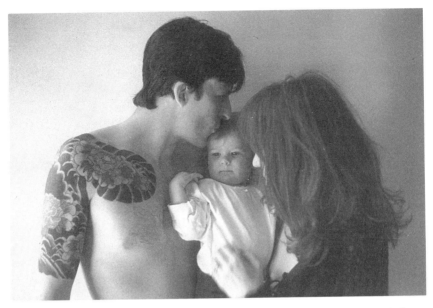

Japanese-style tattoo on Rob Ehrler, with his wife, Marlene, and baby, Jacqui. Tattoo by Mike McCabe, Shadow World Tattoo. (PHOTO © LYNNE BURNS)

Although the statement is personal, the vision is a joint effort between collector and tattooer. Modern tattoo art combines the best elements of other art forms: It might be religious, spiritual, inspirational, erotic, naturalistic, violent, abstract, popular or commercial art in both style and content. But one of the differences between art hanging on walls and art inside skin is the general lack of pretense found in tattooers, their clientele or their tattoo art.

Though the *Wall Street Journal* account presents just the West Coast version of modern tattooing, Ed Hardy (along with Malone and a few others) does deserve much of the credit for changing both the tattoo image and the image of the tattoo. Hardy's own training as an artist, along with his love of the tattoo, drove him first to study and then to experiment. He helped to change the tattoo so that its aesthetic essence was quite different from what had come before. But Hardy's other great gift was in delivering the message to the public, even when that public didn't care to hear the message. Getting the word out required "a bit of

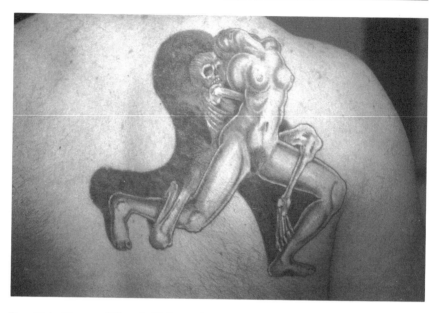

Dr. Kris Sperry, "Death Takes a Woman," based on a work by Kathe Kollwicz. Tattoo by D. E. Hardy.
(PHOTO © KRIS SPERRY, M.D.)

carny, having the platform *(Tattootime)* and then constantly being out there pitching."

All across the country, though, at just about the same point in time, there was an awakening. Oh, the collective consciousness of the baby boomers! Oh, the joy of discovery! Tattooers across the United States studied and practiced old and new styles of tattooing, combining Japanese, traditional American tattooing, traditional Native American images, cave drawings and petroglyphs, cartoon art, pop art. Cliff Raven in Chicago. Zeke Owen down south. Spider Webb, Paul Ortloff, Ruth Marten, Mike Bakaty in the New York area. Sculptors and painters in various sections of the country became fascinated by body art, especially the Japanese body suit, and discovered a new canvas. Skin.

The Pacific Coast tattooers had an advantage: They didn't work underground like the "illegal" New Yorkers. In San Francisco, Hardy opened Realistic Tattoo in 1974, the first appointment-only studio. With a Bachelor of Fine Arts degree in printmaking from the San Francisco Art Institute, he knew that to change the tattoo

The Modern Tattoo Experience

I got my first tattoo four years ago when I was thirty-one. I had always wanted a tattoo, and I had gone in and out of tattoo shops watching, waiting until I found the right artist. I wanted to mark myself.

(Photo © 1993 Jessica Tanzer)

My first tattoo was done by a big, burly, bearded, biker dude. He had just tattooed the band Poison, and it was important to me to have a traditional tattoo experience. I got a classic skull image on my left arm. Now I have about twelve to fifteen individual tattoos, including a Pink Triangle on my shoulder. I wanted a back piece because it's the largest canvas on the body. I don't draw but I explained what I had in mind to the artist, Freddy Corbin. I wanted light and movement, flow. He sketched it, then laid it out . . . a tangible manifestation of what I had envisioned. I was—and still am—thrilled. The tattoo really speaks about the light I feel inside, the light coming from within and shining through.

—Woody Woody Go-Go

(The ankh tattoo pictured here was done by Michael McCabe. The back piece may be seen in the color section. Both photos © 1993 Jessica Tanzer.)

So I Woke Up on the Morning of My Thirty-eighth Birthday, a Tattooed Jew

I had thought through every reason why I shouldn't get a tattoo. After my mother died, I started thinking about why I should. My mother always took a philosophical view of things. She was an optimist, a believer. Every time she took a fall, she came back strong. Her belief system drew upon everything positive, possible and beautifully impossible in creation. When I thought about her in this way, I always imagined a phoenix. A mythical bird rising up from the ashes, born again in flames.

Donna Gaines, the Tattooed Jew.
(PHOTO © STEVE BONGE, N.Y.C.)

The phoenix stands for immortality, resurrection, the spontaneous regeneration of spirit and matter.
I had made my decision. I would get a phoenix.

—DONNA GAINES, PH.D., SOCIOLOGIST, AUTHOR OF *TEENAGE WASTELAND: SUBURBIA'S DEAD END KIDS*

art form required knowledge, intense dedication and a unique sensibility. Hardy understood at a core level that the new tattoo art needed to be intellectually suitable for a visually sophisticated audience.

It's now twenty years since the emergence of the modern tattoo. Many of the creators, Hardy included, are looking back to traditional American-style tattooing for new sources of inspiration. Scotty Lowe, a tattooer in New Jersey, is informed by the images, themes and style of artists such as Grant Wood. Younger tattooers create newer images, some of which are totally unique to the medium. Filip Leu of Switzerland mixes in psychedelia, cartoons, commercial art and traditional styles to create an aesthetic that can be found only on skin.

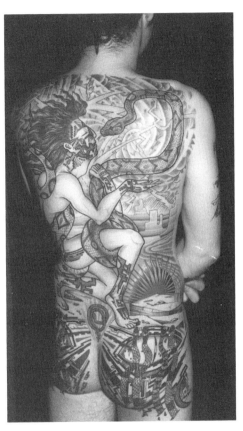

Snake shaman, D. E. Hardy. (PHOTO © 1992 D. E. HARDY)

Tattooer Scotty Lowe's new flash is informed by traditional American-style tattooing, along with the images of American artists such as Grant Wood. (FLYING ACE © SCOTTY LOWE, 1992)

C H A P T E R

5

IN THE TATTOO STUDIO:
WHAT REALLY HAPPENS ANYWAY?
(ESPECIALLY FOR THOSE OF YOU
WHO DO NOT HAVE A TATTOO
AND ARE CONSIDERING
GETTING ONE)

There I was, untattooed, with a contract to write a book about tattoos. Clearly I had to get tattooed, and fast.

I had already decided who I wanted to do my tattoo. I had met her at the National Convention in New Jersey in 1992. Vyvyn Lazonga's work combined traditional styles and images, along with unique abstractions and geometric designs. Technically and artistically her work is excellent. Vyvyn's tattoo on my friend Kathleen is exquisite. But Vyvyn was in Seattle and I was in New York. I just couldn't afford to get on a plane and fly out there.

My dilemma: I knew all the local tattoo artists. I'd hung out in enough tattoo shops throughout the years. I didn't want to insult anyone. I rationalized it: I'm not getting a back piece, I'm not getting sleeved. I'm just getting a small tattoo. So I chose Shotsie Gorman of Wayne, New Jersey. We had been close friends for seven years. Because of that I gave him carte blanche. "You know me. You design the tattoo. All I care about is that it's on my ankle."

And that's all I'm going to tell you for now. I had to wait while he did a sketch. So you'll have to wait, too.

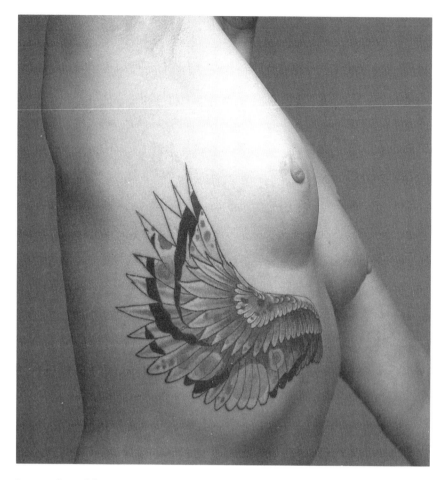

Some of Kathleen's ink, by Vyvyn Lazonga.
(PHOTO © PETER KOLK)

If you've already got a tattoo, or two, or three, this chapter is likely to serve as a fond memory of what it was like your first time (remember that first time?). Or it may serve as a show and tell of the experience that you *selectively* remember. Anyway, it's the way I remember my first.

Most people don't allow as many liberties to be taken with their tattoo design as I did. In other words, most people know what they want, and they work with the artist to make it happen. Other people simply want something quick and easy, right off the wall.

If it's a large, unified look you're after, a back piece or sleeves and chest work, you'll want to discuss the look, style

My Tattoo

My back is a pure occupational tattoo, like a miner might get crossed shovels or a teamster his union logo. I am a writer, which is what I always wanted to be. Tattooist Shotsie Gorman and I built the Imperious Muse from Ronnie Spector's hair, Bardot's face and Ava Gardner's body. The typewriter is modeled on an old Remington that I still own.

—CHRIS PFOUTS, WRITER, MAGAZINE EDITOR,
INDIAN MOTORCYCLE OWNER

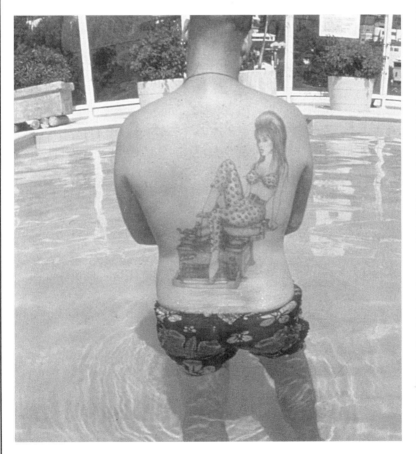

Chris Pfouts. Tattoo by Shotsie Gorman.
(PHOTO © DEBBIE ULLMAN)

and feel of the work with the artist. Then you'll get to see a sketch, and the artist will show you how the sketch lays out on your body.

If you're planning a small tattoo, it's still a very big deal because it's such a commitment: Your body will be indelibly altered. The tattooist realizes this and knows that it's an important decision. As New York tattooer Jonathan Shaw said to me, "Coming to the studio is a special event for many people."

The experienced tattooer has seen all types of reactions from virgin tattooees. On my first visit to a shop some twenty-three years ago, I looked around, but I didn't get tattooed. I chickened out. I was the only female there and the two guys waiting ahead of me at Spider Webb's were all polite enough to say: "It's okay. You go first. We'll watch." I stood over a guy who was having his stomach tattooed—he grimaced a lot. My male friend kept reminding me that a tattoo could never be removed, that I couldn't be buried in a Jewish cemetery. His fourth try was successful. "I guess I could wait a little while longer." As he

Perhaps you'll select your tattoo design from a wall of flash. These designs at the Fineline Tattoo Studio of Mike and Mehai Bakaty. (PHOTO © LYNNE BURNS)

drove us back to Brooklyn, I kept thinking of Janis Joplin. She didn't chicken out.

On my second visit to get a tattoo, I made an appointment. Of course, I was thirty minutes late. I couldn't even pretend to make an excuse; my lateness was just too obvious. But I didn't back out. Instead I made a lot of nervous jokes. Shotsie calmed me down by wise-cracking back. Then he showed me the tattoo he had designed for me. It's a stylized version of my horoscope sign, using aspects of my personality that he knows well. It's very much how Shotsie sees me: It's got flames and water and smoke, and there's a spiritual edge to it, too.

"Uh, don't you think it's a little too big? And I'm not sure about the placement. I really wanted it over here, or here." I pointed. "Nah. It's not too big." Shotsie reassured me. "And the most important thing about a tattoo is how it moves with the body." He was right, of course. Even though it's too big (well, maybe it's really not too big), it does pick up the curve of the ankle into the foot. And it looks really sexy when I put on a pair of high heels. And when it's warm outside and I don't wear socks or dark pantyhose, you can see the tattoo peeking out, sliding down onto my foot.

After he finished the tattoo,

Shotsie talked of the dreams he had after he got his first tattoo, and how powerful and magical those dreams were. He spoke too, of waking up and glancing quickly at his arm a few days later—and becoming extremely frightened. His arm seemed foreign and removed, a part of him, yet not a part of him.

I asked about fainting. "Lots of people faint," explained the tattooer. "We have smelling salts. Lots of guys get so anxious, they build up the idea of getting the tattoo so much that they pass out the minute the needle first makes contact. Some people throw up. One client passed out when he heard the buzz. The needle hadn't even touched him."

When a person knows what he wants, it's a highly creative, collaborative project for tattooer and tattooee. People select tattoos that make physical—and permanent—their dreams and desires, their inner demons, their worldview. Michele Breen, who worked at Shotsie's, has a magnificent flamingo on her back. Mick Beasley is about to add a favorite carousel horse to one man's permanent art collection.

Steve Bonge has a bizarre sense of humor. His backpiece, "Welcome to New York," is the ultimate Big Apple picture postcard from Hell. The central

The Care and Feeding of Your New Tattoo—How to Discourage Infections and Keep the Colors Bright

Shotsie gave me this information after I got my first tattoo. He developed these tips through years of experience and working closely with a dermatologist. Other tattooers give out similar information.

"The life of your tattoo is dependent upon the care it receives in the first few days. Firstly, keep the tattoo covered with the bandage for at least twelve hours. After this time remove the bandage. If the gauze sticks to the skin, proceed to wet the area down with lukewarm water, then remove the gauze carefully. Once the tattoo is exposed, wash thoroughly with soap and water. Be sure to remove all surface blood and rinse off all remaining soap.

- Do not rebandage the tattoo.
- Do not apply Vaseline or any petroleum jelly.
- Do not apply alcohol. At this point pat lightly to dry.
- Do not rub or scratch the tattoo. Then, with clean hands, apply a light coat of Bacitracin ointment, a minimum of three times a day for a week.
- Do not let the tattoo dry out. This ointment can be purchased at any local drugstore. If a rash occurs, discontinue use. Alternatives are A&D Ointment or Micotracin. If the rash persists, Dermassage hand lotion can be applied.

The tattoo will develop a layer of dry skin; let this skin fall off naturally.

- Do not pick the tattoo.
- Do not expose to direct sunlight for two weeks.
- Do not swim for one week.
- Do not soak in sauna, steambath or bathtub for one week.

After the skin has fallen off there will be a period of adjustment for the new skin. It is advisable to apply a hand lotion.

The tattoo is your responsibility after you leave the studio. Use common sense."

figures are a couple of characters from a 1940s pulp detective novel. Behind them is a New York skyline scene that demands closer inspection. The subway motorman (is that what he is?) is instantly recognizable to anyone who's ever been on the New York underground. But why should I continue to describe this tattoo, when you can view it in the color section. It's a very excellent tattoo in terms of design, image, execution and artistry, and a credit to both men involved in the effort: Bonge and tattooer Bob Roberts. It's like every great work of art—there's always a new detail to see and study.

What most people like about their tattoos is the permanence of the image. Tattoos provide meaning and commitment in a world where those qualities are sometimes lacking. What's also cool about a tattoo is how it grows on you. I really kind of

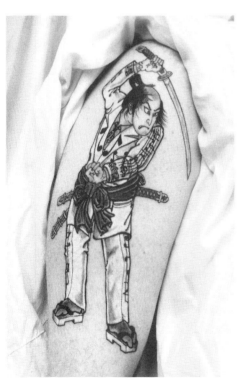

Samurai arm piece on Bill Brown by Ed Hardy. (PHOTO © TRINA VON ROSENVINGE)

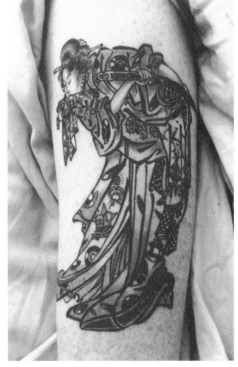

Geisha arm piece on Bill Brown's other arm by Ed Hardy. (PHOTO © TRINA VON ROSENVINGE)

hated my ink when I first got it—it was so foreign. Then I started to like it. Then, after a while, I didn't even notice it anymore.

Skin is an interesting medium for an artist. All skin is different, and all skin takes ink differently. Artists learn about their media though the experience of working with it. Tattooists are the same. They understand that skin types respond uniquely to tattooing. Having worked with many types of skin, they're quick to sense individual needs. They also know that keeping the skin surface moist as they're working helps to provide a good texture to work with. Many tattooers have said that thin, fine skin is the easiest to tattoo, with women's skin generally being the most pleasant and elegant canvas to work on. Tougher skin requires more effort to get the ink to stay in.

What a client generally doesn't see is the preparation that is required of the artist. Walk into any tattoo studio an hour or two before it opens and you'll find the tattooer as technician, inventor, craftsman. Tattooers experiment with different needle configurations. Tattoo needles are quite small and can be bunched in a variety of ways: at different angles, or with few or many needles. There are outliners and shad-

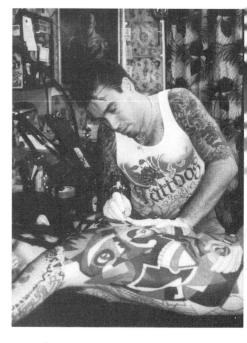

Jonathan Shaw working on Luke Miller's back piece. (Photo © Jonathan Shaw, Fun City Studios, New York City)

ers, both made up of different numbers of needles placed at different angles. The needles are soldered onto needle bars in the configuration desired by the tattooist, who decides on the number of needles and bars and their angles in relation to each other. Then the bars are inserted into tubes, and the tubes are placed into the tattoo machine. The machine punctures the skin evenly, going in and out, in and out, at about 2,300 insertions per minute. That's constant. But to get fine

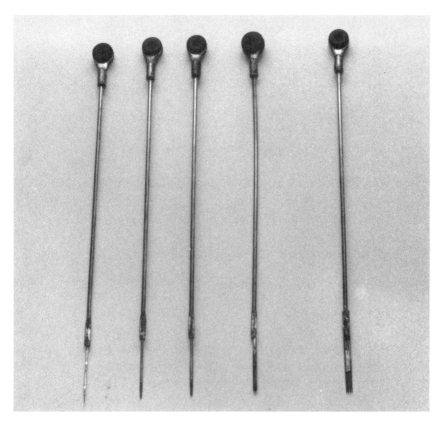

Tattoo needles attached to needle bars. Taken at Shotsie's Tattoos.
(Photo © Lynne Burns)

Tattoo Tip of the Year

Use your needle bar one time on a customer and then break or cut the needles off the bar while the customer is watching. By doing this, you are showing that you care. A lasting impression, if nothing else. Don't worry about the cost of the needle bar; include it in the price you are charging for the tattoo. By using your needles on a one-time basis, you will make many points with your local health inspector. Keep the used needles in a separate container for correct disposal.

—From the 1991–1992 Spaulding and Rogers catalog
(see Chapter Ten)

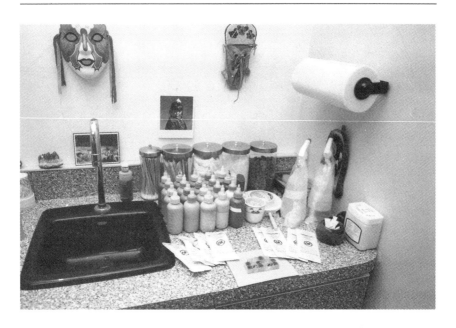

A tattooist's work area, ready for clients. This space is at Shotsie's. (PHOTO © JOANNE CHAN)

or bold lines, or to add perspective and depth, a tattoo needs shading. The artists buy needles, then create the needle groupings they need, soldering the needles with flux (a binding and finishing agent) to bars. The number of needles and their placement make a difference: An artist might want to arrange the needles at slightly different lengths or angles or layers, weaving the needles and bars into different arcs and diagonals.

A tattooist can purchase ready-made groupings of needles. But just as a painter may take a ready-made brush and personalize it, a good tattooer will also make his own needle groupings. "We make up a selection of different needle configurations for each day. A three-needle will give fine detail for outlining. A four or a five will be a little thicker. For a much larger piece, you might want to outline with a seven. On my back piece of Lindbergh, we used a fifty-needle to shade." Scotty Lowe talking tattoo talk. The language of the business. The process isn't completed until needles, bars and tubes go into autoclaves, those serious medical pressure cookers that do the sterilizing.

That's what you don't generally see in a tattoo shop, unless you're really into hanging out.

What you do get to see are the clients. And how they react. The next client after me, Lynn, already had a tattoo of a butterfly on her bicep. She wanted a cover-up: a larger tattoo that would incorporate the older design into the new one. She explained that she wanted an Art Nouveau butterfly. Shotsie deftly painted one on with a brush, freehand. It was lovely, a perfect representation of what she had described. "No, no. It's not what I want at all. I want something Art Nouveau." Shotsie glanced at me; he had seen this routine many times. Lynn was nervous, stalling for time.

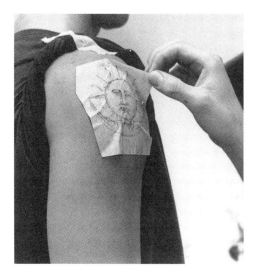

The stencil is applied to the arm. Taken at Shotsie's Tattoos. (PHOTO © LYNNE BURNS)

Shotsie delved into his extensive library and came up with several photos and illustrations of different butterflies. Lynn made her selection, which looked nothing like her description. She chatted briefly with Shotsie about the colors to be included. Shotsie photocopied the image, made some changes, then traced out the design onto gelatin-type duplicating paper, the stuff that comes off purple.

To prepare, Shotsie washed his hands in the sink in his studio. He wiped down Lynn's skin with alcohol, then sprayed the area with green soap and water. If Lynn had been a guy the skin would have been shaved, then washed a second time.

The tattooer placed the de-

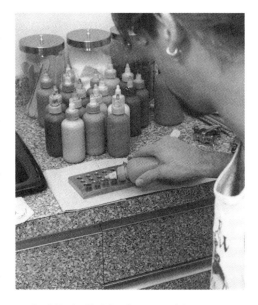

Eric fills individual caps with colored pigment. Taken at Shotsie's Tattoos. (PHOTO © LYNNE BURNS)

Eric opens the autoclave paper on the sterilized needle bar. Taken at Shotsie's Tattoos. (PHOTO © LYNNE BURNS)

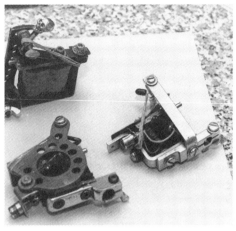

Tattoo machines without tubes and needle bars. Taken at Shotsie's Tattoos.
(PHOTO © LYNNE BURNS)

Eric loads needle bar into tube, then places all in tattoo machine. Taken at Shotsie's Tattoos. (PHOTO © LYNNE BURNS)

sign duplicate onto the arm, over the old tattoo. To make the pattern adhere to the skin, Shotsie rubbed deodorant stick over the design sheet. Then he peeled off the sheet, and there was the design—purple outlines of the butterfly had been transferred onto the skin.

At this point, Shotsie dipped a tongue depressor into a jar of Vaseline, put the glob onto the area to be tattooed, smoothed it down and rubbed a little bit of Vaseline onto his hands. "The Vaseline helps the machine run smoother on the skin, and helps when you go to wipe off the excess inks."

He selected an individually wrapped needle bar and tube.

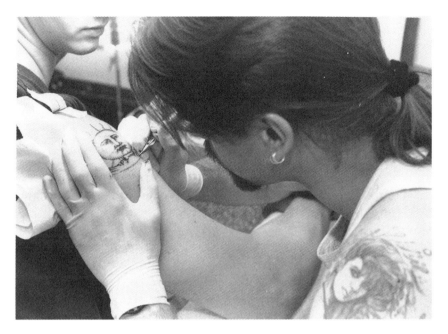

Eric tattooing. Taken at Shotsie's Tattoos.
(PHOTO © LYNNE BURNS)

The tube selected was then placed in the tattoo machine. The wrapping paper indicated with a big OK and a check mark that the needles had been through the autoclave sterilization process. Shotsie then set out tiny little caps and poured the colors he'd be using into the caps. Then on came the latex surgical gloves.

Shotsie started the machine. It whirred and buzzed, perforating the skin and pushing ink. Everyone chatted. Every so often he would spray down the skin with water and wipe it off with a clean paper towel. Every so often he would change needles. About thirty-five to forty minutes later he was finished.

"You sort of miss the machine, the sound, the vibrations when it stops. You miss the

The pain? I call it sweet pain.

—TIM "BRONSON" FALK

One of my clients, a recently divorced woman, came to me and said, "I want a mark on my body that my ex-husband had never seen." And so, with that tattoo, she gets a new sense of herself.

—RUTH MARTEN, FORMER TATTOO ARTIST

pain, don't you? At least, that's how I felt." Shotsie pointed to the full-length mirror. Lynn studied her arm. She smiled. "Just what I wanted. Perfect. Thank you." Another happy client. Before she left, the tattooer applied a coating of Bacitracin. Then he handed her a flyer with instructions on how to care for the new tattoo, to prevent infections and to keep the colors bright and vivid. He even gave her free Bacitracin samples.

The client went off to the receptionist to pay for the tattoo. She had a choice of Mastercard, Visa or cash. The $100 fee also included the time spent by the artist in selecting the design and transferring it. Tattoo prices vary based on location, the competence and experience of the artist, and what the market will bear. The best tattooers in the country command between $125 to $250 an hour.

Because a tattoo needs to heal for a few weeks before additional work in the same area can begin, a major piece of art, a back piece for example, can take many hours of work spread out over many weeks. It will cost many hundreds or even thousands of dollars. It will give the owner of the tattoo great pleasure; it will give the artist a feeling of pride and satisfaction; and it will inspire delight, awe and perhaps even envy in the friends of the collector.

The pain? It's a very embraceable pain. It's odd. It feels like you're being scratched by a cat while you're being massaged by magic fingers. The area that's being worked on is hot. Add that to the vibrations of the machine and the pain is transformed into a strange, sexual sensation.

—AMY, THE TATTOOED AUTHOR

The Tattoo Process without Benefit of a Machine: The Japanese Tattoo

The Japanese tattoo is called *ire-zumi*, which literally means "insertion of ink," or *hori-mono*, which means "something carved, sculpted or engraved." It is an art form unto itself, practiced by accomplished artists and seriously studied by the best American tattooists. Ed Hardy has lived and worked in Japan, first apprenticing with and now working with Japan's finest tattoo masters.

The Japanese tattoo is done by hand, in private studios. The photographs in this section show the step-by-step process of a young couple as they choose matching woodblock images and then have the images tattooed. These photographs were taken in the early 1970s when it was quite rare for a Japanese woman to be tattooed.

Hori Yuno II at work.
(PHOTO © MARTHA COOPER)

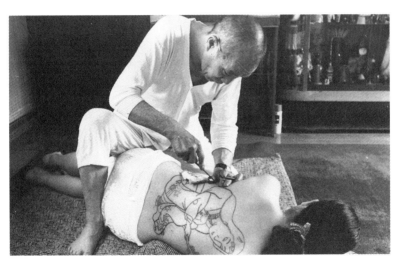

"Does it hurt when you're tattooed by hand, by the Japanese?"
"It hurts. It's made worse by the sound of the little hammer tapping into the tattoo instrument."

—A TATTOO ARTIST WHO HAS BEEN TATTOOED
BY A JAPANESE MASTER

The process up close. (PHOTO © MARTHA COOPER)

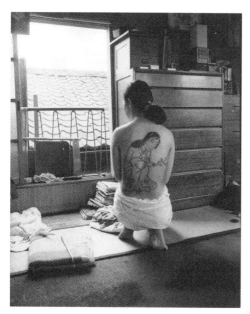

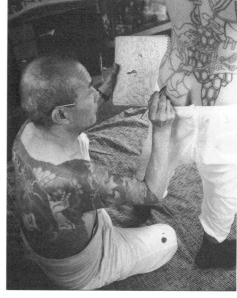

Admiring the work in progress.
(PHOTO © MARTHA COOPER)

*Hori Yuno II sketching the design
on the boyfriend.*
(PHOTO © MARTHA COOPER)

Tipping

A tattoo is a personal service, like a haircut or a manicure. So I think you should tip the tattooist. Maybe if you're just picking out some flash off the wall, you might not feel as inclined to give a tip, but if you're having custom work done and you're pleased, then you should show it by tipping!

—ANTHONY, NEW YORK CITY SOCIAL WORKER,
OWNER OF SEVERAL CUSTOM TATTOOS

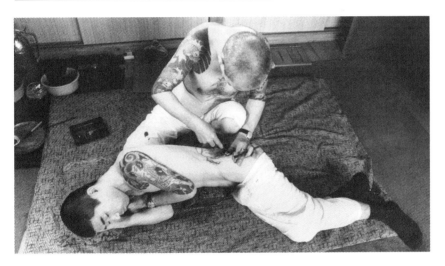

At work on his back. (PHOTO © MARTHA COOPER)

When I got my tattoo fifteen years ago, the tattooer said "One dollar more for your name." So I got my name, Al, above the snake.

—AL

(PHOTO © LYNNE BURNS)

Cover-up Work

Cover-up work is absolutely fascinating. If your old flame is gone but her name lives on, take heart. Great tattoo artists can transform the work into a bright new design, incorporating elements of the old work or simply inking over it. These cover-ups were done by the Flying Ace—Scotty Lowe, of Shotsie's Tattoos in Wayne, New Jersey.

Cover-up work, before and after. Cover-up tattoo by Scotty Lowe. (PHOTO © SCOTTY LOWE)

THE TATTOOISTS

I wrote this book to celebrate tattoos, so in this chapter I thought you should hear from the artists directly.

For a long time, I believed that tattooing was the ultimate working-class art form. Being friends with many tattooists hasn't changed my opinion. The artists share the background and sensibilities of their working-class clientele. Amsterdam tattooer and Tattoo Museum curator Henk Schiffmacher (Hanky Panky) said in a *Washington Post* interview, "It's an art form, you know. A poor man's Rembrandt."

Tattooing is a perfect way for a man to remain macho while exploring and developing his sensitive side. I generalize, of course. But most of the tattooists I've met—the baby boomers—have working-class roots. Their dads were cops, factory workers, plumbers. A few of the tattooists I've met didn't fit my stereotype. Their parents were middle-class professionals, but they admitted to being "bad boys." One of them, now with sons of his own, said it sheepishly. Another, a retired tattooist, told me: "Hey, I was a juvenile delinquent back in the fifties."

No more. Today, the younger tattooists come from every social class. After I was interviewed on National Public Radio, a school teacher with a prestigious New Jersey address called me. She was delighted to hear that tattooing was breaking into the mainstream. It validated what she had a tough time accepting: her son's career choice. He tattoos out west. A young tattooist I've met recently is the son of two college professors.

Based on my nonstatistical, nonscientific poll, the baby boomer generation of tattooists took to the art so as not to leave their working-class roots behind. "I went to art school, but I got into tattooing cause I hated the pretense of the art world." "I needed to make a living . . . and all I had was an art degree." No-bullshit, real people. But they're visual artists. And they behave as artists do, even though their medium is skin. It comes through in all the interviews.

What I also heard from many tattooists is a desire for acceptance—a sincere wish to have the general public accept tattooing as art. On the West Coast, the wish is pretty much a reality. Tuttle started it, Hardy developed and promoted it so that tattooing is considered a legitimate art form. As a spokes-person for the art, Hardy couldn't have been more ideal. He's always been clear about his—and tattooing's—image. Artistic, intelligent, professional. But the legitimacy of tattooing is still an East Coast issue. Anthropologist and tattooer Michael McCabe said: "Jerry Brown's decree did away with that issue on the West Coast. There's no oppression from the culture there. The East Coast is parochial. It's the establishment. But it's changing. The kids are no longer initiated into tattooing by personal experience. Instead, they're getting into it via the media."

Scotty Lowe yearns for change: "East Coast people are just more conservative than people on the West Coast. Here in New Jersey people don't go for a lot of the big, fantastic back pieces."

What I see when I see a tattooer is a tough job. A tattooist has to be versatile. He or she probably needs to do many different kinds and styles of tattoos to make a living—small, large, flash off the wall, custom designs. Like any commercial artist, a tattooist has to please a client. The difference is that the client wears the work, which can undoubtedly be a sensitive issue. A special relationship develops between tattooer and subject. A tattooist is making his

or her mark on another person. "It's an invasive process," said Shotsie. Lots of issues get brought up and out, especially if the client is having hours of work done.

A tattooist is shrink, friend, mentor, adviser. Sometimes it's difficult to separate out all the roles. I know a guy who'd been close friends with his tattooer for many years. As he was working on my friend's back, the tattooer started going through a particularly insecure period, a mid-life crisis. One day he turned to his friend/client: "I have to know. Am I your friend or your tattooist?"

My favorite question is "Were you nervous the first time you gave someone a tattoo?" All give the same answer—an overwhelming yes. Except for Bill Funk, the son of Philadelphia Eddie. He grew up around tattooing. "I was cutting stencils when I was ten, twelve years old. I couldn't wait to do my first tattoo. When I was ready, I had my dad to work on."

Here are some of the things tattoo artists said about their work:

D. E. (Ed) Hardy
San Francisco, California, and Honolulu, Hawaii

Readers of Tattootime *and serious tattoo art collectors are all well*

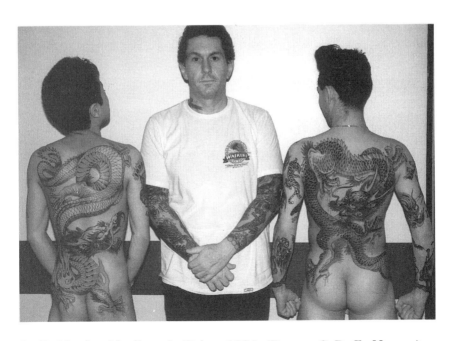

D. E. Hardy with clients in Tokyo, 1991. (PHOTO © D. E. HARDY)

aware of Hardy's early-childhood love of tattooing. We've seen his picture in Tattootime *at age ten, as tattooist. It's an image that's at once adorable, precocious and astounding.*

"When I was in art school in the mid-1960s, I began looking at American tattooing. It's a powerful folk art form. I liked the old designs. But it was the Japanese that got me hooked again. I went to Japan in 1973 to work in a traditional environment. Then I came back to San Francisco and opened Realistic in 1974. Instead of walk-ins, I based the studio on the Japanese premise: one on one with the client.

"I corresponded with Japanese tattooers until the early 1980s. In 1983 I returned to Japan to study further, to get tattooed by Hori Yoshi II and to work. I tattooed many of Japan's rock and roll kids. Their enthusiasm for Western tattooing caused me to look again at tattoo's California roots, to the Pike in Long Beach. I made annual work trips to Tokyo throughout the '80s. In 1986 I set up residence in Hawaii. It gave me more time and space to think, to reassess all the art I loved and the thousands of tattoos I'd done.

"In Hawaii, I focus on my writing, publishing, painting and drawing. About one-third of my time is spent in San Francisco at my studio, Tattoo City, doing actual tattooing. I reexamined the power symbols appropriate to the West, and now I've become more involved with that. The giant panther head I did is a perfect fusion of Japanese and American styles.

"A tattoo is not an inanimate thing. You're dealing with people. It's sensitive. Tattooing is a true collaborative effort, an extension of the self. With a tattoo, the client can make themselves the artist.

"Many of the tattoos I've done have made people feel so much better about themselves. When you can give a person the psychic armor to help them get better, that's a successful tattoo."

Mike Bakaty
New York, New York

A working artist, Mike's serious interest in tattooing was initially inspired by the Japanese tattoo. He has recently been joined in his studio by his son Mehai, also an accomplished tattooist, who has a substantial following of his own.

"For me, the very best part of this whole deal is in getting to work with my son. And the best part of that is that in a day-to-day working relationship, he gets to know me as a person and

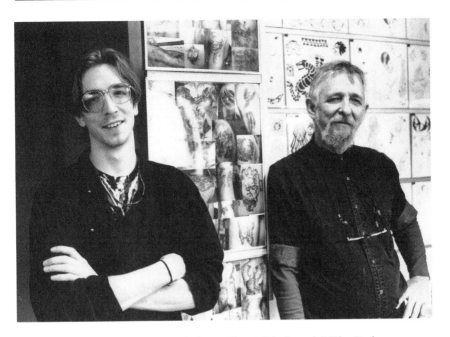

Father and son tattooers in their studio: Mehai and Mike Bakaty.
(PHOTO © LYNNE BURNS)

an artist, not just as Pop. I never had that with my old man."

Mick Beasley
Glen Burnie, Maryland

Mick is married to tattooer Tom Beasley.

"I was working in Virginia and was hired to be the buffer between Tom and his then-wife Juli (tattooer Juli Moon). I looked at Tom—and he's now my husband, so I can say this—and I thought he had the personality of a dishrag. I thought he was so stuck up. In reality he's reserved and unassuming. I looked at him, I looked at his work and I said: 'You do beautiful work.' Even though I had been tattooing for two years, I didn't realize things like that could be done on skin.

"Tom is a technical wizard. His line work is impeccable. To master the art, you must be a technician first. I have no specific personal style, but I pattern myself after Tom and Kari Barba: work that's solid and clean, real bright, with motion and power in it.

"I still get scared when I tattoo. I say to myself: 'Yep, you can do this.' It's an awesome responsibility. Your clients remember everything about their

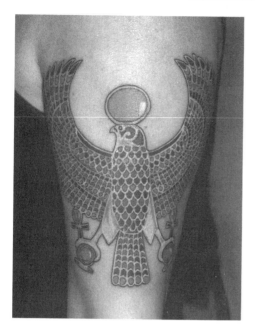

A jewel of a tattoo from Dragon Moon's Tom Beasley. Designed to resemble an Egyptian armband, complete with ankhs.
(Photo © Tom and Mick Beasley, Dragon Moon Tattoo)

time in your studio, the conversations you had, everything you talked about. Sometimes I won't do something that a client wants if it's something I personally find distasteful, but I'll try to tell the client I can't do it with a sense of humor.

"A lot of people initially say they don't want to get their whole body tattooed. They get a shoulder done. Then another shoulder. Then a back piece. And some of it might be totally unrelated. I advise people to think about it first, make it into a whole, come up with an idea, a concept for the work.

"I went to Dragon Moon to get a tattoo, and I ended up marrying the guy."

J. D. Crowe
Norfolk, Virginia

He's a tattooer, distributor of tattoo-related products—T-shirts, temporary tattoos, and co-promoter of Tattoo Tours.

"Where I work, the simple designs are still the most popular—roses, eagles, panthers. That's the meat of tattooing, and probably will be for the next hundred years. I'm in a Navy town. I do a bunch of anchors. Guys come in and get what's on the wall, thirty-year-old designs. It's what you make available.

"Women? Men? It's not even a statistic anymore. Straight, sensible businesswomen get tattoos. It's just not that big a deal. Instead of what your mom's going to think, now people bring their moms."

Brian Everett
Albuquerque, New Mexico

"Jack Rudy was instrumental in getting me to where I am today. The first time I saw Jack's work I was intrigued. That was

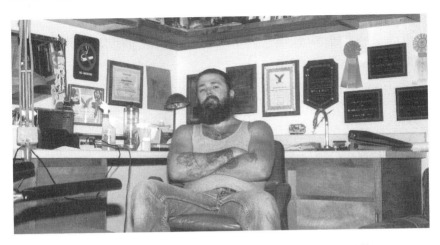

Brian Everett in his Route 66 Fine Line Tattoo studio in Albuquerque, New Mexico. (PHOTO © BRIAN EVERETT)

back in 1979, at a convention. I had only seen standard American-style tattooing up to that point. I was flabbergasted. I had learned traditional tattooing: step by step, you outline, shade, pack it full of color.

"But I was a painter and worked in pastels. I had always been interested in portraiture. I had studied it. Jack did a lot of work on me and he told me, 'If you could only tattoo the way you paint.' That really opened me up, changed the way I viewed tattooing. I hadn't been using my fine art skills in my tattoos.

"The portraits are a bond between client and artist. It breaks down communication barriers. The client shares things he normally wouldn't. And that breaks

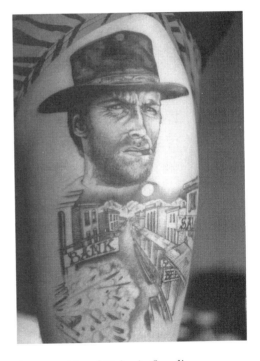

An example of Brian's fine-line portraits. Clint Eastwood. (PHOTO © BRIAN EVERETT)

down your barriers, too. This is a very personal art.

"One man came to me whose little boy had died. He wanted a portrait of his son. And as I worked, he talked about what his boy had done when he was alive. He talked, too, about the other children in the hospital. As he spoke, I got tears in my eyes. This was so intense; it wasn't just drawing a picture. The fact that I was sharing such an important part of this man's life was very rewarding.

"Now I have three guys in my shop besides myself. Two are the sons of artists."

Ruth Marten
New York, New York

Ruth is a retired tattooist who started work in 1973 and retired in 1980. She's also an illustrator, painter and sculptor. She's responsible for this book's cover photo concept and did the "tattoo" artwork for it.

"I had no bankable skills after graduation from art school. I had to support myself. I had already been tattooed at Buddy's in Newport, Rhode Island. I was a painter and an illustrator, so I started to tattoo, self-taught. To get clients, I'd hand out business cards at parties.

"There were almost no women in the field at the time, except for Jaime Summers and

a few others. Because of the type of people I knew, I attracted an arty clientele: always a lot of women, some prestigious clients, a big gay scene.

"I got attracted to the Polynesian, Marquesan and Maori tattoos. A revelation! I had never seen anything like it. And my clients were great! They started to give me carte blanche, asked me to fit the art to their bodies. I started to do tribal-style things in 1975. Then Japanese-style. I had interesting clients who wanted unusual things and felt I could do it.

One of the country's first well-known female tattooists, Ruth Marten. She and Mimi sit in front of some of her paintings. (PHOTO © LYNNE BURNS)

"I got drunk on champagne when I did my first tattoo. It took me hours to do anything. And you can't practice. Just on potatoes. That's not the same as skin. In the old days, the tattooists would pay derelicts to be a canvas. My friend Roger, my first tattoo, was neither a derelict or a potato. He got drunk, too.

"To me, tattooing is a magic symbol. A protective device. The monks tattoo in Thailand and that's why Thai tattooing is so good—it's not fashion, it's spiritual. And it's a feast there; one tattoo is more beautiful than the next.

"I'd never tattoo again. It's too intense. A tattooist is a cross between doctor, confessor, clerk and mechanic. I could never get the machines to work properly.

"I hope the kids today grow into the magic. Ultimately tattooing is not a business. It's an art form from which you make your money."

Mike McCabe
New York, New York

"I was born in Boston, lace-curtain Irish. My dad was a construction worker with down-to-earth values. But he took us to the ballet. My college degree is in fine art. The pretense of the art world turned me off. So self-

indulgent. Tattooing was a whole other art thing. It wasn't formalized. And the people I studied with, Tyler and Thom Devita, had a visionary, mystical quality that made tattooing an appealing medium."

Spider Webb
Bridgeport, Connecticut

He's the clown prince of tattooing: born in the Bronx; author of several books on tattooing, including Pushing Ink *and* Heavily Tattooed Men and Women; *and founder of the Electric Crutch Band.*

What should I write about you, Spider?

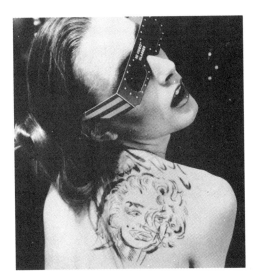

One of Spider Webb's more inspired ideas: the 3-D tattoo. Yes, the glasses come with the tat. (PHOTO © SPIDER WEBB STUDIOS)

"Anything but the truth. Everyone loves me. I'm comic relief."

Spider, are there politics in the tattoo world?

"I didn't know we were supposed to vote."

How did you get into tattooing?

"Stupidity."

He got his first tattoo at age fourteen from Brooklyn Blackie in Coney Island. "It was the dumbest thing I ever did. And it hurt too. I fainted!"

"Tattooing is one way of making a mark, and I use that mark like a painter would use a paintbrush. I spend my days fishing and tattooing people and making paintings and sculpture and videos. I do whatever I want and have a lot of fun."

Ilija Grunwald
Venice Beach, California

At age twenty-three, he has been tattooing for three years. His father is a professor of art in Stuttgart, Germany.

"My father told me, 'Find something to do that's creative without a boss.' So I'm into tattooing. Now I'm a partner in this shop.

"I think Ed Hardy's a genius. He helped the tattoo evolution get going. The younger artists? Eddy Deutsch—he's mind-boggling. Marcus Pacheco. I believe it's important to learn from the people I admire. Otherwise I'll stay stagnant. Marcus worked on my arm for five hours and I learned just from watching him."

Gill Monte
Los Angeles, California

Born in Detroit, he grew up in southern California. He's an actor with a Screen Actors Guild card.

"Too many youngsters in the business now are not paying their dues or giving respect to the old-timers. Tattooing is so mainstream, so acceptable now. Zeke Owens can walk around in Anaheim and nobody would know who he is!

"I traveled for fourteen years: military bases, carnivals, all the motorcycle rallies, learning, doing.

"People say about me: 'All he does is skulls,' but I do everything! The best of what I can do. My advice: Don't get tattooed by someone who isn't heavily tattooed. Always wear a rubber. And have fun!

"Tattoo Mania, my shop, is fun tattoos for fun people—catch me if you can!"

Jonathan Shaw
New York, New York

His Fun City Studio is like a museum. It's filled with tattoo collectibles and artifacts and art by Robert

Gill Monte, the ink-slinger himself, in front of his Tattoo Mania studio. (PHOTO © STEVE BONGE)

Williams, Pam Roberts, R. Crumb. The Crumb is inscribed: "To an Old Scab Vendor. R. Crumb, 1990."

"I worked a lot in the traditional tattoo parlors. I consider it a bridge between the past and the present. That qualifies me to say I'm a journeyman tattooer. There's a whole school of yuppie tattooers dedicated to the gentrification of this folk art. I hold their precepts in utter disregard.

"I paid my dues. I stayed with tattooing when it wasn't an easy thing, when it was an outlaw profession. No money. No kudos from the art community. When it was a racket. Today it's artsy-fartsy, yuppified, gentrified. Cushy. But a lot of us were there when it wasn't.

"Technical skill is the most important thing. Without it, there's no foundation. I tip my hat to tradition: You've got to learn technique before you can be creative.

"Luke Miller is the result of years of abstract design sources. His back may be my best work as of this point. I'm like Keith Haring and his ilk. I'm no Robert Williams or Botticelli. I have a certain aesthetic, a sense of balance and spaces. I think about how a piece will look ten years from now. Because I'm into an urban setting, I looked at graffiti and combined it with Borneo-style tattooing, Pre-Columbian influences. There's nothing tribal about New York or me; I'm a city boy. So what I do is more like urban American war paint.

"Cosmetic tattooing? I don't consider it tattooing.

"Advertising tattoo supplies encourages hacks. If anyone

wants to learn to tattoo, they'll find a way. Their destiny will lead them. We need to clean tattooing of the scourge of scratchers that are plaguing the profession.

"As far as I'm concerned, Filip Leu is the greatest all-around living tattoo artist." (See Jonathan in the color section.)

Kevin Quinn
Los Angeles, California

"I've been working as a tattooist for five years. I studied art in college, in Michigan. I was a musician, but I didn't like the collaborative effort in the music business. I had gotten tattooed in Detroit and it was horrible. I knew I could do better.

"I consider myself a generalist—no specific style. I feel now I can do anything in a pinch. I like the contemporary stuff a lot, the kids in San Francisco—Eddy Deutsch, Freddy Corbin. Greg James and Robert Benedetti of Sunset Strip Tattoos have been my main teachers and influences.

"I work by appointment only. There's no sign out front, no flash on the walls. It's real cutting edge. People come here to hang out so now I have to do my drawing at home. With Pote

and Jesse, my two partners, we cover all ends of tattooing here.

"Tattooing requires a lot of learning and growing with it. As soon as I figure it out, I'll move onto the next thing, whatever that is.

"I want to be the next celebrity tattoo guy! My work can handle it!" (See Kevin in Chapter 1.)

Shotsie Gorman
Wayne, New Jersey

"I think people who gravitate to tattooing have a tremendous fear of others. We have to put our hands on people, deal with people, so it forces us to confront our phobias on a daily basis.

"I did a portrait of a child who was killed in a cyclone nearby. It was really a spectacular tattoo. I helped the father cross over the pain. At one point while I was tattooing, I had to leave the room. It was so powerful. I wanted to be able to capture something for him and I think I did. My dreams that night were filled with the experience. That tattoo is one of the best pieces of work I've done." (See Shotsie in the color section.)

CHAPTER

7

WHAT'S A BOOK ABOUT TATTOOS WITHOUT A CELEBRITY CHAPTER?

T his is it. The obligatory celebrity chapter. I think I've already established in the history chapter that Hollywood did not invent the tattoo. These days, though, it's hard to tell.

Rock stars, movie stars, sports stars and superstar models all have embraced skin art. The only group of celebrities who seem to have passed on the trend are the country music stars. I'm trying to make sense of that: Is there really a new breed of country music artist? Forty years ago, I would have expected the country and western artists to be tattooed. Blue-collar guys, singing about trucks and trains and stuff; seems like a tattoo would have been the perfect accessory to the lifestyle. But they weren't. They still aren't tattooed. Rock stars have claimed the tattoo turf as their own. I'll speculate: Now that country music has the fastest-growing recording sales and radio ratings, are the stars showing creeping signs of upward mobility? After years of being looked down on by the East Coast culture elite, have they bought into the old-fashioned tattoo stigma?

I'm hopeless. I want my favorite country stars to be tattooed:

Janis

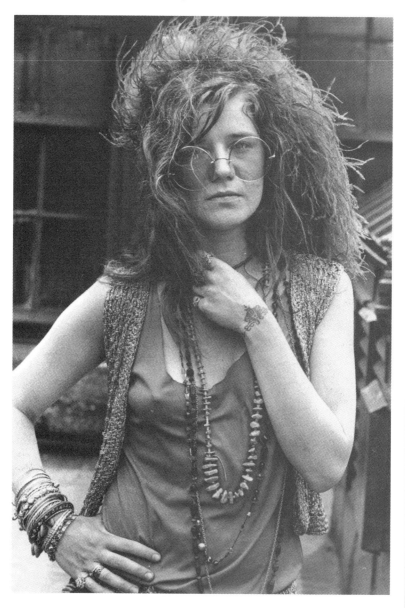

Janis Joplin. Tattoos by Lyle Tuttle.
(PHOTO © DAVID GAHR/*TIME* MAGAZINE)

Dwight Yoakum, Marty Stuart, Rodney Crowell, Lyle Lovett (my favorite). He's no longer available, but at least he had the good taste to marry a woman with a tattoo.

As for the sports stars, that's given me real fits. I wanted to be a sportswriter from the time I was sixteen. I watch a lot of basketball. I see a lot of tattoos on the players. This is great because it helps people get over their old-fashioned, prejudicial, stereotypical image of a tattooed person. Personally, it causes me angst. When the New York Knicks, my all-time favorite basketball team, played the Chicago Bulls in the NBA playoffs in 1993, I was torn, my loyalities divided. The Knicks hadn't made it this far since 1974. But two of the Bulls stars were tattooed: Scotty Pippin and (aahh!) Michael Jordan (a fraternity thing, said the Bulls' team photographer). I didn't know what to do. Who should I root for? My beloved Knicks? Or the Tattoos?

But I digress. You wanted to read about celebrities and their tattoos. As a service, here's a brief listing of some of the celebrities who are tattooed. And just because I like celebrity anecdotes as much as you do, I'll throw in whatever good stuff I could find out.

In the 1960s you got tattooed to be out. Now you get tattooed to be in.

—J. D. Crowe

An incomplete listing of who and what, in no specific order:

Roseanne Arnold	**Roses and "Tom"**
Tom Arnold	**Portrait of Roseanne, Star of David, "Rosie"**
Whoopi Goldberg	**Woodstock from Peanuts**
James Brown	**Eyebrows**
LaToya Jackson	**Pet boa**

"I don't want to reveal some of this stuff. It's too personal. I know. I'll say my tattoos are like the flames on a '55 Chevy."

—ROBERT PASTORELLI, ELDON ON "MURPHY BROWN," WHO HAS THREE TATTOOS

Robert Pastorelli. Tattoos by Richie of Fine Line Tattoos in South Amboy, New Jersey. (PHOTO © 1992, SETH GURVITZ)

CHER	**Necklace, flowers on derriere, bicep tattoo, others**
KENNEDY (MTV VJ)	**Elephant tattoo, Romanian flag, Elvis**
MICHAEL STIPE (REM)	**Cartoon**
OZZY OSBOURNE	**Assorted**
WILLY DE VILLE	**Bicep cat**

Sean Connery. From the James Bond movie Never Say Never Again. (PHOTO © EVERETT COLLECTION)

Lyle Tuttle was in a preproduction meeting, preparing for a television interview with Dick Clark. "Lyle, you're best known for tattooing women—you tattooed the queen of folk music, Joan Baez, and you tattooed the queen of rock, Janis Joplin. What woman would you most like to tattoo?" asked Clark. "Jackie Kennedy Onassis." Clark thought a moment, then asked Tuttle, "And the man you'd most like to tattoo?" Lyle didn't miss a beat. "You!"

Members of:
RED HOT CHILI PEPPERS
AEROSMITH
GUNS N' ROSES
POISON
MOTLEY CRUE
THE INDIGO GIRLS
GIN BLOSSOMS
ANIMAL BAG
BON JOVI
JUDAS PRIEST
FABULOUS THUNDERBIRDS
FISHBONE
X
THE RAMONES

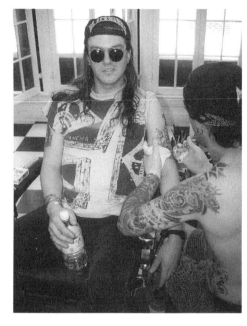

Kevin Quinn tattoos Izzy of Guns n' Roses. (PHOTO COURTESY OF KEVIN QUINN, LOS ANGELES)

I was working on this woman, and I asked her what she did for a living. She told me she was an actress. This being Hollywood, I said, "Oh, you mean you're a waitress, huh?" And she said, "No, I'm a bit past that." So I asked her if she was doing soaps, commercials, things of that nature. And she gently took me by the arm and pointed to the billboard out on Sunset Strip. Julia Roberts then said, with good humor, "I guess you don't get out much?" And I said, "Nah, I work a lot." I felt kind of silly.

—KEVIN QUINN, WHO TATTOOED JULIA ROBERTS WITH THE CHINESE CHARACTERS DENOTING STRENGTH SURROUNDING A HEART. KEVIN HAS ALSO TATTOOED MEMBERS OF GUNS N' ROSES AND CAN BE SEEN IN ONE OF THEIR MUSIC VIDEOS. HE'S THE ONE WITH THE TATTOOS.

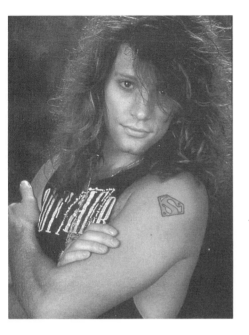

Jon Bon Jovi. Tattoo by Sunset Tattoos, Los Angeles. (PHOTO © MICHAEL GRECCO/ OUTLINE)

JON BON JOVI	**Superman logo, others**
JON MCVIE	**Penguin**
GREGG ALLMAN	**Coyote on forearm**
SEAN CONNERY	**"Scotland Forever" and "Mum & Dad" on forearm**
PETER FONDA	**Dolphins on shoulder and three stars on forearm**

There's a juicy piece of gossip floating around the tattoo world. Seems some big stars may be partners in a Hollywood tattoo shop. Oh, you want to know which stars? And what tattoo shop? Forget it. I'm not telling!

FLIP WILSON	**Cross and a winged 13**
PEARL BAILEY	**Heart on thigh**
DARYL HALL	**Star on shoulder**
MELVIN VAN PEEBLES	**"Cut on dotted line" on his neck**
RINGO STAR	**Half moon and shooting star**
BERNIE TAUPIN	**Bat**

Waiting for Lyle Tuttle in his shop one day was a notice advising him of a certified letter. He was more interested in that certified letter than he was in the woman in the shop. She was studying the sheets of unfinished tattoo designs he kept in the studio. Lyle told me, "You'd be surprised how many people pick one of the unfinished designs off the sheet because they think it's new. I was so absorbed in the certified letter slip, I didn't realize it was Joan Baez, picking out a tattoo from the sheets." Joan's husband, David Harris, had just gotten out of jail, where he had been tattooed with a rose with Joni in it. Baez got a flower to match from Lyle, who said, "Her child, Gabriel, was only about eighteen months old then, so Joan did Lamaze breathing the whole time I tattooed her."

CHRISTY TURLINGTON	**Flower on ankle**
LENNY KRAVITZ	**Cross, Japanese-style dragon**
DENNIS RODMAN	**Portrait of his daughter, Harley Davidson, cross, shark, others**
SCOTTY PIPPIN	**Bicep, leg tattoos**
MICHAEL JORDAN	**Horseshoe-shaped fraternity tattoo**
MIKE TYSON	**Mike**
LEE TREVINO	**"Ann" on right forearm**
KIRBY PUCKETT	**"Kirby" on arm**
ANITA POINTER	**Flower**
SUSAN RUTTAN	**Shoulder tattoo**
JODY WATLEY	**Cupid**

Dennis Rodman of the Detroit Pistons.
(PHOTO © EINSTEIN PHOTO/ A.E.)

Was It the Tattoos That Got Them the Part?

Two of the actresses who played Amy Fisher in the made-for-TV movies have tattoos: Drew Barrymore (cross, Minnie Mouse, others) and Alyssa Milano (chain with cross).

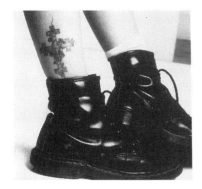

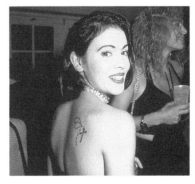

Drew Barrymore.
(PHOTO ©
DAN ARSENAULT/OUTLINE)

Alyssa Milano.
(PHOTO © GAMMA LIASON)

Press accounts have not indicated if the real Amy Fisher has a tattoo.
Ask Joey Buttafuoco?! And, no, we don't know if Joey has a tattoo. Ask Amy?!

JORMA KAUKONEN	**Various**
HENRY ROLLINS	**"Search and destroy" with sun back piece, assorted others**
DONNIE WAHLBERG	**Crest**
MARKY MARK	**Sylvester the Cat with Tweety Bird in his mouth**
MELANIE GRIFFITH	**Yellow pear on her derriere, others**

> The late tattooist Bob Shaw recalled the days when he owned a studio in Hollywood. After Sonny and Cher broke up, Cher visited the studio. "She had his name covered with another tattoo, a floral design."

JOHN COUGAR MELLENCAMP	**Woman with long hair on right shoulder**
ROBERT MITCHUM	**Obscenity on arm**
SUSAN SAINT JAMES	**Ankle bracelet**
SEAN PENN	**"Madonna"**
ORIBE	**Mermaid and others. His most recent, a woman on a rocket ship, is "the girl of my dreams."**
NICOLE MILLER	**Butterfly, sun/moon/cloud on ankle**

> People have asked me, what about your tattoos when you're ninety? Why would it bother me then? I would still want to get tattooed even when I'm a grandmother.
>
> —NICOLE MILLER, FASHION DESIGNER FOR MEN AND WOMEN

AHMET ZAPPA	**(unknown)**
HOLLY ROBINSON	**Shoulder tattoo**
TONY DANZA	**"Keep on Truckin'"**
LORENZO LAMAS	**Assorted**
BRIAN SETZER	**Assorted**
SLIM JIM	**Assorted**
NICHOLAS CAGE	**Back tattoo**
JOHNNY DEPP	**Assorted**
FLO (THE FLUORESCENT LEECH, MARC VOLMAN)	**Various**

Jonathan Shaw tattooing Johnny Depp.
(PHOTO © JONATHAN SHAW, FUN CITY STUDIOS, NEW YORK)

We called Anthony Kiedas of the Red Hot Chili Peppers for a quote. His people said that he was in Europe and was way too busy to talk to us or even to give us a quote. We do like the classy thing that he did. He directed his people to give us the name of his tattooer: Hanky Panky of Amsterdam.

ANNIE SPRINKLE	**Various small tattoos**
JOE COLEMAN	**Dragon on bicep**
CARRE OTIS	**Wrist bracelet, others**
MICKEY ROURKE	**Bicep tattoo**
CHARLIE SHEEN	**Bicep tattoo**
GLEN CAMPBELL	**Dagger on arm**
ETHYL EICHELBERGER	**Eagle on back**
BILLY IDOL	**Assorted**
JAYE DAVIDSON	**Assorted**
AARON NEVILLE	**Various**

Aaron Neville has about six tattoos. He tattooed his arm with a snake wrapped around a dagger because his brother Charles had one "and I wanted one just like it." The others? "I was just young and crazy putting tattoos on. They mean that my arms are marked forever. My tattoos are part of me now. I'm not ashamed of them. They're something I did as a youngster and they're there to stay." Though we're thrilled that Neville pursued his singing career, who knows? He might have gone in for other artistic pursuits: "I put tattoos on a couple of my friends: A dagger on one and the word "Mother" on another. I did them with two sewing needles tied around a matchstick. It was done in prison, there was no india ink, so I used pencil lead."

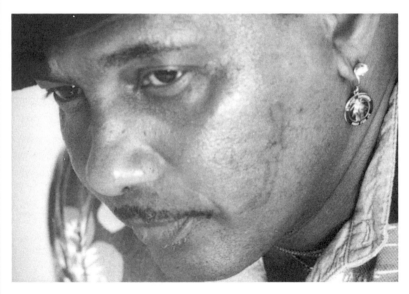

Aaron Neville.
Tattoos by Aaron Neville.
(PHOTO © BROOKE BERDIS)

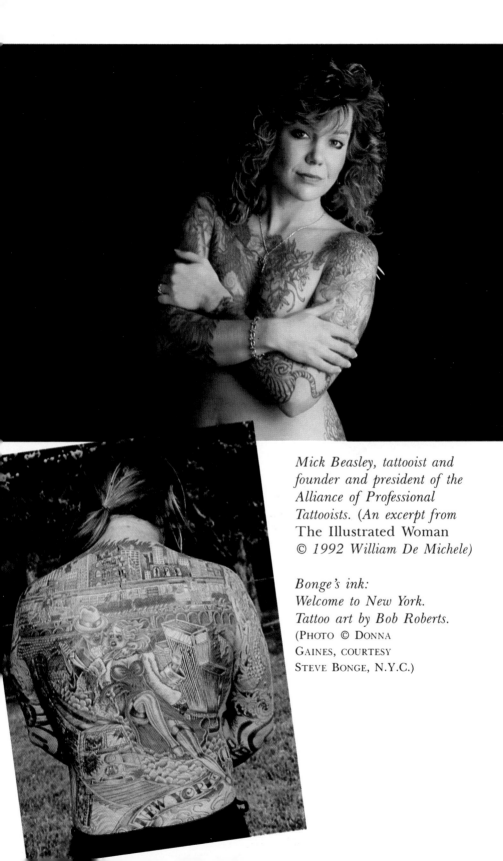

Mick Beasley, tattooist and founder and president of the Alliance of Professional Tattooists. (An excerpt from The Illustrated Woman © *1992 William De Michele)*

Bonge's ink: Welcome to New York. Tattoo art by Bob Roberts. (PHOTO © DONNA GAINES, COURTESY STEVE BONGE, N.Y.C.)

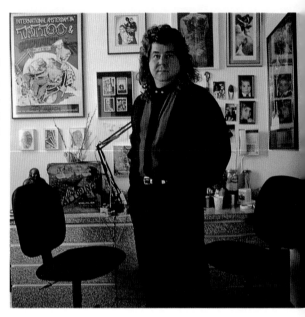

*Tattoo artist Shotsie
Gorman in his Wayne,
New Jersey, studio.*
(PHOTO © JAMES
SALZANO)

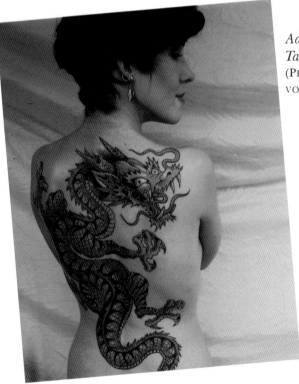

*Adrienne Tolin.
Tattoo art by Bob Roberts.*
(PHOTO © TRINA
VON ROSENVINGE)

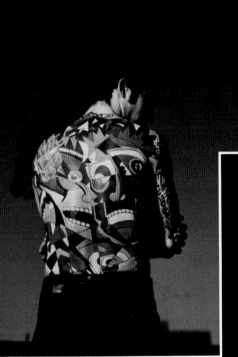

Luke Miller. Tattoo art by Jonathan Shaw, from an original painting by Mary Fleener.
(PHOTO © JOANNE CHAN)

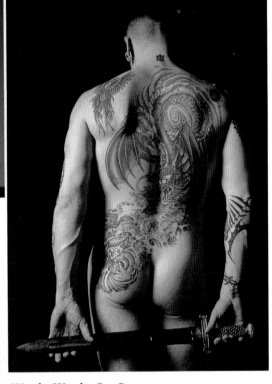

Woody Woody Go-Go. Tattoo art by Freddy Corbin. Additional tattoos by Mike McCabe, Jim Snapper, Lou of Miami.
(PHOTO © 1993 JESSICA TANZER)

Bird Man. Tattoo art by Shotsie Gorman.
(PHOTO © TOM MCGOVERN)

Lee Anderson and Gretchen Gooden. Gretchen's upper arm tattoo art by Eddy Deutsch, lower arm tattoo art by Marguerite. Lee's arm tattoo art by Samantha Peterson and Spider Webb. Additional tattoo art by Mike Bakaty. (PHOTO © JAMES SALZANO)

Tools of the trade. A tattoo machine and travel case, circa 1930s. From the collection of Shotsie Gorman. (PHOTO © JAMES SALZANO)

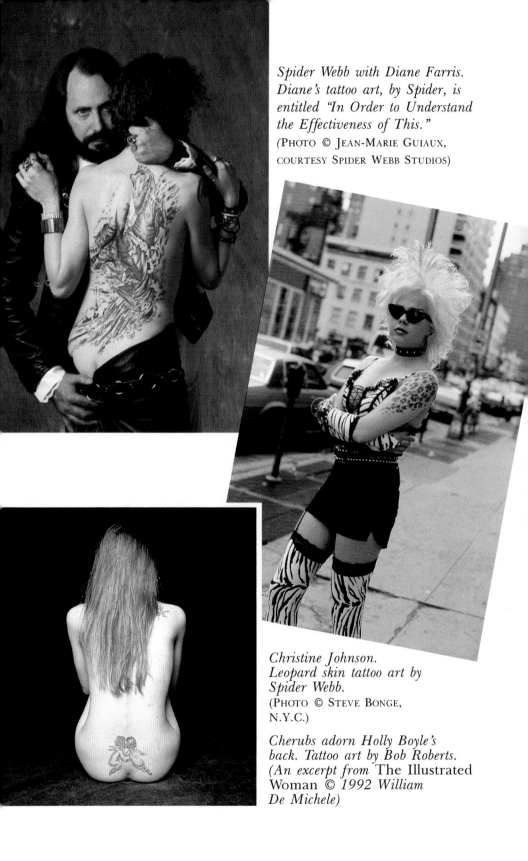

Spider Webb with Diane Farris. Diane's tattoo art, by Spider, is entitled "In Order to Understand the Effectiveness of This."
(Photo © Jean-Marie Guiaux, courtesy Spider Webb Studios)

Christine Johnson. Leopard skin tattoo art by Spider Webb.
(Photo © Steve Bonge, N.Y.C.)

Cherubs adorn Holly Boyle's back. Tattoo art by Bob Roberts. (An excerpt from The Illustrated Woman © 1992 William De Michele)

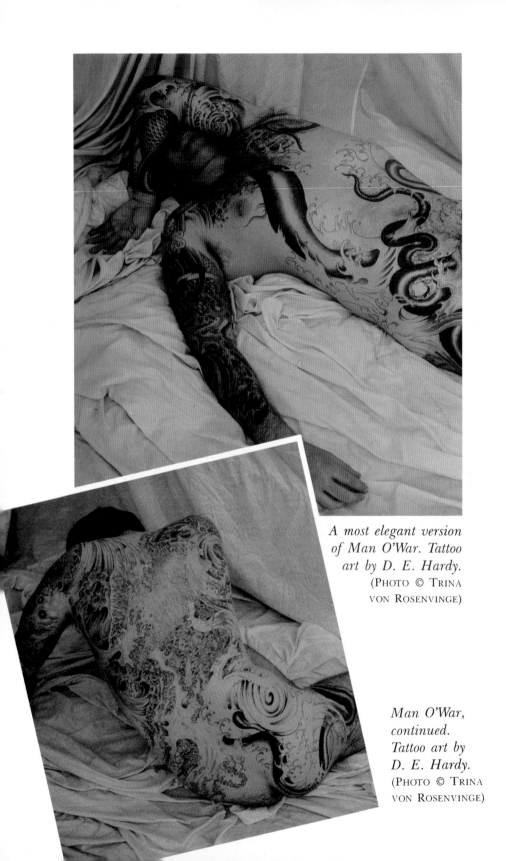

A most elegant version of Man O'War. Tattoo art by D. E. Hardy.
(PHOTO © TRINA VON ROSENVINGE)

Man O'War, continued. Tattoo art by D. E. Hardy.
(PHOTO © TRINA VON ROSENVINGE)

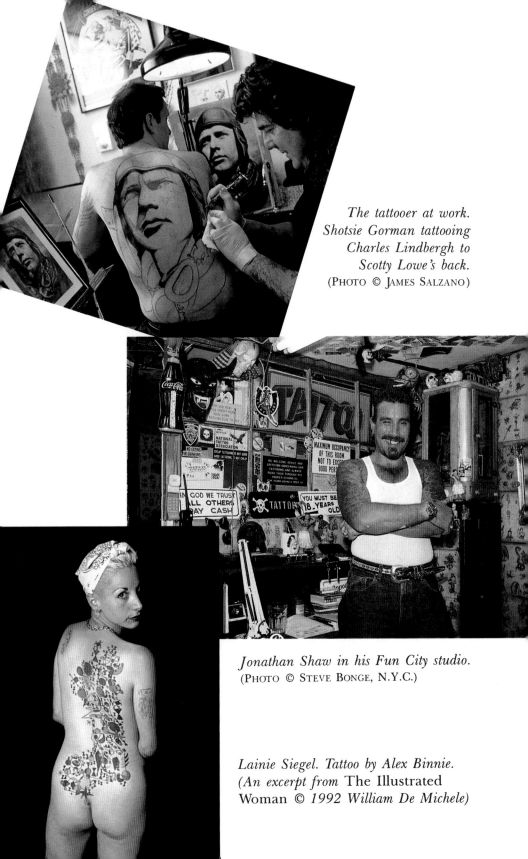

The tattooer at work.
Shotsie Gorman tattooing
Charles Lindbergh to
Scotty Lowe's back.
(PHOTO © JAMES SALZANO)

Jonathan Shaw in his Fun City studio.
(PHOTO © STEVE BONGE, N.Y.C.)

Lainie Siegel. Tattoo by Alex Binnie.
(An excerpt from The Illustrated
Woman *© 1992 William De Michele)*

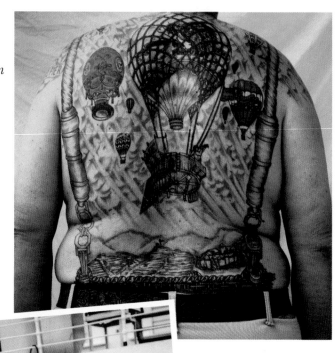

Gene Houghton. Tattoo art by Ken Larsen. (Photo © Trina von Rosenvinge)

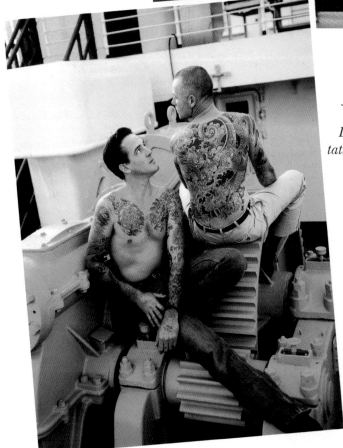

Dan Thomé and Jughead. Dan's tattoo art: Cliff Raven and Don Nolan. Jughead's tattoo art: D. E. Hardy, Pete Gardner. (Photo © Trina von Rosenvinge)

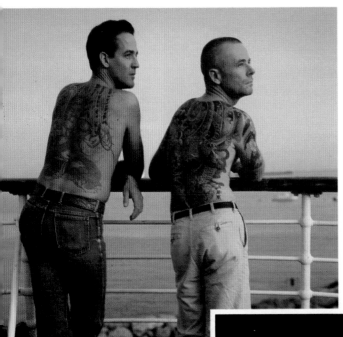

Dan Thomé and Jughead. Dan's tattoo art: Cliff Raven and Don Nolan. Jughead's tattoo art: D. E. Hardy, Pete Gardner. (PHOTO © TRINA VON ROSENVINGE)

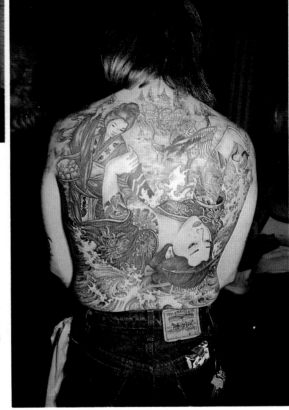

Tattoo art by Kari Barba. (PHOTO © STEVE BONGE, N.Y.C.)

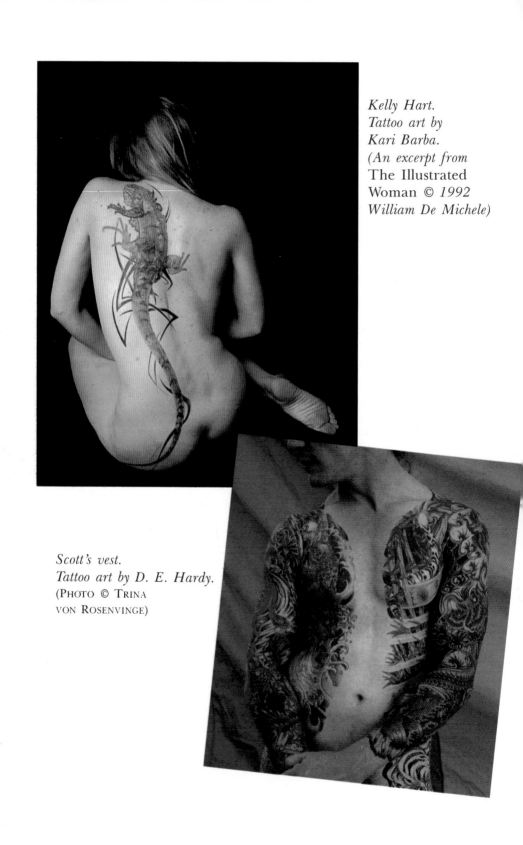

Kelly Hart.
Tattoo art by
Kari Barba.
(An excerpt from
The Illustrated
Woman © *1992*
William De Michele)

Scott's vest.
Tattoo art by D. E. Hardy.
(PHOTO © TRINA
VON ROSENVINGE)

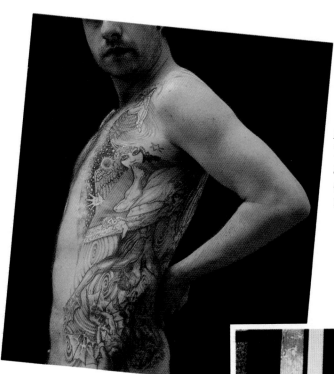

Fallen Angel.
Tattoo art by
Shotsie Gorman.
(Photo © Tom
McGovern)

Matching make-up and tattoo.
Make-up by Sarah Jenkins.
Tattoo art by Hanky Panky of
Amsterdam.
(Photo © Steve Bonge, N.Y.C.)

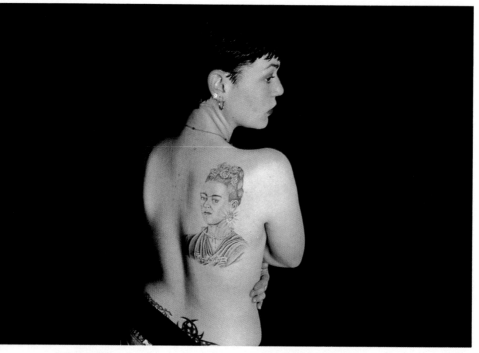

Silvia Maycher wears her favorite artist, Frida Kahlo. Tattoo portrait by Tony Edwards. (An excerpt from The Illustrated Woman © *1992 William De Michele)*

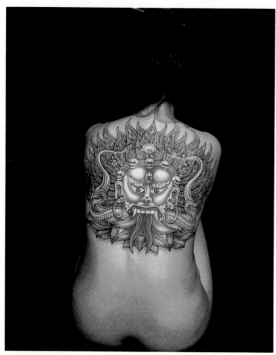

Lenore. Tattoo art by Guy Aitchison. (An excerpt from The Illustrated Woman © *1992 William De Michele)*

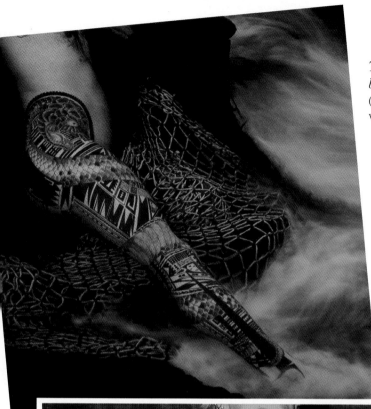

Tattoo art by D. E. Hardy. (PHOTO © TRINA VON ROSENVINGE)

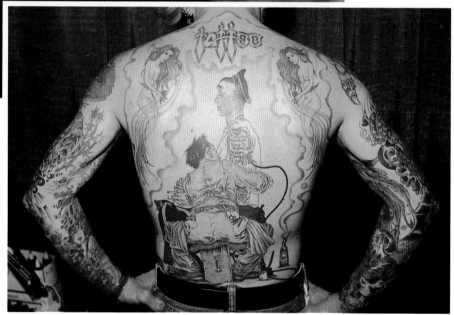

A tattooed version of a Norman Rockwell on Andy Capp.
Tattoo art by Steve Ferguson. Tattoo letters by Philadelphia Eddie.
(PHOTO © STEVE BONGE, N.Y.C.)

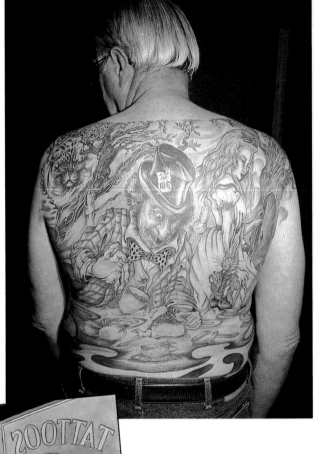

*The Mad Hatter's
Tea Party on the back
of Lou Robbins.
Lou produces the
Mad Hatter's Tea Party
tattoo festival in Maine.
Tattoo art by Ian of
Redding, England.*
(PHOTO © STEVE
BONGE, N.Y.C.)

*"M" is for the Many
Things She Gave Me.
(Copyright © 1993 by
Art Spiegelman,
reprinted with the
permission of Wylie,
Aitken & Stone, Inc.)*

Morbella. Tattoo art on back by Hanky Panky and Terry Tweed.
(PHOTO © STEVE BONGE, N.Y.C.)

Morbella. Bullfight tattoo art on sides by D. E. Hardy.
(PHOTOS © STEVE BONGE, N.Y.C.)

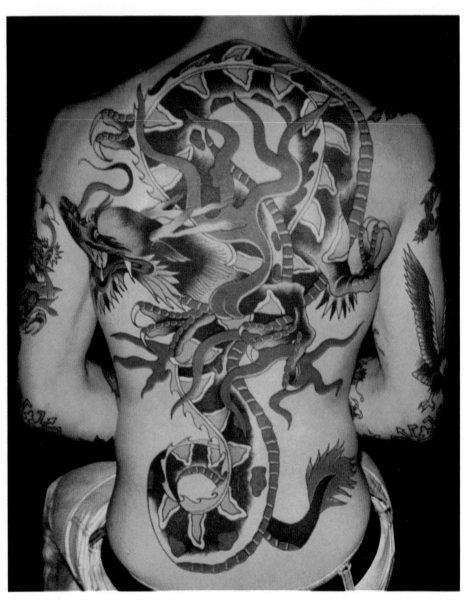

Thom Devita. Tattoo art by Huck Spaulding, done around 1970.
(PHOTO © HUCK SPAULDING)

What Did Moscow Have to Say about the Princeton Tiger?

"My gosh, I have been investigated by the FBI, the IRS, by the Senate Intelligence Committee. My mail is opened. I don't have any secrets left," said Secretary of State George Shultz in 1987. "That's the only thing left, what is on my rear end." His wife said about the tattoo that "he got it at Princeton" when he was a student. "When the children were young, they used to run up and touch it and he would growl and they would run away."

JFK, Jr.	**Shamrock**
FDR	**Family crest**
Winston Churchill	**Anchor**
Josef Stalin	**Death's head**
Barry Goldwater	**Crescent and four dots (a snake bite), signifying that Goldwater is a tribal chief and that he attended the tribe's summer dances**

James Brown in 1992. He had his eyebrows done by Sheila May in 1991. (Photo © Everett Collection)

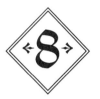

CHAPTER 8

PERMANENT MAKEUP: JUST ANOTHER NAME FOR A TATTOO ... BUT NOTHING IS FOREVER: THE ART OF TATTOO REMOVAL

A lot of people have told me, "Once you get your first tattoo, the next one's easy." And it is. You suffer through angst before your first tattoo: "Should I do it? It doesn't come off. What should I get? Where should it go?" That's why it took me so long to get tattooed. Too many decisions. So much skin. So little time.

When I heard about cosmetic tattooing, I thought, piece of cake. I told my husband I'd be getting my eyebrows done, and he panicked. "What if you don't like it? What if it's too dark?" What if, what if?

What if I want more!? Getting my eyebrows tattooed was one of the greatest things I'd ever done for myself. Come on—look closely. You absolutely cannot tell. One less link in my morning wake-up, makeup chain. I'm almost ready to get my eyeliner done. Almost. I still think it looks a little scary. But the upside of permanent eyeliner: I'll wake up looking wonderful, or at least a whole lot better. And I'll be in such star-studded company with my permanent makeup: James Brown; socialite and cosmetics company magnate Georgette Mosbacher; millionaire Donald Trump; and

former Miss America Mary Ann Mobley. Advertising executives. Corporate vice-presidents. It's rumored that Michael Jackson has permanent make-up, but he's not talking, and neither are the country's best-known cosmetic tattooers.

Permanent makeup is just what it sounds like it is—makeup that's tattooed on. It goes anywhere that regular makeup would go and wears a lot better. Eyeliner, eyebrows, lipliner, full lip tinting, beauty marks. Even cheek color and under-eye concealer can be tattooed on, applied in much the same manner as makeup. Reconstructive tattoos are applied to hide scars or to offer a trompe l'oeil solution to a surgical situation.

The fact that permanent makeup is a tattoo puts a lot of people into a serious state of denial. My Korean friend, Sarah, freaked out when she saw my tattoo. Several weeks later I mentioned cosmetic tattooing, and she casually remarked that her mother's eyebrows were done nearly a decade ago in Korea. "Sarah, you hate my tattoo. And yet you like your mother's eyebrows." "It's different," she tried to explain. "Everyone has it done in Korea. It's not the same thing. It's not on your body. It's not a picture." Many people who view artistic tattoos with disdain have permanent makeup. And the person who applied the permanent makeup used the same machine, in the same manner as an artistic tattooer, no matter what it's called.

I found the idea of never having to struggle at 6:00 A.M. to focus to apply a fine line of eyeliner pretty appealing. As an aging population of baby boomers begins to require magnifying mirrors and reading glasses, it's easy to see why cosmetic tattooing is a growing trend. "As America gets grayer, more and more women will have it done," predicts Dr. David Duffy, a dermatologist practicing in southern California. Permanent makeup doesn't smudge, it doesn't run and it stays on for years.

Dermapigmentation practitioners are all over the globe, working in Paris, in Seoul, in New York, in Hollywood. Korean beauty salons in New York cater to the Asian trade and employ cosmeticians who provide permanent makeup along with facials, manicures and bikini waxes. Sarah showed me the ads in the Korean newspapers: "Eye tattooing" is the translation. I was warned not to ask for it. "You're white. That's a tattoo. Tattooing is illegal in New York."

The people who apply permanent makeup generally don't

Sheila May at work.
(PHOTO © RON GROPER,
COURTESY SHEILA MAY)

dare refer to themselves as tattooers, although the best of them are or have been at some point in their career. They're well-trained artists who choose to do cosmetic and reconstructive tattooing. Sheila May of Pacific Palisades, California, was an artistic tattooer for years before she began to do cosmetic tattooing, scar cover-up and re-

construction work. She now runs a business devoted exclusively to permanent makeup and cosmetic and surgical tattooing.

May told me: "I began tattooing in 1966, when I was one of only a handful of women around the world tattooing professionally. I was taught by my husband. Ten years later, I moved to San Francisco and went to work for Lyle Tuttle. For years I had talked about tattooing eyebrows and eyeliner. My husband and my tattooist friends all thought it was a crazy idea. They told me I'd go broke doing it, although they all pointed out that George Burchett claimed in his book *Memoirs of a Tattooist* that he tattooed makeup back in the 1920s.

"Chuck Eldridge of the Tattoo Archive in Berkeley said that East Coast society ladies were having lipstick, cheek color and eyeliner tattooed around the turn of the century. But all the people who said it was a silly idea were men. They didn't have the same affinity for makeup that I have.

"After a year or so in San

Sheila May's eyeliner was applied by an M.D. Her son, who works with her, as well as in radio, has done the touch-ups. He also has applied permanent makeup to her eyebrows.

George Burchett darkens eyebrows permanently, circa 1930s. (PHOTO © BETTMANN ARCHIVE)

Francisco, I moved to the Los Angeles area, where I opened a tattoo studio exclusively for women. I did pastel, feminine tattoos by appointment only. In 1978 I started doing cosmetic tattooing. I found that if you did a solid black line with blue-black ink, it looked like a tattoo of eyeliner. But I found that when I mixed the pigments so the colors were softer, if I blended and shaded the same way I would do with my own makeup, then there was no reason why every woman wouldn't want it.

"I advertised. Word spread. The people who came to me were upscale women: hipper, educated, monied and with an artistic sense. I did eyebrows first, then eyeliner, then lips.

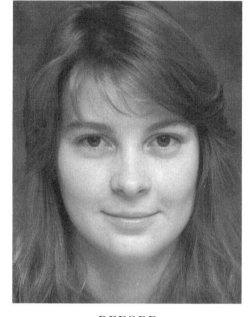

BEFORE

Shannon May (Sheila's daughter) before. (PHOTO © SHEILA MAY)

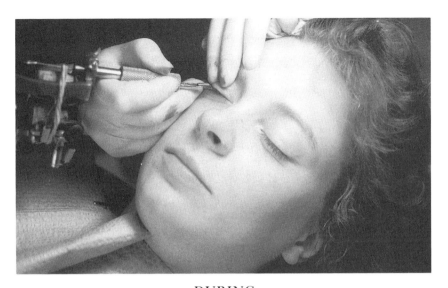

DURING

Shannon May as Sheila applies permanent eyeliner.
(Photo © Don May, courtesy Sheila May)

The business began to take off. And then I began to get referrals from medical doctors, both for makeup and for scar cover-up work. My clients didn't like the pain involved with the procedure, so they went to their doctors for local anesthesia before they came to me. The doctors would then ask to see the results, and they thought it was terrific."

Sheila May is assertive in a sweet way, attractive and knowledgeable about the business she helped to create. Though she was very much a part of the professional tattoo community back in San Francisco (her ex-husband still tattoos), she rarely has anything to do with tattoo-

ers these days, concentrating on her clients, and waking up at the ungodly hour of 4 A.M. to trade commodities futures. She is a smart, cautious businesswoman. Her image is upscale, her clientele the same. Her prices are very high.

Professional tattooers are hip to May, because her cosmetic and surgical work is regarded as the best in the country and possibly in the world. What makes May's work so good is the fact that, no matter what she might call herself, she is in fact a tattooist. Like the best tattooists, she's intensely interested in the machines, the pigments, the procedure, how to make the work look better. I watched as

May mixed pigments for lipliner. I looked at the color, then looked in the mirror at my own lips. I pulled out my fancy French name-brand lip pencil, "Nude." Remarkable! May explained: "I blend the lip color to match one of the most popular lip pencil colors." Watching May do lipliner is a lesson in makeup application. The line is soft and well blended. You can't tell it's there.

Like artistic tattooists, there are things May just won't do. "I tend not to do full red color on lips. I do lipliner and then shading, blending the color. I only use iron oxide pigments on the lips. These are dusty rose, with a slight tinge of rust. The lips are so vascularized, the skin is so thin that pigment tends to fade there. Reds contain chemicals (including mercury and cadmium) that may cause allergic reactions in rare instances."

As an allergy sufferer I was curious. May and other tattooers have indicated that the reactions, which occur in one in several thousand people, tend to be localized: itchy, scaly patches of skin around the tattooed area after the normal tattoo healing itchiness fades. There's also the problem of delayed reactions.

Regarding allergies, May reported, "We noticed that in people we tattooed the pig-ments build up. You may have no reaction for years, but then you may add one more tattoo, and it may be that one that causes the immune system to produce the histamines which give an allergic reaction. That's why I stay away from certain colors and use only those pigments that I've worked with successfully for years."

When May did my eyebrows, I asked her to use a lighter shade. I was concerned, afraid. And besides, I had just bought a blonde wig. What if the color was too dark? She convinced me to go a bit darker, for a closer

AFTER

Shannon May fully made-up. The fine eyeliner is tattooed. (PHOTO © SHEILA MAY)

eyebrow color match. She started to work. The same buzz, the same sticking. Except it didn't seem to hurt as much. The strangest thing: Halfway through my first eyebrow, I felt like I had to sneeze. "Oh, lots of my clients get that." Who knows why? Maybe it's pressure on the sinuses.

After each eyebrow, May takes a break, lets the client examine the work. It looked pretty good. At last, I had even eyebrows. But dark. Too dark. Do I panic now, go home and cry or call one of the laser removal doctors? "Don't worry. The color lightens in five to seven days. And in a week it will be much lighter. We can go even darker on you." "Uh, no, I think I'll wait. I'll come back for a touch-up in ten days."

May knew what she was doing. After two days of healing, the color lightened considerably, to the point where I had to admit that Sheila was right. The best part: I put on some of my old eyebrow makeup above my newly tattooed brow to see if the color matched. I don't know why I was surprised. It was exact.

Look, I know this sounds like an ad for Sheila May, but quite honestly I was impressed. May is a skilled tattooist with a pleasant, reassuring manner. She made me look better than when I walked in. Is every cosmetic tattooist as good as she is? Probably not at this point. May perfected the system and has been

The scar throughout the eyebrow area will be tattooed in a color to match the client's skin tone. (Photo © Sheila May)

After the tattoo of the scar healed, the eyebrow was tattooed with little lines to match the hair color and the shape of the other eyebrow. (Photo © Sheila May)

doing it longer than anyone else. Her advice? Don't expect to get all your makeup done permanently. May says that it's tough to do blush evenly, and that's understandable. Think about the light hand you need to apply blush with powder and a brush (if you're a guy, ask a female friend or your wife), then imagine transferring those skills to a tattoo machine, ink and needles.

"Eyeshadow also requires an enormous amount of shading, and under-eye concealer is tricky to color in evenly. You need to use white in under-eye concealer and white lasts longer than other colors, so you may wind up with a much lighter color under your eye than you'd like." Personally I think it would hurt too much to attempt because the skin under the eye is so thin.

Permanent eyebrows and eyeliner are the first choices of May's clients, followed by lipliner, scar removal/cover-up and aureolas following breast reconstruction. "Eyeliner was the first thing that I wanted to do, the thing that I myself wanted. Eyeliner makes every difference in the world. You wake up with it and you always look good. Permanent eyeliner

Vitiligo before cosmetic tattooing.
(PHOTO © SHEILA MAY)

Vitiligo after tattoo.
(PHOTO © SHEILA MAY)

All tattoos fade with time. Dr. Steven Snyder, dermatologist, has studied and removed tattoos for ten years. He believes that "if people lived for 200 to 300 years, their tattoos would fade completely."

generally lasts longest before it begins to fade." Touch-up schedule: Eyeliner lasts four to six years, brows and lipliner need to be reapplied after two to four years.

The process is quite similar to what happens in a regular tattoo studio. May uses gloves and an autoclave, and, true to her training, she solders needles onto needle bars herself. For a long period of time, even the number of cancellations she received was about the same as in an artistic tattoo studio (40 to 50 percent for first-time clients). To counter those cancellations, May now does consultations first. Her cancellation rate now is about 10 percent. There is one major difference, though, between a regular tattoo shop and Sheila May's studio. The doctors.

During an initial consultation with Sheila, you fill out a questionnaire, take a patch test and discuss your expectations. A week later you chat about how you'd like your eyeliner to look. Then you visit the medical doctor in the next building for a brief eye examination and a subcutaneous shot of xylocaine at the base of the lashes. May explains, "I advocate the pain-killer. I find I can get the pigment in better because the client is more relaxed."

As in artistic tattooing, there are few complications. "During the first consultation, I explain to my eyeliner clients that they can lose their eyelashes; it happens in rare instances. Swelling and bruising are also possible."

Doctors who do cosmetic tattoos—and call it surgery, micropigment implantation, dermapigmentation, dermalpigmentation, anything but tattooing—are finding that even though they may be a master of the scalpel, they really don't know much about a tattoo machine. The machines they've been sold by medical supply houses are inadequate and overpriced. The doctors are now even willing to admit that it takes years of experience to apply a good tattoo—and cosmetic and reconstructive tattoos are just that, exquisitely fine tattoos. "Many M.D.s are just not

as talented or skilled as tattooers," explained Dr. Duffy. That's why more doctors are turning to professional tattooers. The tattooers schedule hours at the doctor's office so that the patients needn't feel the "stigma" of visiting a tattoo studio.

Once doctors realize that they don't have to be tattoo artisans, they turn to the professionals. Sheila May, with nearly thirty years of tattoo experience, is a well-regarded speaker at medical conventions. Her topic: treating vitiligo (vitiligo is a disease in which the skin loses pigment) with tattooing. Tattoos color the discoloration, so that the skin tone appears to be even. She's also lectured extensively on creating nipples and aureolas after mastectomies. "You can build a new nipple, but you can't replace the areola. There is some artistry required in the blending. I make

Colors are blended to match the skin, then applied in a small area as a test. Lisa Bernabe, an artistic and cosmetic tattooer, worked for several weeks on a woman with scars all over her lower legs. They were old scars, remnants of an active, tomboy childhood. The first treatment produced cover-up that was too light. "We like to go lighter, rather than darker, at first. That way we see how the skin takes to the ink and the color. If it's too light we can easily blend the color to make it darker," explained Bernabe.

Permanent makeup is forever. It's a tattoo, and even though it does fade and require touch-ups, it doesn't come off. You can cover up your permanent makeup with different-colored regular, old-fashioned, nonpermanent makeup, but it's still a tattoo. The best cosmetic tattooists advise you to choose your cosmetic tattooist the same

> People compensate for injuries with beautiful designs. There's a natural urge to decorate. It's eternal, so primordial.
>
> —RUTH MARTEN, FORMER TATTOO ARTIST

the edges soft, and I don't put in too much color. Otherwise, it could look painted on."

Reconstruction work and scar cover-up take several weeks.

way you would your artistic tattooist—with great care. Visit the studio, see the work in person. Find out how experienced she or he is, how many years

she's been tattooing. Ask for referrals. Avoid cosmetic tattooists who do not have experience as regular tattooers. And check the sterilization facilities just as you would in an artistic tattoo studio.

Cosmetic tattooing looks and sounds like a good idea. And in the hands of a skilled and well-trained tattoo artist, it is in fact a great idea. Obviously I'm thrilled. But I also believe that cosmetic tattooing has opened up an enormous amount of hassles for consumers, for artistic tattooers and for experienced professionals like Sheila May.

Cosmeticians and other people who take a weekend course in "micropigment implantation" using the "single-needle dot method" may have been trained by sleazy fly-by-night operators who provide weekend workshops, sell cheap equipment and then take off. Sheila May has been called as an expert witness by the Federal Trade Commission in a court case involving unscrupulous operators who charged people thousands of dollars for permanent makeup training sessions. She reported, "They made outrageous claims about what permanent makeup could do—wrinkle removal and more—and sold inferior equipment. They passed themselves off as experts, training people to just

barely graze the epidermis of the skin, so the procedure would be 'painless.' Some pigments stayed in, some didn't. They charged $2,000 to $3,000 for the workshop. Now twenty percent of my business is fixing the work of nontrained cosmetic tattooers. I get people who have eyebrows that are purple and black. They look like they've been scribbled on with Magic Marker and worse. Some of it is frightening—and very sad."

There's another price tag attached to cosmetic tattooing, for both artist and subject. It may bring out a person's natural beauty, but it also brings out the neurotic beast. Women who are constantly unhappy with the way they look are going to be very picky about their makeup. And they're going to be even more neurotic about their permanent makeup. "Some women will stare at the mirror and agonize over that eyeliner for hours," explained Sheila May. "One client came in twenty-five times over a two-year period. It got to the point where I finally had to limit the number of visits. After the initial consultation, I charge a flat fee which includes four months of consultations and touch-ups. I want my clients to know that I'm there for them, should they have any questions or need

touch-up. After the four-month period, I charge nominal consultation and touch-up fees."

Lisa Bernabe's prices include one touch-up visit one month after the initial application to perfect the lines and color. Her fees: Fine eyeliner is $300 and needs one visit; $400 for two visits (medium eyeliner); $500 for bold eyeliner, which requires three visits. Her consultation fee of $35 includes a patch test for allergies and is credited toward the first application of permanent makeup. Costs for lipliner and full lips range from $300 to $500; eyebrows, depending on the amount of work to be done, range from $100 to $300; and skin pigmentation and reconstruction and the redefinition of a hairline are priced at $200 an hour (that's what Donald Trump reportedly had done after bald-spot-lessening, scalp-reduction plastic surgery). Should you want to have a beauty mark tattooed on your face, Bernabe charges $50.

Sheila May's fees are substanially higher: $650 for eyebrows, $650 for lipliner and $1,100 for eyeliner. Fees for cosmetic tat-

tooists who work in or with an M.D.'s office are in the upper range, and should you choose to have your cosmetic and reconstructive tattooing done by a doctor, you'll pay a good deal more than that. If the procedure is prescribed by an M.D., medical insurance may cover the cost.

After appearing on most of the national daytime talk shows, and after applying permanent makeup to some of Hollywood's biggest stars (who of course, prefer to remain anonymous), Sheila May is philosophical: "I thought that I'd just about be able to pay my rent with cosmetic tattooing. I had no idea it would grow this big. The initial response wasn't that positive— I struggled for several years. Husbands would pitch a fit when their wives revealed they wanted it done—they thought it would look tattooed! And the snide remarks I got at cocktail parties when people asked what I did for a living! That's how I coined the phrase dermapigmentation. I didn't call myself a tattooist. But in the end I have to admit, that's what it is: tattooing."

Tattoo Removal

For the botched permanent makeup cases that Sheila May can't fix, and for those people who feel that their artistic tat-

toos aren't too artistic, there's always cover-up work. Or two new tattoo-removal procedures: Chemical peel and laser.

May recommends the peel: "I've yet to see laser tattoo removal work. TCA is still the best method and it leaves little scarring. I send the worst eyebrow and eyeliner cases to Dr. David Duffy." Duffy has had years of experience with various tattoo-removal procedures, and none worked to his satisfaction. He is absolutely against the use of one seems to know. I think lasers should remain in academic institutions."

Duffy quickly continues. "I stopped doing tattoo removal for a while because nothing worked particularly well on large tattoos. Then I started to see people with poorly done permanent eyeliner and brows. TCA is a peeling agent that's not strictly toxic. It works best on fine lines and it really removes the ink. It's not perfect. It doesn't work well on india

> I sometimes get upset when I see people getting ink just for the sake of getting it, or because it's so trendy now, because to me it's art. Tattoo removal just isn't a future option for me, although I expect it will become very popular in five to ten years when many of these people realize they (and their tattoos) are no longer hip and the huge Chinese dragon on their forearm means nothing to them.
>
> —HOLLYWOOD SCENE OBSERVER TATTOOED WITH ONE SMALL, PERSONALLY SIGNIFICANT IMAGE

lasers. "What happens to the pigments when the laser removes them? The ink doesn't come out of the skin. It stays in the body. Are we making these pigments cancerous? Who knows? The laser industry doesn't know. They just want to sell lasers. That's one of the reasons why I won't use lasers. No inks, and there can be some scarring. In some cases there is loss of pigment or loss of eyebrows. But I've done 500 to 600 cases with TCA and 95 percent of the people are happy."

Duffy has lectured extensively about his TCA tattoo-removal procedure. Here's what he tells doctors:

The Bad News According to Dr. Duffy

Will look horrible before it looks better.

Scarring is to be expected.

Must protect from sunlight for six months.

Probably will require repeated procedures to remove all color.

Must pay in advance but sometimes insurance will help after psychiatric evaluation.

No guarantees.

Dr. Duffy's Good News

Time is on your side:

50 percent of patients are happy at twelve months.

75 percent are happy at twenty-four months.

90 percent are happy at three years.

Duffy's final advice: Don't get a tattoo.

Duffy's advice on tattoo removal wasn't quite what I wanted or expected to hear. That's because I had already heard about a new laser procedure that Mick Beasley was going through. She claimed that the Med-Lite Laser Technique was virtually scar-free. As for Dr. Duffy's concern that lasers may cause cancer, well, I think all of us have already heard it reported that hamburgers may cause cancer, and there have been no reported cases of laser-caused cancers.

Every six weeks, over a period of several months, Mick Beasley spent a half-hour with Dr. Steven Snyder, a dermatologist in Owings Mills, Maryland, to remove "a really ugly back piece that I had done when I was very young, before I knew about great tattoo artistry. It's very embarrassing. I'm a tattooer! I was miserable about it, because no one in the business could cover it up. Then I found Dr. Snyder and his little magic wand."

Dr. Snyder did not invent the procedure, but he has quickly become known throughout the tattoo profession since he started using the Med-Lite Laser in 1992. "I've been removing tattoos since 1984, and I wasn't satisfied with the results of previous treatments: dermabrasion, other laser techniques, surgical excision. They all left some type of scars or didn't remove all of the tattoo. This procedure provides a tremendous feeling of satisfaction for both the patient and myself. A tattoo can be removed with no scarring."

The cost of removing the tattoo depends on its size and the amount of time the procedure takes. A one-inch by one-inch tattoo might require three or

four treatments spaced six weeks apart. At $200 per treatment, the total removal cost of $600 to $800 is probably ten times what it cost to get the tattoo. "For the people who come in and say, 'I never take the kids to the beach because of the mistakes I made as a teenager, well, this is a godsend," said Dr. Snyder. "We can selectively remove portions of a tattoo, just a name, for example." The most popular tattoo removal in his office: "love/hate" across the fingers. That's l-o-v-e and h-a-t-e, one letter per finger.

What I found most interesting was that Mick Beasley is not the only well-known tattooer being treated by Dr. Snyder.

He's already established himself as "tattoo remover to the tattoo stars." Snyder shared a booth with Beasley at a tattoo convention and promptly began treating a well-known East Coast artist and a West Coast superstar tattooer. Snyder explained why: "For a lot of people who were heavily tattooed when they were young, or have used up the whole canvas and want to get another tattoo, this is an ideal procedure."

I liked talking to Snyder. He was very technical. I imagined him to be one of those pocket-protector type of kids in high school; he got so excited when he talked about the laser. I couldn't resist: I asked him to

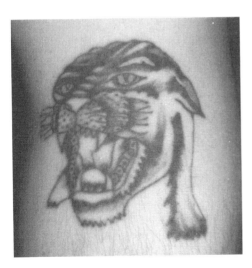

Tattoo before laser reoval.
(Photo © Steven B. Snyder, M.D., Owings Mills, MD)

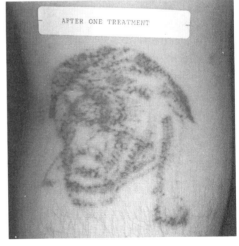

AFTER ONE TREATMENT

The same tattoo after one laser removal treatment.
(Photo © Steven B. Snyder, M.D., Owings Mills, MD)

The Rose Replacing the Breast:
The Personal Is Political (and Quite Beautiful)

Andre O'Conners, a writer and radio talk show host in California, is consistently getting out the message that after treatment, one in three women who gets breast cancer will die of it. After her mastectomy, she chose to symbolize this message artistically. Instead of an artificial breast, O'Conners had a real tattoo applied over the seven-inch mastectomy scar. She wrote in *Ms.* magazine that "although something negative happened, it's now something beautiful that I am proud to show people."

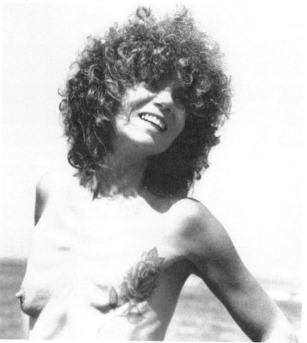

(Photo © 1993 Deidre Lamb Photography, Fort Bragg, CA)

The rose was tattooed by Chinchilla, of Triangle Tattoo in Fort Bragg, California, who said, "I always want to thank the willing souls who trust us with their precious skins. I feel honored to have been the controller of that magical wand of a tattoo machine that transformed Andre's mastectomy scar into a beautiful red rose."

share his feelings about tattoos. "This work has really enlightened me on the beauty and quality of tattooing that's available. Taking a booth at the tattoo conventions with Mick has let me see tattoos that are better than oil paintings. I'm really an admirer of Jack Rudy—his portrait work is unbelievable."

Dr. Snyder does not currently have any tattoos. He says he is not thinking of getting any, not even one little tattoo.

CHAPTER

9

THE LEGAL AND FORENSIC ISSUES

I approached a cosmetician at the Chanel makeup counter in New York City's Bloomingdale's. "Do you see many women here with cosmetic tattoos? You know, eyebrows or eyeliner?" I asked this after I had bought eyeliner, lipstick, powder and a few other things. "Only Orientals. You know, tattooing is illegal in the United States!" I countered her with: "It is? I think it's legal in most places, but illegal here in the city." "Oh, is that right? I knew it was illegal here. I thought it was the same all over the country. I know a couple of tattooists in Brooklyn—my husband had some great work done by Tony, and I'm going to go to him after I have my baby. I'm five months pregnant now. I really like tattoos. I'm going to get a . . ." And on she went, describing just what she wanted to get.

The Legal Issues

The cosmetician maintained a "tattooing is improper" attitude, until I revealed a nonjudgmental outlook. And she mistak-

enly assumed tattooing was illegal all over the United States. Tattooing is not only legal in most parts of the country, it's a legitimate art form, practiced by men and women who take pride in the results of their work, and in how they perform their work. In areas where tattooing is legal, tattoo shops and studios are generally licensed by the community, just like any other business. But that's not where the legal hassles occur.

Cosmetic tattooing is probably the most mainstream and least offensive form of tattooing. It's acceptable in circles where tattoos are still viewed as an exotic means of expression. I think it's great, but I see it causing the most problems.

Permanent makeup is being widely marketed to the beauty culture business—hairdressers, cosmetologists, cosmeticians. Superficially this seems to make perfect sense: "There's a terrific makeup person at my hairdresser, and now she's doing permanent makeup. I'm going to have my eyebrows done next time I get my hair cut." Just about anyone in the beauty trade can sign up to take a two-day seminar, where promoters sell inferior equipment at outrageous prices. These cosmetologists go out and start doing cosmetic tattooing, calling themselves permanent color

technicians or any one of the latest euphemisms. Both Sheila May and Lisa Bernabe told me about the seminars and what goes on at them. It was the artistic tattooers who made me aware of the downside.

Cosmetologists, cosmeticians and hairdressers have their own state-authorized licensing boards. Tattooists are not hairdressers or makeup artists; they are not regulated by a state's board of cosmetology. Tattooers employ sanitary sterilization and waste-disposal procedures. They have to; their business depends on it. Cosmeticians and hairdressers don't use autoclaves or take courses about blood-borne pathogens and infectious disease prevention. With some fast-buck operators offering quickie courses in the application of permanent makeup, state boards of cosmetology and boards of electrology are now seeking to protect the public by licensing cosmetic tattooists—and, along with them, they want to license artistic tattooists as well.

"In Colorado in 1993 beauty—beautifying the skin—has been redefined to include tattooing," explained Mick Beasley of the Alliance of Professional Tattooists. "With that redefinition the state of Colorado is seeking to license and regulate tattooers—all tattoo-

Some Localities That Ban Tattooing:

Indiana
Massachusetts
New York City
Ocean City, Maryland
Oklahoma
South Carolina

Locations That Have Stringent Regulations

Fort Lauderdale and Jacksonville Beach, Florida, both require a licensed medical doctor on the premises when tattooing is being performed.

ers, cosmetic and artistic. The state claims that permanent color technicians—cosmetic tattooers—are beauty workers. But that's not how we view our work. We're not enhancing beauty. We apply art to the skin.

"Now it's up to the tattoo community to convince these states—Colorado and Oregon are the first two examples—that tattooing is separate from beauty, with our own issues, including sterilization. As tattooers, we need to work within the system to make legislation work for us. My dad, who worked for years as a lobbyist in Washington, is conducting seminars for tattooists in several states, showing artists how to, why to and where to use the legislative process to help us keep the art safe and legal.

"Who would you rather have do your cosmetic tattooing? A tattooer who's been tattooing for years or a cosmetician trained in applying makeup and cutting hair? Who should regulate tattooing? People who are artists and do tattooing, or people who cut hair and apply makeup? As tattooing continues to grow in popularity, other states may jump on the bandwagon seeking to regulate tattooing in new ways."

Tattooing can be regulated only in the states where it is legal. Several states and major cities ban tattooing altogether. In most cases, tattooing was made a violation of the specific location's health code, with many of these laws dating from the late 1950s through the mid-1960s, after a hepatitis out-

break was directly traced to tattooing. According to some sources, New York City tattooists were given the opportunity before the ban to show that they could and would practice sterile techniques, but they found it difficult to organize themselves. Now Beasley and the Alliance of Professional Tattooists are seeking to self-regulate with published bylaws and standards, and in so doing to keep the bureaucrats off their backs.

Tattoo legislation is generally instituted because of health concerns. Dr. Kris Sperry, the tattooed M.D. in the Fulton County (Georgia) Medical Examiner's office agrees. "There's a very reasonable paranoia on the part of health departments, due to various outbreaks of hepatitis B. Hepatitis B is a fairly delicate microcosm and can be spread. Reputable tattooists take precautions against the spread of pathogens and microcosms. But, not all tattooists are working out of studios, with autoclaves. There are scratchers working out of kitchens, vans, basements and swap meets, in unsanitary facilities, so it becomes easy for some bureaucrats to ignore the good and come down on tattooing."

It's funny, when I went to get a tattoo I didn't think of hepatitis. I thought of what I would imagine most people think of when they realize a tattooist uses needles, punctures the skin and draws blood: AIDS. But I hadn't heard of any cases of AIDS traced back to tattooing. In the past, Sheila May said, "No one from the government really cared. No one from Los Angeles County has come around since I opened in 1978. You receive a license and you follow the Department of Health rules and procedures. But now with AIDS, people are more concerned. It's important to keep everything you do ultra-hygienic."

AIDS just isn't an issue, according to Dr. Sperry: "We haven't yet seen a documented case. There have been innuendos in the medical literature, but they've been easy to poke holes in scientifically. Some doctors are waiting in the wings to

Yes, it's real. Yes, it hurt. No, it doesn't come off.

—ANSWERS TO THE STANDARD QUESTIONS ASKED WHEN YOU
REVEAL YOU HAVE A TATTOO

prove it, but I strongly believe it's impossible to transmit a case of AIDS through tattooing." The Federal Centers for Disease Control, which issued guidelines for tattooists in 1985, has not seen a single case of HIV transmitted through tattooing.

After they look over his curriculum vitae (resume and bio), the bolder legal professionals who have just met him generally ask Dr. Kris Sperry, deputy medical examiner of Fulton County, Georgia, the same question: "Do you have a tattoo?" His response. "Of course. Doesn't everyone?"

The Forensic Issues

Kris Sperry is a crusader. He travels the country on his own time to teach the APT course. He writes extensively in medical journals and lectures frequently at conventions about tattooing. He's carved out quite a niche: He's the only tattoo doc with credentials in both the medical community and the tattoo subculture.

Sperry was a pathologist working in New Mexico when he began to notice the tattoos on the bodies of his autopsy cases. Some were street-style or prison-style, but some were excellent—clean, artistic tattoos. He got tattooed by Ed Hardy. Then he began his own personal quest, his serious study of tattoos and tattooing.

As a forensic pathologist, one of Sperry's areas of expertise is identification through tattoos. Because tattoos are "permanent, easily recognizable, memorable markers of individuality, they can be utilized as a reliable means of identification." And because tattoos go into the third layer of the skin, they can be used as forensic tools even after a body begins to decompose.

The tattoo community and forensic pathologists have long been aware of the valuable information contained in a tattoo. Periodically, in its newsletter, the National Tattoo Association

includes police bulletins that report that, say, an unidentified female was found. The bulletin describes the victim, including pertinent geographical information. A police contact is included alongside a photograph that shows the victim's tattoo. Often tattooists can help in the identification process.

Police say that when a body is found, it is usually identified fairly quickly; otherwise typically the victim remains unknown for years. A tattoo offers a distinctive means of identification. That's why New Jersey police are so baffled by the case of Tiger Lady, a young woman whose body was dumped on Interstate 80 in New Jersey in 1991. The seven-inch tiger tattoo gave the woman her "name," and it gave the police what they thought would be an easy way to determine who she was. Detective Richard Clayton of the Warren County Prosecutors Office said, "We've gone to many of the tattoo conventions in the area over the past two years. We showed the photo of the tattoo and the composite. It was pointed out to us that this probably wasn't a work done by a well-known artist; the lines weren't perfectly straight and clear." Tattooists indicated it might have been privately done, perhaps by someone without a lot of experience.

After two years, all we still have are her dental records and the tattoo. We know somebody put the tattoo there."

I called Detective Clayton after I saw the tiger tattoo in the *New York Times*. He said that some of the tattooists he talked to were hesitant: "You know how it is with cops," he said. He intimated that tattooists generally didn't want to get too close to cops. It was a traditional attitude that still holds up today. I wondered: There are lots of tattooists who tattoo lots of cops. I've seen them, talked to them. And National's newsletter works. So I thought it was rather strange that the detective had not gone deeper. I assumed he had visited the local tattoo shops. He hadn't—only the conventions. I asked him if he had encountered Dr. Sperry. "He's a doctor?" said Clayton. I learned later that he promptly called Kris, who told me that he receives many phone calls from police across the country seeking help.

After I gave Clayton the doctor's phone number, he opened up a little. He told me his tattoo desire fantasy: "I really wanted one when I was in the service" (he's now in his mid-fifties) "but I never could quite figure out what it was that I wanted to live with for the rest of my life."

It struck me as funny. I hear

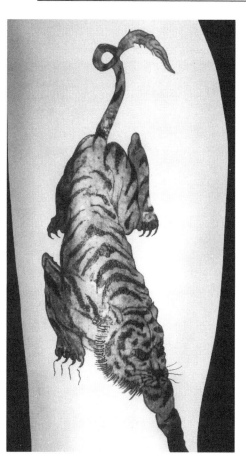

An artist's composite. The tiger tattoo has been superimposed on a mannequin leg and then retouched where necessary.
(PHOTO COURTESY OF NEW JERSEY STATE POLICE, MAJOR CRIME UNIT AND WARREN COUNTY PROSECUTOR'S OFFICE, MAJOR CRIME UNIT)
Anyone with information concerning this investigation is urged to contact the foregoing agencies at: (908) 475-6275, (609) 882-2000 or 1 (800) LADY

tattoo desire and tattoo envy stories over and over (Imagine how many times tattoo artists hear them!). Everyone wants to get a tattoo, and then they don't. I suggested to the detective that he visit several local tattoo shops if he was seriously interested in getting a tattoo. The conversation drifted back to Tiger Lady.

Would I print a picture of the Bengal tiger in this book? I agreed, but only if the detective would sign the proper photo licensing form. He initially declined. I then contacted the New Jersey State Police headquarters in Trenton. Detective Sergeant August Wistner authorized the release of the photographs and the signature. Detective Clayton sent me the copies of the Tiger Lady photographs, which you see here. If you have any information that may help to identify the young woman, call the hotline number at the Warren County Prosecutor's Office: (800) 822-LADY.

Cave painting. (Photo © 1991 Seth Gurvitz)

CASHING IN ON THE TATTOO CRAZE

I chose this title because I think that's what's happening. Everywhere I look, someone's cashing in on what's become a craze. Including me—I wrote this book, didn't I? I like this tattoo mania. Instead of seediness, now there's FASHION, FUN, STYLE, HISTORY, TRADITIONS and MONEY. Where once people turned away from tattooed folks, now they embrace us and what our tattoos represent. And you don't have to go slumming to find a tattooist. Let your fingers do the walking. Look up tattoo studios in the Yellow Pages, or just drive over to the nearest strip mall.

I went through an awful lot of lean years with my tattoo festival. Should I assuage the guilt that's now creeping over me (because I may actually, finally, make a little money) by declaring, à la Ted Turner, "I was in tattoos before tattoos were hot"? Or should I simply sit back and enjoy the show? Enjoyment, definitely. What a show!

Issue a press alert that there's a gathering of tattooed people and watch the videotape crews swarm in. Tattoos may be the photographer's ultimate wet dream. They can't get enough of

tattooed subjects, turning out the images onto picture postcards, calendars, trading cards. One photographer put his pictures onto T-shirts and buttons and sold them at the conventions.

Products marketed for, to and by the tattooed proliferate. Magazines claim a combined circulation of 250,000. Clothing and jewelry to enhance the decorated body are sold at both tattoo conventions and the exclusive Bergdorf Goodman.

Are all these products doomed to be the pet rocks of the '90s? Hardly. Tattoos don't come off so easily. Rock stars on MTV aren't going to cover up their tats. Hollywood celebrities will continue to pose. Models prancing down runways will coquettishly display tattoos.

As we become familiar with tattoos we're less inclined to be shocked or surprised by them or their owners. Then we get to the point where we're willing to accept them for what they are. Just ink. Tattoos. Body art. Not some scarlet letter telling the world we're wanton criminals, sexual perverts, biker scum, sailors, soldiers or just plain weird.

Nonetheless, tattoos aren't for everyone. But neither are sports cars, motorcycles or trips to Disneyland. Tattoos are a major growth industry, a bright light in the economy. The list of tattoo-related products and services grows exponentially. Here are just a few of them.

Temporary Tattoos

In 1987 extensive media coverage revealed George Shultz's Princeton tiger tattoo. A substantial national uproar ensued. In 1993 the most popular product sold at the Bill Clinton inauguration store in Washington received only one minor mention in the *Washington Post*. The product: the Bill Clinton temporary tattoo.

Temporary tattoos are what fashion models use to appear hip. They transform yuppies into macho men, if only for a few days. They let little kids look like their favorite rock stars. They provide the illusion of a tattoo without the commitment.

Remember cockamamies, the little lick 'em, stick 'em things that came packed along with bubble gum? They were a big craze in the 1950s and early '60s. The application was a little awkward and a lot icky: Rub some water on the back of the

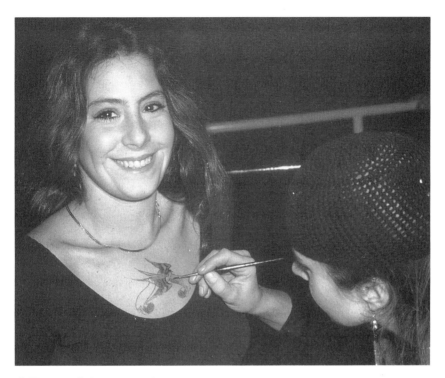

A Temptu being painted on. (PHOTO © TEMPTU MARKETING, INC.)

paper. Press the sheet against your skin, colors down. The water loosened the image. Pull off the paper, and bingo—you had a cockamamie on your skin. Cockamamies begat temporary tattoos, which are so sophisticated in design and manufacture that some of the best photographers on the tattoo scene have had trouble telling them from the real thing.

Some kids who ate up the cockamamies (and the bubble gum that came with them) grew up to be hippies and got into body painting. The urge to dec-orate has always been quite strong among my generation. Today the baby boomers, along with the twenty-somethings, are the prime consumers of artistic tattoos and temporary tattoos.

Unlike cockamamies, temporary tattoos stay on for more than a day. The design is printed onto the skin by applying alcohol to the back of the transfer. Temporary tattoos are supplied by a wide variety of manufacturers and distributors, including real tattoo artist J. D. Crowe and a company called Temptu Marketing.

Temptu also produces a line of fakes that include outline transfers only and paints. Apply the outline transfer, then color it in, just like a real tattoo.

Roy Zuckerman, president of Temptu, started the company after his father Dr. Samuel Zuckerman, a cosmetics chemist, figured out how to make fake tattoos look real. Zuckerman senior created the illusion for the Bruce Dern–Maude Adams movie *Tattoo*. Creating a better fake tattoo wasn't as ridiculous as it sounds. Moviemakers had a long history of problematic fakes. During the filming of the Ray Bradbury story "The Illustrated Man,"

Rod Steiger would sweat under the lights, and the "tattoos" would melt and run. Dr. Zuckerman developed a safe, long-lasting, relatively realistic-looking tattoo substitute. His son immediately saw the potential and started mass marketing temporary tattoos. Now they're like real tattoos. All over the place. Except that these come off, with a dab of alcohol or baby oil.

For temporary tattoo information, contact Temptu Marketing, 26 West 17th Street, 5th floor, New York, New York 10011, or J. D. Crowe Temporary Tattoos, P.O. Box 1923, Grafton, Virginia 23692.

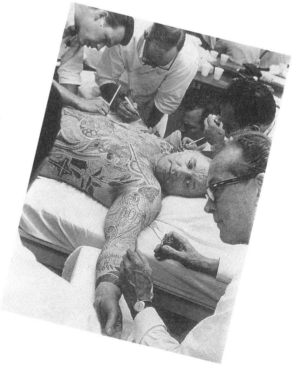

The illusion of real tattoos: Rod Steiger gets made up for his role as Ray Bradbury's Illustrated Man. (PHOTO © EVERETT COLLECTION)

Magazines

In 1980 I worked with a woman who had a biker boyfriend. Every so often she'd bring in one of the biker mags to the office. I think she did it on purpose, just to see our reactions. Of course, I was freaked. Bearded, burly bikers sporting lots of tattoos on their bulging biceps. And their babes! They were tattooed, too. In 1980 those were the few magazines that treated tattoos seriously. These days, the tattooing of America has created a demand for magazines. Among the publications devoted exclusively to tattoos are:

Tattootime, edited and published by Hardy Marks Publications. Ed Hardy's business card reads: "Tattoo art defined." This publication has done just that. It's intelligent and visually arresting. One of my friends, a serious art collector, glanced at it and couldn't contain herself: "Honey, *this is art!*" More like a soft-covered book than a traditional magazine, it's printed on heavy stock with a lush cover. Articles, interviews and serious anthropology commingle with art photographs and tattoo art trends. Each themed issue (e.g., New Tribalism, Art from the Heart) features the work of Hardy and other accomplished tattoo artists who tend to be in his circle of associates. *Tattootime* is published on an irregular basis. All five issues are in print and may be found at specialized bookstores and tattoo shops. For more information, write to Hardy Marks Publications, P.O. Box 90520, Honolulu, Hawaii 96835.

Tattoo Revue, published by *Outlaw Biker* magazine in New York, has been called the professional's choice by many tattooers. The magazine is dedicated to continual coverage

Tattootime.
(Courtesy: D. E. Hardy

Tattoo Revue. (COURTESY *TATTOO REVUE*, OUTLAW BIKER ENTERPRISES, INC.)

of what people are doing all over the tattoo world. Managing editor Michele Delio credits the artists for making the *Revue* what it is today, with "the quality of tattooing much better in the five years that I've been at the magazine. The artists have more formal art training and their technical skills are much better. Tattooing is coming into its own as an art form." The *Revue* features lots of photos, along with articles about tattooers, their styles, their studios and their clients. If you want a fast education about tattooing

today and have time to read only one magazine, this is the one. I should say here that I've written for the *Revue*, and I still have nice things to say about it! For more information, write to *Tattoo Revue*, 450 Seventh Avenue, Suite 2305, New York, New York, 10123-2305.

Skin Art is the all-picture *Tattoo Revue* spin-off magazine. Michele Delio said that: "Readers told us that their favorite section in the *Revue* was the all-photo random section featuring assorted photos from all over, so we published a magazine featuring just that." Designed with a more mainstream, trendy look, the magazine features several themes in each issue, devoting pages of photos to each topic. Don't look for wordy articles; there are none.

Tattoo Expo issues are one-shot specials that feature who was there and what went on at the major national tattoo conventions: Dennis Dwyer's and J. D. Crowe's Tattoo Tours and the National Tattoo Association's Annual Convention. *Tattoo Expo* is published by Outlaw Biker's *Tattoo Revue*.

Tattoo, the monthly tattoo magazine that's distributed in over thirty countries, claims a global circulation of 200,000. It's similar in format to *Tattoo Revue*, though it appeals to a slightly more wide-ranging au-

dience. Tattoo's editor Billy Tinney makes personal appearances at all the big motorcycle and tattoo events, and like Michele Delio is considered an important member of the tattoo family. Each month *Tattoo* (published by the Easy Riders family of magazines) does at least one serious interview and photo essay on a tattoo collector. Photographer Pulsating Paula, who also shoots for *Biker* magazine, is considered a celebrity in her own right on both the biker and the tattoo scene. Easy Riders and *Tattoo* sponsor several well-organized regional motorcycle events, motorcycle rodeos and tattoo contests. Easy Riders also publishes a special annual tattoo issue. I haven't written for *Tattoo*, but the magazine has featured the Coney Island Tattoo Festival. For more information, write to Paisano Publications, 28210 Dorothy Drive, Agoura Hills, California 91301.

Edited by New York tattooer Jonathan Shaw, each monthly issue of ***International Tattoo Art*** features an interview with one

Tattoo. (COURTESY: *TATTOO* MAGAZINE, PUBLISHED BY PAISANO PUBLICATIONS, INC.)

Photographer Pulsating Paula. Paula shoots for Easy Riders' Tattoo *and* Biker *magazines. Tattoos by Phyllis, Dunellon, New Jersey.* (PHOTO © PULSATING PAULA, TAKEN BY HER HUSBAND, JEFF)

International Tattoo Art.
(COURTESY *INTERNATIONAL TATTOO ART*)

of the "old-timers" who helped shape modern tattooing. This magazine is well-designed and beautifully art-directed, and is both intelligent and appealing. It's considered the chief competitor to *Tattoo Revue*. It features only the work Shaw likes, and the good news is that Shaw's got *great* taste in art. Because of that, he includes regular articles about the underground artists whose work serves as the inspiration or model for many modern tattoos. Write to Butterfly Publications, Ltd., 462 Broadway, 4th floor, New York, New York 10013.

Tattoo World Quarterly is new from the folks who brought you *International Tattoo Art.* This promises to be the *National Geographic* of tattooing. It will be edited by Hanky Panky of Amsterdam.

The first issue of **Skin and Ink** came out late in 1993. This magazine, which just may have the best title, is published by Larry Flynt, editor and publisher of *Hustler* magazine. It's just another me-too magazine. Stick to *Tattootime, Tattoo*, the *Revue* and *International Tattoo Art.*

New Jersey tattooer Shotsie Gorman created (the departed) **Tattoo Advocate Journal** to compete with Ed Hardy's *Tattootime.* The difference: The *Journal* covered every aspect of tattoos and tattooing, even going so far as to discuss controversial topics. Printed on high-quality paper, with expensive printing techniques, *Tattoo Advocate* ceased publication after three issues. I wrote for this one, too. Back copies are available from Shotsie's Tattoos, 1275 Route 23 South, Wayne, New Jersey 07470.

Tattoo Historian provided interesting tattoo facts and anecdotes from the master: Lyle Tuttle. Though currently not being published, back copies

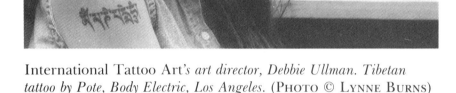

International Tattoo Art's *art director, Debbie Ullman. Tibetan tattoo by Pote, Body Electric, Los Angeles.* (PHOTO © LYNNE BURNS)

are available from Lyle Tuttle's Tattoo Art Museum, 30 Seventh Street, San Francisco, California 94133.

Conventions

In 1976 Ed Hardy, C. W. Eldridge and their friends and associates attended the first national tattoo convention.

Several hundred people, maybe even a thousand, attended. At that convention, the practice of renting booth space began. Tattooers from all over were the exhibitors, plying their trade on the convention floor.

A competition was held, along with the de rigueur awards dinner, encouraging tattooers to bring along their best work. Since the work just so happened to be attached to human beings, the contest guaranteed at least a semblance of attendance.

Eldridge, Hardy and friends knew instinctively that, for better or for worse, tattooing was

A tattooist's view of tattoo conventions. Original art by Cliff Raven.
(COURTESY OF PHILADELPHIA EDDIE FUNK AND THE NATIONAL
TATTOO MUSEUM, WITH SPECIAL THANKS TO BILL FUNK FOR HIS
ASSISTANCE)

about to change dramatically. But it would take nearly twenty more years for tattooing to enter the nation's pop mainstream. If MTV is the medium that got tattoos there, then the convention is Broadway. Live theater at its finest.

In 1993 tattoo artist, businessman and Tattoo Tour copromoter J. D. Crowe entertained 6,000 tattoo fans, collectors, artists and gawkers in San Diego at the first Tattoo Tour. After surveying the crowd and viewing the media circus created by crews from NBC, CBS, ABC, CNN, Japanese television and the syndicated television program *Entertainment Tonight* (along with press photographers from the local papers and the Associated Press), Crowe realized that, had he been around today, P.T. Barnum would have created the Tattoo Convention. "He'd 'a beat us all to this one."

What a festival! Thousands of exhibitionists showed off tattooed bodies. Hundreds of

photographers jockeyed for position, pushing and shoving and snapping away at the convention competition. The two oldest and wisest photographers, who had been through years of conventions, invited tattooed men and women to visit their studios—rooms or suites at the convention hotel, complete with backdrop, lights and props. The photographers generally offer the subjects a print in return for a photo. No pictures are taken without the signing of a model release, which grants the photographer rights to the likeness in perpetuity. Who among so many exhibitionists wouldn't want a great photograph, taken by an excellent photographer? These talented lensmen are skilled at making everyone look fabulous.

Savvy tattoo photographers set themselves up as stock photo houses, peddling their pictures to magazine editors, book authors, postcard and calendar publishers. The photographer with the best business sense chose to do it himself. He published his own book, *The Illustrated Woman*—shot the photos, set the type, designed the book (he worked for years as an art director and graphic designer), hired a distributor—and sold out every $65 copy of his first print run. You can see some of

The Illustrated Woman *book cover. The cover subject is tattooist Juli Moon.* (PHOTO © 1992 WILLIAM DE MICHELE, PUBLISHED BY PROTEUS PRESS, 1992)

Bill De Michele's photos in the color section of this book.

Tattoo photographers are a strange lot, bound to their subjects and made desperate by them. The desperation grows palpable as the scene grows larger. I've seen it both as festival promoter and as author of this book. One photographer became proprietary about a tattoo, for chrissakes! Claimed to have discovered it. Grew angry when the tattoo's owner said he preferred having a friend photograph his tattoo, not some

stranger. I've watched photographers come and go on the scene, and the ones who stick with tattoos are now like caged animals, fiercely fighting to hold on to their turf, as more and more photographers discover the same collectors, exhibiting the same tattoos. Who's going to make those tattoos look different? Who's got the freshest new idea, the new angle, new lens, new filter? And who will buy all those pictures? There are only so many tattoo magazines and postcards to sell to the subculture, the members of the tattoo family.

The 6,000 people in attendance at the San Diego Tattoo Tour may have changed all that. There are more and more tattooed people. The media is now hip: Tattoo conventions are some of the country's best live shows. The performers are the participants, the participants are the performers—true living theater.

The conventions are a little bit overwhelming and a lot of fun for everyone. There's outstanding artwork. Terrific, tight bodies, with very little clothing covering them up. And competitions! All tattoo conventions award prizes to the collectors and artists, with prizes in several categories for men and women.

There's lots of stuff to buy,

Bill De Michele. The leg belongs to Kim Hone. Tattoos by Shotsie Gorman. (PHOTO BY DAVE KRAUS, COURTESY WILLIAM DE MICHELE)

Tattooists Crazy Ace and Greg Kulz chat before a photo shoot. Tattoo by Leo Zulueta. (PHOTO © STEVE BONGE, NYC)

including tattoos, of course, from the world's best artists. There are usually fifty to sixty tattooists working at each of the larger tattoo conventions. You can also purchase sheets of flash, designs by tattooists. There are T-shirts, clothing to show off the tattoos, postcards, books, photographs, videos.

The people at the conventions are interesting, and there's a feeling of participating in something that's offbeat, exotic, a little bit underground, illicit, sexy. There are bikers, artists, doctors, lawyers, teachers, punks, rockers, even Hollywood celebrities. Show up and you might even get to be on television. What makes a tattoo convention is the energy. An amazing, speedy rush, magnified by the buzzing of the tattoo machines.

Tattoo conventions are not for the easily offended or the squeamish. There's usually a fair amount of tasteful nudity. Noticeable too are a number of seriously pierced people. But the conventions are fun. Collectors are generally only too happy to talk about their work with people who want to ask more than the standard dumb questions. And, as at any gathering of professionals, you'll find the tattooists to be incredibly busy, working hard, discussing business with their

peers and staying up late, catching up with people they haven't seen since the last convention.

For information on tattoo conventions, see the listings in

*Elizabeth Weinzirl, at National's New Jersey Convention in 1992. Weinzirl was then 90 years old. Over 50 years ago, her husband, an M.D., was intrigued by an article he had read about tattooist Bert Grimm. Weinzirl throught: "It will please my husband. It's only a tattoo. Why not?" She was a legendary collector of Bert Grimm's work and beloved on the tattoo scene. She passed away in 1993 and will be deeply missed. (*Photo © Pulsating Paula*)

Tattoo magazine and *Tattoo Revue*, or contact J. D. Crowe and Dennis Dwyer, Tattoo Tours, 4138 East Grant Road, Tucson, Arizona 85712; telephone: (602) 881-9026 or (804) 867-8899; the National Tattoo Association, 465 Business Park Lane, Allentown, Pennsylvania 18103; and the Ink Slingers' Ball, c/o Gill Monte's Tattoo Mania, 886 West Sunset Blvd., Los Angeles, California 90069; telephone: (310) 657-8282.

Conventions

Conventions are essential for contact, and over the last fifteen years or so the tattoo convention has become the central medium of cross-pollination. Artists can see what other artists are creating, either in person or through the evidence of the living flesh. Fans and collectors can get work from artists whose home base is far from their own, or from nomadic talents who are hard to find. Conventions also vividly demonstrate the wide scope of interest in the art—people from every cranny of society turn out to show off their work. You come away from a convention with a great feeling of kinship for all these varicolored people.

—CHRIS PFOUTS, EDITOR AND WRITER, *INTERNATIONAL TATTOO ART*; FORMER EDITOR, *IRON HORSE*

Tattoo Supplies

I've heard this comment too many times: "Tattoo suppliers are evil incarnate." I've heard it said exactly that way and in several other forms, some a little nicer, some nastier. The comment is made by tattooers and only tattooers. The names of the tattooers who have said it are incidental, because it's the attitude behind the comment that counts. And the attitude is a throwback to the old days when tattooists didn't want to supply their rivals with the tools of the trade. They'd make it difficult for young people to break in. Those who toughed it out

learned the business. Those who didn't, well, they didn't belong, did they?

Selling tattoo supplies was a controversial issue in the old days and it remains one now. Artists who vehemently oppose supplier advertising give these reasons. They want to discourage casual, nonserious people from picking up a machine without knowledge of technique, sterilization and hygiene. They don't want scratchers coming along and charging quality prices for inferior work, which disparages the work of the professional artists. But the laws of supply and demand still work pretty well. Collectors do seek out the work of the best artists. The best tattoo artists are currently busier than ever.

So is the largest supplier of tattoo equipment in the world, Spaulding and Rogers Manufacturing, Inc. Perhaps that's why the owner takes the most flak from the tattoo community. Huck Spaulding went from being Paul Rogers's tattoo partner in Jacksonville, North Carolina, to being Paul Rogers's partner in tattoo supplies. When Rogers retired from the supply business years ago, Spaulding moved back to Voorheesville, a rural town in upstate New York, near Albany. He's been involved in tattoos for more than forty-five years, supplying tattooists for thirty-six years. Spaulding says, "Everything was always a big secret. Your brother down the street wouldn't help you. They were afraid. But, hey, I like the competition. It keeps me on my toes."

If you look at it from a mainstream perspective, Spaulding is one of the people most responsible for bringing tattoos to a larger public. More than 100 people work in the Voorheesville manufacturing facility and warehouse, built in 1991. "What we once did in a little workshop by hand is now done by nine Bridgeports." Spaulding's proud of his tool and die machinery.

I toured the factory and was amazed. Every inch of it, including the machine room, is spotless and sanitary. But even with high-tech computers assisting the telephone order tak-

It's just ink.

—RUTH MARTEN, RETIRED TATTOO ARTIST

Huck Spaulding. (PHOTO © HUCK SPAULDING)

> It's just a tattoo.
>
> —J. D. CROWE, TATTOOER AND COPROMOTER
> OF THE NATIONWIDE TATTOO TOURS

ers, there's still a real homespun quality to the business. A graphic designer who works with Huck explains: "Before computers, an order would come in, and the order takers would flip through Rolodexes. They'd find the name and on the card would be the order history. Sometimes the tattooist would have a question about a machine, or about pigments. Huck would take a look at the card and then personally get on the phone and help. Today all that's different is the lack of cards. He still goes out of his way to help.

"Everybody who bad-mouths Huck—well, I think they're jealous. Huck is a real sensitive guy. I just heard that he sent a tattooer some money. He did the same for me, many years ago when I was really hurting. But, even now, some of these people, the ones he'd been so generous to with his time and his knowledge, are many of the same people who say nasty things about the fact that he sells equipment and helps people to get started in this business."

It was hard for me not to like Huck. He's a colorful character and a great American success story. Before he became a tattooer, he was a ranked stock-car racer and owner of a wildlife/animal show that played fairs and carnivals along the eastern seaboard. "When I was a teenager, I thought I could make a living trapping and hunting. I was so naive," Huck said as we walked to his home. He wanted me to see his trophy room. What did I know? I thought trophies were something you win at the Super Bowl or when you're the basketball league champs.

Huck's trophy room is packed with hundreds of stuffed animals he bagged on safaris and hunting expeditions. I was overwhelmed and a little unsettled. "Go ahead. You're supposed to walk on them," boomed an amused Huck as he watched me step around and over the animal skins dotting the floor. Spaulding's a skilled hunter; he's made a lot of money, so he's able to afford to go on a lot of exotic hunts. The trophies include a

grizzly and a huge brown bear.

Huck's perspective as both supplier and tattooer inspired him to write *Tattooing A to Z: A Guide to Successful Tattooing*. It's a serious career guidebook with information on every aspect of tattooing, including a chapter about business practices. There's advice about the importance of a professional attitude and workplace. And though some people view him with disdain, others are generous: "Huck helped me greatly. I bought all my supplies from him and he was always there to answer any question about every aspect of the business," said former tattooer Ruth Marten. "I was one of the few women tattooing at the time, and he was always a gentleman. I have nothing but the highest regard for him."

To get a little picture of how big this business is, Spaulding and Rogers now publishes four catalogs: a 260-page catalog of design sheets; a 64-page tattoo equipment booklet, which includes the unique tattoo machine Huck developed and patented; a 24-pager of books, magazines, videos and T-shirts; and a 6-page folder of more than fifty tattoo colors, including some of the newer cosmetic pigments. For more information, write to Spaulding and Rogers Manufacturing, Inc.,

One of the four Spaulding and Rogers catalogs. (Photo © 1993 William De Michele, art by Ted Naydan)

Route 85, New Scotland Road, Voorheesville, New York 12186.

Tattoo Suppliers

There are many reputable tattoo suppliers around the world. For more information on where to find suppliers in your area, please check the tattoo publications listed in this book, visit the tattoo conventions and see if there are suppliers present, and talk to the tattoo professionals in your area to get their opinion.

Tattoo Museums/Archives/Collections

Tattoo museums don't have big endowments. They're not wealthy institutions with large collections. They're labors of love started and kept going by men and women who adore the subject. They should. They're all practicing tattooists.

The curators are happy to share knowledge and information with interested people, and all have been quite helpful in the compilation of this book. Lyle Tuttle's museum in San Francisco is probably the most extensive; a small portion of the collection is still on view in his shop. C. W. Eldridge's Tattoo Archive in Berkeley is one of the organizers of an ambitious not-for-profit undertaking: the Paul Rogers Foundation, which will seek grants and funding from other sources, including foundations, the public and the National Endowment for the Arts.

Folklorists *do* consider tattooing a folk art. The Museum of American Folk Art last held a tattoo art show in 1971; it's time they did another. Tattoo designs, machinery and more are in the permanent collection of the Smithsonian.

The collections listed below preserve tattoo art and culture on a grass-roots level. Write or call with questions. And please support them!

Tattoo Archive, 2804 San Pablo Avenue, Berkeley, California 94702; telephone: (510) 548-5895. Contact: C. W. Eldridge.

Triangle Tattoo and Museum, 356B North Main, Fort Bragg, California 95437; telephone: (707) 964-8814. Contact: Chinchilla.

National Tattoo Museum, 3216 Kensington Avenue, Philadelphia, Pennsylvania 19134; telephone: (215) 426-9977. Contact: Philadelphia Eddie and Bill Funk.

If you're a good tattooer, you don't have to worry about anyone else. Let him worry about you.

—HUCK SPAULDING, TATTOOER AND PRESIDENT OF
SPAULDING AND ROGERS MANUFACTURING, INC.

Chuck Eldridge, tattooist and curator of Berkeley's Tattoo Archive.
(PHOTO BY DON PITCHER, 1989, COURTESY TATTOO ARCHIVE)

A recent photo of Lyle Tuttle, with tattoo artifacts from his collection.
(PHOTO BY STEVE BONGE, NYC)

Tattoo Art Museum, 30 Seventh Street, San Francisco, California; telephone: (415) 775-4991. Contact: Lyle Tuttle.

There are also museums in Amsterdam, Japan and Israel:

Tattoo Club/Museum of Israel, 85 Aluf-David Street, Ramat-Hen Ramat-Gan, Israel. Contact: Sailor Mosko.

Tattoo Museum of Amsterdam at Hanky Panky Tattoos, Oz Voorburgwal 141 ES, Amsterdam, Netherlands 1012. Contact: Hanky Panky.

Ohwada Tattoo Design Institute, Azyma So 47-1 Makado-cho, Naka-ku, Yokahama, Japan 231.

Tattoo Books, Videos, Historical Information, Odds and Ends and Other Good Stuff

A catalogue of interesting tattoo-related "stuff" is available from C. W. Eldridge at the Tattoo Archive. Postcards, reproductions of old tattoo business cards, World War II decals and flash sets are some of the items offered for sale. Eldridge's *Tattoo Archive Scrapbooks* and *The Archive File* are among the intelligent, serious booklets and newsletters devoted to such tattoo topics as Hupa Indian tattooing.

Call or write for a catalog ($1.00 fee, refundable with purchase): C. W. Eldridge, Tattoo Archive, 2804 San Pablo Avenue, Berkeley, California 94702; telephone: (510) 548-5895.

Clothing

Is there actually clothing designed and constructed to show off tattoos? The answer is yes— and no. Some people go to the trouble of cutting strategically placed holes in T-shirts, jeans

and other garments to let their tattoos peek out. Others simply purchase clothing that leaves little to the imagination. The scanty clothing seen at tattoo conventions ranges from leather bras and miniskirts to lace-up leather pants and skirts, bathing suits, and bikinis; for men, the no-shirt look is acceptable. Then there's the covered-up, buttoned-up, long-sleeve look favored by many who choose to hide all their tattoos, revealing them only when they're about to enter a tattoo competition or undressing for all the standard reasons.

And then there are the fad products. These are the dopey items that are made for the nontattooed masses who want to appear to be hip. These items range from men's briefs "tattooed" with full-color flash on the left cheek (from men's wear designer Ron Chereskin), to Calvin Klein pantyhose with simple little outline "tattoos" on the ankle.

T-shirts featuring tattoo designs, as well as the ubiquitous logo T-shirts featuring the name of your favorite tattoo studio, are widely available, either from your favorite tattoo studio or from **J. D. Crowe** (P.O. Box 1923 Grafton, Virginia 23692).

The designs by **Agatha From New York City Custom**

Agatha modeling designs from her collection for New York City Custom Leather. (PHOTO © CLIFF WEISS, COURTESY NYC CUSTOM LEATHER AND AGATHA)

Leather (312 East 9th Street, New York, New York 10003; telephone: (212) 674-3895) are among the most popular on the New York tattoo scene, with excellent quality, craftsmanship and styling. Just about everything laces or snaps up, to reveal lots or a little. Leather tattoo flash patches are fun, giftable and not pricey at all. Agatha made me a fabulous

Men's Ruin patch, modeled after one from Jonathan Shaw's extensive collection. Clothing prices range from $200 to $1,000 for very customized bullet vests.

Chrome Hearts is Hollywood's answer to Hermès, the exclusive French leather, clothing and jewelry manufacturer. Both craft high-quality leather and silver items, and prices of items from both are stratospheric. Hermès is for the uptown, horsey set; Chrome Hearts is for the upmarket bikers. Chrome Hearts has already won the coveted CFDA (Council of Fashion Designers of America—the major fashion designers' association) award for Accessories Designer of the Year, after only a few years in business. Please ask all your friends to buy copies of this book so that I can afford to buy something from Chrome Hearts. Find their lush leathers and sterling designs at Bergdorf Goodman in New York, Maxfield in Los Angeles, Brown's in London, L'Eclaireur in Paris.

Brightly colored decoupage pins and earrings based on old flash designs are adorable, handmade and reasonably priced. Contact **Brigitte Salezius**, Westerstraat 225, 1015 ME Amsterdam; telephone: 011 31 20 6257 297.

There's a strange and sort of wonderful clothing item called Body Webs, which covers but at the same time reveals. Contact **Body Webs**, Box 626, Kissimmee, Florida 34746; telephone: (407) 870-2701.

Lyle Tuttle, retired tattooist, historian and master promoter of tattoos, has been making jewelry at his northern California ranch. His 18K gold skulls stare out at you with ruby or emerald eyes—he and his wife, Judi, sport matching bracelets. Skull earrings and liberty and eagle bolos are part of the sterling silver collection. Contact Lyle Tuttle, 30 Seventh Street, San Francisco, California; telephone: (415) 775-4991.

For more tattoo-related clothing, check the listings and ads in the tattoo and motorcycle magazines.

Ads

I knew tattooing was becoming more mainstream when tattoos started showing up in ads. Here are a couple of ads I like. They

I had wanted a tattoo ever since high school. I promised myself that if I still wanted one five years later, and if I found an image I could live with *for the rest of my life*, that I would do it.

Tattoo by Ilija, Venice Tattoo Studio.
(PHOTO © JOE LO TRUGLIO,
COURTESY BROOKE BERDIS)

One day, when I was stuck on a script, I was doodling the two flowers that always cheer me up instantly: sunflowers and daisies. The film strip in the image just happened—film is my passion. If you want to get deep about it, the tattoo signifies a union of female and artist.

I'll be proud to show my tattoo to my grandchildren, and hopefully they'll see it as a sign of commitment rather than temporary insanity.

—BROOKE BERDIS, WRITER, DIRECTOR, FILMMAKER,
PHOTOGRAPHER, TALENTED FUNNY PERSON

feature tattoo images, but they don't pander. There's even a funny ad for Bernie Moeller's tattoo studio. A couple of the Gap's celeb ads show tattoos. And Guess Jeans features several good-looking young tattooed man-boys. On the downside, one insurance company wouldn't let us use their ad, which featured an illustrated tattoo of a graph. Perhaps they were afraid of the image problems. (The illustrator was Ruth Marten, retired tattooist.)

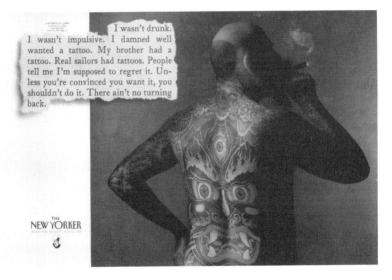

Captain Colors is featured in this ad for the New Yorker. *Tattoos by Bill Salmon. Art director: Jeremy Postaer. Photography by Dan Escobar. Advertising Agency: Goodby, Berlin, Silverstein/San Francisco.*

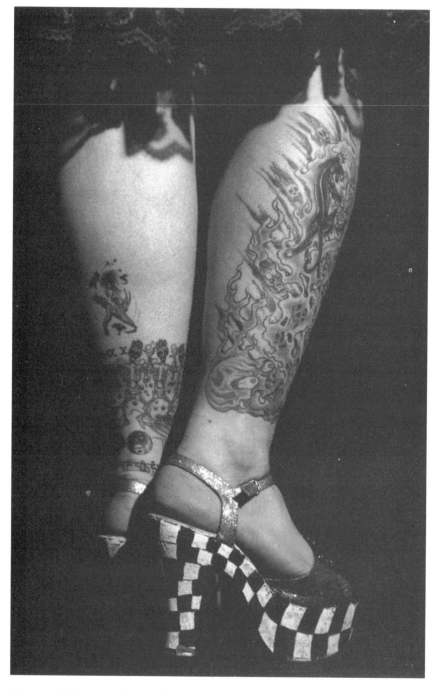

Tats on Plats on Gia Jupiter. (PHOTO © 1990 SETH GURVITZ)

C H A P T E R
11

GET COLORED: A WORLDWIDE
LISTING OF TATTOO SHOPS

Tattooed people choose their minority. Listed here are more than 1,000 tattoo shops to help you become red, white, blue, black, green, yellow, pink, purple . . .

Tattoo shops and studios encourage visitors, and of course they encourage business. But many tattoo artists would like to see the client in person first, so they don't give out their phone number until they meet you. So, some shops listed here have complete addresses and phone numbers listed, some have addresses only. Remember that addresses and telephone numbers change. We've done the best we can to compile an accurate list. If we didn't include a particular shop, it was an unintentional oversight.

No shop is recommended, this is simply a listing. It is not meant to be a complete list of every tattooist. We make no claims regarding any of the artists or shops listed or not listed. For more tattooists, see the tattoo publications or visit the tattoo conventions mentioned in the previous chapter.

A word about health and legal issues. Legislation regarding tattooing is undergoing rapid changes with states, cities, and counties enacting laws as this book is going to press. For legal reasons we did not list tattooists and shops in the communities that we knew had laws and health code regulations banning tattooing.

Argentina

Miahira Professional
 Tattooing School
Av. Cordoba 2922
1187 Buenos Aires, Argentina
 9611703
54-1-961-1763

Professional Tattoo School
Av. Cordoba No. 2922
1187 Buenos Aires, Argentina
 9611703
54-1-961-1703

Tattoo Studio
Sanchez De Bustamante 1337
Buenos Aires, Argentina
 9617331
54-1-961-7331

Australia

Four Roses Tattoo
104 Hindly St.
Adelaide, SA
Australia

Indelible Illustrations
94 Currie St.
Adelaide, SA
Australia

Bob's Tattooing
Shop 4 Olympic PDE
Bankstown, Australia

Dynamic Tattoo
Rear 132 Boronia Rd.
Boronia, Victoria
Australia

Expert Tattooing
Logan Rd. and O'Keefe St.
Brisbane, Stones, Queensland
Australia

Kustom Tattoos by Little Mick
187 Barry Pde. Valley
Brisbane, Queensland
Australia
61-7-252-8881

Australian Tattoo Company
171 Lonsdale St.
Dandenong, Victoria
Australia

Peter Backman's Tattooing
89C Foster St.
Dandenong, Victoria
Australia

Illustrated Man Tattoo Studio
137 William St.
E. Sydney, NSW
Australia

Southside Tattooing
26 Henry St.
Fremantle, WA
Australia

Dragonlady Graphics
700 Anzac Highway
Glenelg, Victoria
Australia

Tattooist Fred
8 Bridge St.
Granvelle, NSW
Australia

Pete and Max's Tattoo
Llankelly Pl
Kings Cross, NSW
Australia
3573223

Tattoo Studio
343 Wellington St.
Launceston, Tasmania
Australia

Tattooing by Bruce McGuire
143 Dawson St.
Lismore, NSW
Australia

Tattoo Grotto
490 Flinders St.
Melbourne, Victoria
Australia

Picture Machine Tattoo
Shop 5, 21 Hoyle St
Morwell, Victoria
Australia

Tattoo Studio
54 Hough St.
Narrogin, WA
Australia

Peter Brackman's Tattoo
55 Portman St.
Oakleigh, Victoria
Australia

Keith's High Class Tattooing
61 James St. (Cnr. William
 St.), Upstairs
Perth, WA
Australia

Whistle Stop Studio
40 Bridge Rd.
Richmond, Queensland
Australia

Frans Tattoo
2B Campbell
Sydney, Bondi, NSW
Australia

Shop 3
113-115 Hall St.
Sydney, Bondi, NSW
Australia

Kings Cross Tattoo Studio
244 Darlinghurst Rd.
Sydney, Kings, NSW
Australia

Illustrated Man Tattoo Studio
228 A. Elizabeth St.
Sydney, NSW
Australia
61-2-211-3751

The Celtic Dragon
41 Enmore Rd.
Sydney, NSW
Australia
61-2-516-5120

Ex Libris Book Shop
P.O. Box 441
Sydney, NSW
Australia

Images Tattoo Studio
Corner Acland and Carlisle St.
St. Kilda, Victoria
Australia

John's Tattoo Studio
12-25 South St., Crystal Ct.
Wodonga, Victoria
Australia

Belgium

Tattoo Eddy
Schipperstraat 19
Antwerpen, Belgium

Tattoo Raeul
STW Naar Edigen 42
1500 Halle, Belgium

Prof. Tattoo Bertje
Amsterdamstraat 55
Oostende, Belgium

Brazil

Caio Tattoo
Otaviano 67, Loja 33
Arpoador Rio, Brazil

Casa De Tatuagem
Av. Irai 546
Mopema SP, Brazil

Canada

Alberta

Smiling Buddha Tattooing
Ltd.
2403 33rd Ave. SW
Calgary, Alberta
Canada
403-242-5922

Zipps' Tattooing
9918 89th Ave.
Edmonton, Alberta
Canada

Roy and Sharon's Tattoo
9434 118th Ave.
Edmonton, Alberta
Canada

British Columbia

Red Rocket Tattoos
2924 Cliffe Ave.
Courtenay, BC
Canada

The Dutchman Tattoos
630 12th St.
New Minster, BC
Canada

Mum's Tattoo
291 Pemberton Ave.
N. Vancouver, BC
Canada
604-984-7831

Canadian Tattoo Assoc.
P.O. Box 327
Qualicum, BC
Canada
604-338-9599

Tattoos by Raz
4601 Lazelle Ave.
Terrace, BC
Canada
604-638-2042

Red Lion Tattooing
935 Hereward St.
Victoria, BC
Canada

Manitoba

Tattoos by Strider
296½ Tache Ave.
Winnipeg, Manitoba
Canada
204-235-0453

Ontario

Joe's Custom Tattooing
159 Norfolk Ave.
Cambridge, Ontario
Canada
519-621-0345

Ray's Tattoo Studio
773 Cardiff Dr.
Clearwater, Ontario
Canada

Dermagraphics by Paul
9 Cork St. E.
Guelph, Ontario
Canada
519-836-8680

Big Dave's Tattooing
544 Barton St. E.
Hamilton, Ontario
Canada
416-524-1745

Squirrel's Skin Art
39 Viceroy Ct.
Hamilton, Ontario
Canada
416-575-4210

Panther Productions
13 Union St.
Melbourne, Ontario
Canada
519-289-5488

Down East Tattooing
4588 Queen St.
Niagara Falls, Ontario
Canada

Wylde Tattoo
647 Lavery St.
North Bay, Ontario
Canada
705-495-6694

New Moon Tattoo
80 Burland St.
Ottawa, Ontario
Canada
613-596-1790

Cory's Tattooing
326 Elgin St.
Sundbury, Ontario
Canada

Lone Wolf Studio
103 Pine St. S.
Thorold, Ontario
Canada
807-680-1044

Dragon Tattoo Studio
225 Violet St.
Thunder Bay, Ontario
Canada

Sundance Studio of Tattooing
331-A Coxwell Ave.
Toronto, Ontario
Canada

Plutos Place
3375 Lakeshore Blvd. West
Toronto, Ontario
Canada
416-503-4513

Beachcomber's Tattoo Studio
 Inc.
1281 Queens St. W.
Toronto, Ontario
Canada

Midway Tattoo
1118 Queen St. W.
Toronto, Ontario
Canada

Adventure Tattoo Inc.
725 Queen St. W., Suite 301
Toronto, Ontario
Canada

Sexual Tattoo
2983 Jefferson Blvd.
Windsor, Ontario
Canada

Creative Tattoo of Canada
130 Pitt St. W.
Windsor, Ontario
Canada

Québec

Tatouage
1880 Est Rue Ontario
Montréal, Québec
Canada

Tatouage Artistique
1962 Ontario E.
Montréal, Québec
Canada

Saskatchewan

Riff Raff Tattoo
P.O. Box 1755
La Ronge, Saskatchewan
Canada
306-425-3482

Valhalla Tattoos
215 Victoria Ave. E.
Regina, Saskatchewan
Canada
306-352-1568

Denmark

Den Gyldyne Drage
Vesterbro 111
Aalborg, Denmark

Tattoo Ole
NY Huan 17
Copenhagen, Denmark

Tato Svend
Lille Strandstraede 9
Copenhagen K, Denmark

Tattooing by Henning
 Jorgensen
Sabrosevej 12A
Elsinore, Denmark
45-4-920-2529

Royal Tattoo
I.II Tvedesvej 3A
Helsingor, Denmark
45-4-920-2770

England

Tattooing by Dave
8 Wellington Rd.
Belston, England

Tattoo Factory
P.O. Box 294 Hockley
Birmingham, England
44-8-862-1098

Tattoo Club of Blythe
48 Hodgsons Rd.
Blythe, Northumberland
England

International Tattoo Art
16 Preston St.
Brighton, E.
England

Wildcat Video International
 Tattoo Art
16 Preston St.
Brighton, E.
England

Tattooing by Fat Bob
Pin Mill, Leslie West Sail
 Barge
Chelmondston, Suffolk
England

Celtic Art Tattoo
321 Sheffield Rd.
Whittington Moor
Chesterfield, England
44-24-623-5176

Miss Wendy Gunn
211 Old Church Rd.
Chingford, England

Tony Tattoo
15 Gauell Rd.
Cobham, Surrey
England

Painless Jeff Baker
Canada Road
Deal, Kent
England

Tattoo Artist
39 Cecil Rd.
Dronfield
England

Classic Tattoos
2 Musley Hill, Ware
Hertfordshire
England

Fat Bob's
35 Woodbridge Rd.
Ipswich, Suffolk
England

The Viking
2 Daffil Grove, Churwell
Leeds, West
England

Exclusive Tattooing
265A Finchley Rd.
London, England

Artistic Tattoo Studio
720 Dundas St. E.
London, England

Skip's Tattoo Studio
34 College Street
Long Eaton, England

Tattoo Art
8 Smiths Dr.
March, Cambs.
England
44-3545-1183

Middleton Tattoo Studio
327A Oldham Rd.
Middleton, England

New Wave Tattoo
44 Beaconsfield Rd.
New Southgate, England

The Wizard Ossie
8 Byker Bridge
Newcastle-upon-Tyne,
 England

Tattoo Phil
2A Billington St.
Northampton, England

Lionel's Tattoo Studio
66 St. Clemens
Oxford, England

Tattoo History Museum
389 Cowley Rd.
Oxford, England

Tattooing by Ron Ackers
Kersey House, Queens Place
S. Seahants, England

Tattoos by Acamon
35 Bridge Rd., Oulton Broad
 Lovestoft
Suffolk, England

Fine Line
14D Rock Terrace
Sulgrave, England

High Class Tattooing
42A Tor Hill Rd.
Torquay, England

"Saz" Tattoo Artist
4 Marsh House Lane
Warrington, England
44-92-557-2248

JJ's Tattoos
321 Sheffield Rd.
Whittingon Moor, England

Tattoo Studio
56A Leonards Rd.
Windsor, England
44-75-386-7447

France

Bebert Tattoo
17 FBG des Balmettes
Annecy, France

Stephane Chaudesaigues
8 Place Pignotte
Avignon, France

Marco Tattoo Studio
34 Rue Leyteire
33000 Bordeaux, France

Prestige Tatoo
12 Avenue Marbeau
LePlessis, France

Tatouage De Lorient
1 Rue Descartes
Lorient, France

Allan Tatouage
1 Rue St. Vincent
Marseille, France

Tatouages
29 Rue A Thiers
13001 Marseille, France

Bernard Tatouage
18 Rue Del'Abbe Groult
Paris, France

Tatouage
6 Rue Germain Pilon
Paris, France

Marcel Tattoo
105 Rue Legendre
Paris, France

Tatouage Tintin
12 Rue Des Penitents Gris
Toulouse, France

Germany

Alf's FTA Studio
Wurzburger Str. 94
Aschaffenburg, Germany

Kalle's Tattoo Shop
Nurnberger Str. 110A
Bamberg, Germany

Black Magic Tattooing
Mulheimer Strasse 30
Berg Gladbach 2, Germany

Bernie's Tatowierstudio
Langenscheidstrasse 3
Berlin 62, Germany

Hango's Tattoo Studio
Mierendorffstra BE 23
Berlin 10, 1000 Germany

Tatoweir Studio
Urbanstr 119
Berlin 61, 1000 Germany

Tattoo Gerard
Hammerfester, Strabe 5
Bremen, Germany

Sting's Tatowierstudio
Postfach 10 06 03,
 Buchtstrasse 45
Bremerhaven, 2850 Germany

Tattoo Bernie
B. Schoebler Bln 62
Dangenscheidtst, Germany

Fine Line Tattoo by Ralf
Corneliusstr BE 102
Dusseldorf 1, 4000 Germany

Alf Diamond's Studio
Dreieichstr 1
Frankfurt, Germany

Samy's Tattoo
Str 2 6000
Frankfurt 1, Germany

Dead Rebel Studio
Wittelsbacher Allee 45
Frankfurt 1, 6000 Germany

Eddy's Tattoo Shop
Ludwig Str. 40
Furth, 8510 Germany

Dead Rebel Studio
Bahnhofstr 97
Giessen, Germany

Tattoo Danny
Silbersackstrasse 8
Hamburg, Germany

Alf's FTA Studio
Konigstr 27
Kaiserslautern, Germany

Larry's Tattoo
Wetzienstr. 4
Karlstrube 1, Germany

Dieter's Tattoo Studio
Genovevastr 4
Koln Mulheim, Germany

Major Tom's Tattoo Studio
Holzgrundstr 6
Kornwestheim, Germany

Tom's Tattoo Studio
Holzgrunstr 6
Kornwestheim, Germany

Peter's Tattoo Studio
Friedrich Ebert Str. 54
Mannheim, Germany

Sohne's Tattoos
Schleissheimer Str. 16
Munchen, Germany

Tommy's Tattoo Studio
Schmeller Str 13
Munchen 2, Germany

Toby's Tattoo
Alarichstr 21
Stuttgart, Germany

Toby's Tattoo Studio
Wagner Str. 6
Ulm, Germany

Southwest Tattoo
Lutzowstrasse 2
Weisbaden, Germany

Greece

Beachcomber's Tattoo Studio
13 Kryistou Str. Plaka
Athens, Greece

Guam

Low Tide Tattoo
P.O. Box 4092
Angana, Guam

Israel

Sailor Mosko Tattoo
85 Aluf-David
Ramat-Hen
Israel

Italy

Studio I
Via Carlo Sigonio-4
Roma, Italy

Urban Cowboys Tattoos
Via Giardino
Verona, Giusti 21
Italy

Japan

Hori-Hide 1
P.O. Box 157
Gifu City, Japan

Tokai Tattoo Club of Japan
P.O. Box 157, 1-11 Kanda
 Machi
Gifu City, Japan

Tattoo Club of Japan
581 Isogo-Cho
Isogo-Ku, Japan

Netherlands

Tattoo Peter
N.W. Brugsteeg 28
Amsterdam, Netherlands

Hanky Panky Tattoo
OZ Voorburgwal 141
Amsterdam, Netherlands
31-20-627-4848

Eddy "Tattoo Zazoo"
Visstery 7, Araham
Gelderland, Netherlands

Tattoo Rene
Botermarkt 6
Haarlem, Netherlands

Tattooing by Duet
Wijaanzeerweg 29
Ijmurden, Netherlands

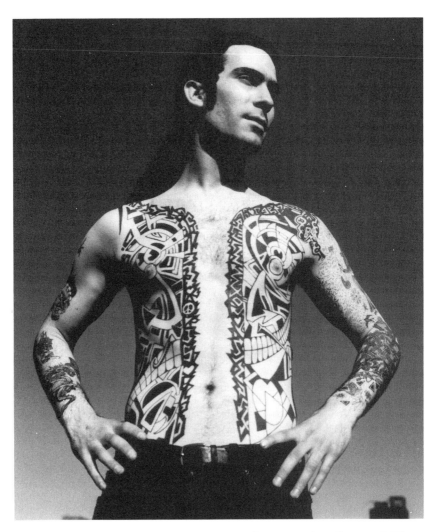

Luke Miller. Tattoos: Jonathan Shaw, Filip Leu (Ghandi, not visible in this photo), Thom Devita, Henry Goldfield (lotus, not visible in this photo). (Photo © Joanne Chan)

Southside Tattoo
Strucht 13
6305 AE Schin
Valkenburg, Netherlands

New Zealand

Tattoos by Merv
171 Karangahope Rd.
Auckland, New Zealand

Auckland Tattooing Studio
49-052 Mt. Roskill STH
Auckland, New Zealand

Dermagraphic Tattoo Studio
1 Truscott Pl.
Massey, New Zealand

Tattoos by Andre
P.O. Box 68362
Newton, New Zealand

Warm Art Tattoo
203 Fenton St.
Rotorua, New Zealand

Tiger Graphics
44 Bisley Ave.
Tahunanui, New Zealand

Northern Ireland

A-1 Tattooing
78 Long Commons
Coleraine Co.
Northern Ireland

Philippines

Tattooing Bong
1924 M Adriatico St.
Malate, Manila
Philippines

Puerto Rico

Indio's Tattoo
P.O. Box 2788
Old San Juan, Puerto Rico

Scotland

Artistic Skin Illustrations
24 Cow Wynd
Falkirk, Glasgow
Scotland

Singapore

Peninsula Tattoo Studio
212 Peninsula Plaza, 2nd
 Floor
Singapore

Spain

Mao and Kathy Tattoo
Avenido San Fernando 79
Apt Correos 47
Rota, Spain

Sweden

Doc Forest
Hagerstensvagen 102-126-49
Hagersten, Sweden

Tattooland
Davidhallsg 4
211 45 Malmo, Sweden

Tatu Bjorn Thumberg
Stangholmsbacken 54
Skarholmen, Sweden

Switzerland

Ralph's Tattoo Studio
Baslerstr 161
7850 Lorrach, Switzerland

Orlando's Tattoo Studio
Bahnhofstrasse 4
4132 Muttenz, Switzerland

Varry's Tattoo
Hauptstrasse 89
4450 Sissach, Switzerland

Tattoo Werner
Moosstrasse 29A
St. Gallen, Switzerland

Tattoo Club of Sweden
Postfach 62 9003
St. Gallen, Switzerland

Ink Funatics
Rudenplatz 4
Zurich City, Switzerland

Tattoo Howy
Haldenstr 1
St. Gallen, Switzerland

Tattoo Club of Switzerland
Postfach 62
St. Gallen, Switzerland

United States

(This selected list is current as of January 1994. Various states and cities have regulations governing the practice of tattooing. If you are interested in the legality of tattooing in your area, consult with your local health department.)

Alabama

Tattoo Workshop
807 S. Qintard
Anniston, AL 36201
205-238-9586

Branding Iron Tattoo
Pelham Rd. Lenlook
Anniston, AL 36201

Magic Needles Tattoo Studio
1409 Jordan Ln.
Huntsville, AL 35804
205-830-0102

Dragon's Lair Tattoo Studio
13 Freedom Ct. Lot F
Montgomery, AL 36108

Gulf Coast Tattoo
Theodore Dawes Rd.
Theodore, AL 36582

Native Dancer Tattoos
P.O. Box 1417
Theodore, AL 36590

Arkansas

Altered Images
8302 Chicot Rd., Apt. 1
Little Rock, AR 22201

Arizona

Mohave Tattoo
2745 Hwy 95
Bullhead City, AZ 86442
602-763-8288

Cellar of Living Art
111C S. San Francisco St.
Flagstaff, AZ 86001

Blue Dragon
322 W. McDowell Rd.
Phoenix, AZ 85003
602-973-4093

Tattoos by Antoinette
2201 N. 9th St.
Phoenix, AZ 85006
602-271-6902

The Crawling Squid
2611 W. Bethany Home
Phoenix, AZ 85017

Dragon Lady
4344 E. Indian School Rd.
Phoenix, AZ 85018
602-957-4640

Electric Needle
2620 W. Butler
Phoenix, AZ 85021

Peter Tat-2
1434 E. McDowell
Phoenix, AZ 85026
602-254-8707

Tattoo Shop
121A N. 5th St.
Sierra Vista, AZ 85635

Kick Ass Tattooing
6825 S. Craycroft
Tucson, AZ 85702
602-574-9760

Fine Line Tattoo Studio
200 W. Grant Rd.
Tucson, AZ 85705

Dennis E. Dwyer Studio
4138 E. Grant Rd.
Tucson, AZ 85712

Ancient Art Tattoo
4138 E. Grant Rd.
Tucson, AZ 85712
602-881-9026

The Enchanted Dragon
4243 E. Speedway Blvd.
Tucson, AZ 85716
602-323-2817

The Enchanted Dragon II
2756 N. Campbell
Tucson, AZ 85719
602-326-7807

Wildcat Tattoo
719 E. 3rd St.
Winslow, AZ 80647
602-289-3904

Rites of Passage
160 4th Ave.
Yuma, AZ 85364

California

Dominick's Ace Tattoo
P.O. Box D 201
Twentynine Palms, CA 92277

Ricky's Tattoo Studio
1536 Webster St.
Alameda, CA 94501

Good Time Charlie's
 Tattooland
3426 W. Lincoln Ave.
Anaheim, CA 92801
714-827-2071

Twilight Fantasy
3024 W. Ball Rd., Suite 1
Anaheim, CA 92804
714-761-8288

California Tattoo
1214 California Ave.
Bakersfield, CA 93304

Midnight Star
10075 S. Union Ave., Apt. 2
Bakersfield, CA 93307

Balboa Tattooing
313 E. Balboa Blvd.
Balboa, CA 92661
714-675-8905

Skin Works
313 E. Balboa Blvd.
Balboa, CA 92661
714-675-8905

Tattoo Archive
2804 San Pablo Ave.
Berkeley, CA 94702
510-548-5895

Custom Tattooing
P.O. Box 5908
Buena Park, CA 90620

American Heritage Skin Art
1324 Mangrove, Suite 216
Chico, CA 95926

California Tattoo
7946 Auburn Blvd.
Citrus Heights, CA 95610
916-723-3559

Larry's Riggs Tattooing
622 N. Broadway
Escondido, CA 95995
619-743-9228

Scott E. Bizzare's Tattoo
 Works
520 Parker Rd.
Fairfield, CA 94533
717-437-2486

Triangle Tattoo
356-B N. Main
Fort Bragg, CA 95437
707-964-8814

World Class Tattooing
2913 N. Blackstone
Fresno, CA 93703
209-224-2270

Crescent Moon Tattoo
15600 River Rd., Apt. 201,
 upstairs
Guerneville, CA 95446

Altered Images
15600 River Rd.
Guerneville, CA 95445

Joker's Wild Tattoo
1605 Pacific Coast Hwy., #108
Harbor City, CA 90710
310-534-4532

Tattoo
6758 Hollywood Blvd., Suite
 200
Hollywood, CA 90028

Hollywood Harley
6609 Hollywood Blvd.
Hollywood, CA 90028

Purple Panther Designs
7560 Sunset Blvd.
Hollywood, CA 90046
213-882-8165

Kevin Quinn
Hollywood, CA 90069
213-850-1948

Gil Monte's Tattoo Mania
8861 W. Sunset Blvd.
Hollywood, CA 90069
213-657-8282

Sunset Strip Studio
8418 Sunset Blvd.
Hollywood, CA 90069
213-650-6530

Wild Child
45 255 Fargo St., Apt. 5
Indio, CA 92201
619-347-0880

Laguna Tattoo
656 S. Pacific Coast Hwy.
Laguna Beach, CA 62654
714-497-3702

Lee Roy's Tattoo Parlor
26 Chestnut Pl.
Long Beach, CA 90802

West Coast Studio
507½ S. Main St.
Los Angeles, CA 90013

Black Wave
118 S. LaBrea
Los Angeles, CA 90036
213-932-1900

Spotlight Tattooing
5855 Melrose Ave.
Los Angeles, CA 90038
213-871-1084

Melrose Tattoo
7661½ Melrose Ave
Los Angeles, CA 90046
213-655-4345

Shamrock Studios
8318 W. 3rd
Los Angeles, CA 90048
213-651-3874

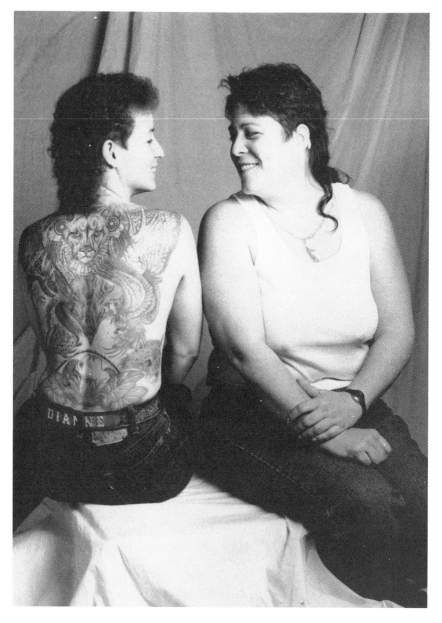

Diane Vishe and Rhonda Gates. Diane's backpiece is by Mr. G.
Rhonda is not permitted to wear jewelry at her job.
Her necklace was tattooed by Chincilla. (PHOTO: DEIRDRE LAMB
PHOTOGRAPHY © 1993 FORT BRAGG, CA.)

Body Electric
7274½ Melrose Ave
Los Angeles, CA 90046
213-954-0408

GTC End of the Trail
520 McHenry Ave.
Modesto, CA 95354
209-524-9937

Miller Cotton's
785 Foam St.
Monterey, CA 93940

Fantasy Tattoo Studio
2602 Ventura Rd.
Oxnard, CA 93030

Tattoo Depot
13522 Van Nuys Blvd.
Pacoima, CA 91331
818-896-1051

New Creation Dermagraphic
 Studio
688 Elliot Rd.
Paradise, CA 95965
916-274-7537

Bob Bitching
P.O. Box 3680
Redondo Beach, CA 90277

Empire Tattoo
2850 West Foothill, Suite 206
Rialto, CA 92403
714-875-2833

Ink Fever Tattoo Studio
5572 Mission Blvd.
Riverside, CA 92509

Riverside Tattoo Co.
10759 Magnolia Blvd.
Riverside, CA 92507

W. Billy and Tina's Studio
Vernon St.
Rose, CA 95678
916-783-9090

Tattoo Factory
5572 Mission Blvd.
Rubidoux, CA 92509

Tattoo Inc.
283 Ardenway
Sacramento, CA 95813

Berdoo Tattoo
1046 W. Highland Ave.
San Bernardino, CA 92403

Avalon Tattoo Studio
1037 Garnett Ave.
San Diego, CA 92109
619-274-7635

San Diego Tattooland
3045 Rosencranz St.
Suite 310
San Diego, CA 92110
619-223-8930

Blue Dragon Tattoos
3904 Main St.
San Diego, CA 92113

Wespac Studio of Tattooing
6363 W. Broadway
San Diego, CA 92166

Inker's Tattooing
6340 El Cajon
San Diego, CA 92111
619-222-5097

Winona of Maui
636 W. Broadway
San Diego, CA 92178

Diamond Club Tattoo Studio
San Francisco, CA 94101
415-776-0539

Tattoos by Lyle Tuttle
30 Seventh St.
San Francisco, CA 94101
415-775-4991

Mad Dog Tattoo
1351 Harrison St.
San Francisco, CA 94103
415-863-3617

Sailor Vern Ingemarson
190 Onondaga Ave.
San Francisco, CA 94112

Everlasting Tattoo
1939 McAllister
San Francisco, CA 94115
415-928-6244

Erno Tattoo
254 Fillmore St.
San Francisco, CA 94117
415-861-9206

Primal Urge Studio
2703 Geary Blvd.
San Francisco, CA 94118
415-474-3442

Dean's Tattoo Headquarters
471 Broadway
San Francisco, CA 94133

Goldfield's Tattoo Studio
404 Broadway
San Francisco, CA 94133

Tattoo City and Ed Hardy
722 Columbus Ave.
San Francisco, CA 94133
415-433-9437

Hit Squad Tattoos
P.O. Box 590865
San Francisco, CA 94159

Picture Machine
3940 Geary Blvd.
San Francisco, CA 94188

Realistic Tattoo Studio, and
 Ed Hardy
2535 Van Ness, Suite 5
San Francisco, CA 94109

Dragon Tattoo
1520 W. San Carlos St.
San Jose, CA 95101

West Coast Tattoo Club
899 W. San Carlos St.
San Jose, CA 95106

Pinky Yun
1520 W. San Carlos St.
San Jose, CA 95126

Tattoo Town
1124 S. King Rd.
San Jose, CA 95122

Body Designs by Spyder
1114 S. Pacific Ave.
San Pedro, CA 90731
213-832-2244

Inkslingers Tattooing
202 W. Canon Perdido St.
Santa Barbara, CA 93101
805-962-3334

Tattoo Santa Barbara
435 E. Haley St.
Santa Barbara, CA 93101
805-962-7552

Santa Rosa Tattoo
1106 7th St.
Santa Rosa, CA 95401
707-526-0471

Inkslinger Tattoo
8342 Foothill Blvd.
Sunland, CA 91040
818-352-2274

Only Skin Deep Tattoos
229 Springs Rd.
Vallejo, CA 94590

World Famous Emporium of
 Tattoo
14442 Victory Blvd.
Van Nuys, CA 91401

Pappillon Tattoo
1301 Main St., Studio 2
Venice, CA 90291

Tattoo Bob of Venice
1301 Main St., Apt. 2
Venice, CA 90291

Ventura Tattoo Studio
610 N. Ventura Ave.
Ventura, CA 93001

Colorado

Radical Sleep Tattoos
4834 N. Broadway
Boulder, CO 80304
303-443-2966

Tattoos by Pirate Butch
6990 Hwy. 2, Commerce City
Denver, CO 80022

Emporium of Design
2028 E. Colfax
Denver, CO 80206
303-333-4870

Skibo's Metro Tattoo
6904 Lowell Blvd.
Denver, CO 80206

Front Range Tattoo
1008 North College Ave.
Ft. Collins, CO 80524
303-224-5241

American Tattoo
9703 W. Colfax
Lakewood, CO 80215

Wizard's Workshop
7004 W. Colfax
Lakewood, CO 80215
303-232-9289

Foot Hills Tattoo
630 Main St.
Longmont, CO 80501

Connecticut

Spider Webb
Captain's Cove Marina &
 Seaport
Bridgeport, CT 06612
203-335-3992

Nomad Tattoo Shop
1753 Barnum Ave.
Bridgeport, CT 06610
203-366-1317

Fine Line Tattoo Parlor
P.O. Box 332
160 Main St.
Deep River, CT 06417
203-525-2011

Fineline Studios
84 Main St.
Deep River, CT 06417

Guideline Tattoo
430 Burnside Ave., Rear
East Hartford, CT 06108
203-526-2011

Papillon Tattoo Studio
47 Pearl St.
Enfield, CT 06082
203-745-2050

Papillon Tattoo Studio
1087 Capital Ave.
Hartford, CT 06106

The Living Art Studio
30 W. Stafford Rd. (Rt. 190)
Stafford Springs, CT 06076
203-684-6266

Beauty Mark
707 East Main St.
Waterbury, CT 06702

The Silver Peacock Tattoo
 Studio
25 High St.
Willimantic, CT 06226
203-423-5235

Delaware

Little Gary's Tattooing
1652 S. Dupont Hwy. Rt. 13
Dover, DE 19901
302-678-0409

Rainbow Mike's
13 W. Market
Newport, DE 19804
302-994-8407

All Inked Up
1924 Lancaster Ave.
Wilmington, DE 19850
302-654-4421

Florida

Daytona Beach Underground
 Tattoo
P.O. Box 3502
Daytona Beach, FL 32018

Tattoo Studio
P.O. Box 3502
Daytona Beach, FL 32018
904-258-1058

Outrageous Tattoos
4802 SW 28th Terr.
Fort Lauderdale, FL 33312
305-964-5646

Myles "Tatts" Taylor
1929 S. Federal
Fort Lauderdale, FL 33452
305-525-7910

The Silver Anchor
5801 N.E. 1st Ave.
Fort Lauderdale, FL 33334

Tattoo World
3550 South Federal Hwy.,
 Rt. 1
Fort Pierce, FL 34982
407-465-6255

Atlantic Tattoo Studio
5803 S. Ridgewood Ave.,
 U.S. 1
Harbor Oaks, FL 32019
904-760-4184

Cash's Tattooing
7151 Park St.
Hollywood, FL 33022

Gold Coast Tattoo
7151 Park St.
Hollywood, FL 33022

White Tiger Tattoo &
 Emporium
10341 S. R. 52
Hudson, FL 34669
813-924-7460

Inksmith and Rogers
 Tattooing
13720 Atlantic Blvd.
Jacksonville, FL 32225

Sandpiper Tattoo
2580 NE Indian River Dr.
Jensen Beach, FL 34957
407-334-3385

Sandpipers Studio
2580 NE Indian River Dr.
Jensen Beach, FL 34957

Louie Lombis Tattoo Paradise
4301 10th Ave. W.
Lake Worth, FL
407-966-8814

Tattoo Time
9230 N. U.S. Highway 17
 and 92
Maitland, FL 32751
407-331-5928

Tatu Tony's
2040 Coppla Plaza
Maitland, FL 32751

Tattoos by Lou
11373 SW 211 St.
Miami, FL 33189
305-238-8333

Tattooer Bill Funk, son of Tattooer Philadelphia Eddie. Tattoos by Eddie and D. E. Hardy. (PHOTO COURTESY BILL FUNK)

Tattoos by Lou of South
 Beach
231 14th St.
Miami Beach, FL 33139
305-532-7300

Fox Tattoo Studio
14710 NE 16th Ave.
North Miami, FL 33161

Merlin's Tattoo
14720 NE 16th Ave.
North Miami, FL 33161
305-944-6306

Moon Over Miami
14906 West Dixie Hwy.
North Miami, FL 33181
305-944-0888

Fred and Peaches Tattoo
6440 E. Colonial Dr.
Orlando, FL 32807

Sailor Bill Johnson
6440 E. Colonial Dr.
Orlando, FL 32807

Ancient Art Tattoo
5575 S. Orange Blossom Terr.
Orlando, FL 32809

Deana's Skin Art Studio
14180 E. Colonial Dr.
Orlando, FL 32862
407-281-1228

Southern Fried Tattoo
761 S. Yonge Hwy.
Ormond Beach, FL 32174
904-672-1888

Angel's Central Florida Tattoo
5118 S. Ridgewood Ave.,
 U.S. 1
Port Orange, FL 32019

Tattoos by Rocky
1641 Port St. Lucie
Port St. Lucie, FL 33452
407-335-4693

Papillon South Tattoo Studio
1283 E. Blue Heron Blvd.
Riviera Beach, FL 33404
407-845-9079

White Tiger Tattoo
1030 N. Washington Blvd.
Sarasota, FL 34237
813-365-8282

Yoli's Unique Tattoo
4215 Bayview Ave.
Tampa, FL 33611

Georgia

The Inker's Parlor
2812 Gordon Hwy.
Augusta, GA 30909
404-737-5319

Creative Tattoo
1316 Wesley Ave.
Brunswick, GA 31520

Fast Freddie's Tattooing
3427 Victory Dr.
Columbus, GA 31903
404-687-9517

Rocket Rick's Tattooing
3601 S. Lumpkin Rd.
Columbus, GA 31908
404-687-5354

Dr. Tatu's Tattoo Clinic
1337 Bankhead Hwy.,
 Suite 102
Mableton, GA 30059

Keith Peacock Tattoos
4019 Chambers Rd.
Macon, GA 31204
912-788-9542

Tattoos by Bob
1105 Rocky Creek Rd.
Macon, GA 31213
912-781-0630

Ace Tattoos
3482 E. Ponce De Leon Ave.
Scottsdale, GA 30079
912-296-7703

Tattooing by Painless Paul
 Nelson
3482 E. Ponce De Leon Ave.
Scottsdale, GA 30079
912-296-7703

Hawaii

Rainbow Falls Tattoo
851 Leilani St.
Hilo, HI 96720
808-961-2621

China Sea Tattoo
1033 Smith Street
Honolulu, HI 96810

Skin Deep Tattoo
2128 Kalakaua Ave.
Honolulu, HI 96815
808-924-7460

Tradewinds Tattoo Studio
1040 Smith St.
Honolulu, HI 96830

Skin Talk
119 Mechant St., Suite 504
Honolulu, HI 96813

Tattoo Hawaii
626 Front St.
Lahaina, HI 96761

Maui Islander
660 Wainee St., Apt. F202
Lahaina, HI 96791

The Tattoo Shop at Maui
120 Hana Hwy., Box 394
Maui, HI 96779
808-579-8714

Floating World
382 Launiu St.
Waikiki, HI 96815

Banzai Tattoo
94 358 Waipahu Depot Rd.
Waipahu, HI 96797
808-677-7250

Iowa

Kustom Inc.
120 Main St.
Center Point, IA 52213
319-849-2139

Custom Tattoos by Curt
904 West State
Centerville, IA 52544
515-856-2701

Roxy's Maiden Voyage
 Tattooing
619 West Second St.
Davenport, IA 52801

Creative Designs Tattoo
 Studio
1528 E. Grand
Des Moines, IA 50316

Tattoo Ted Nelson
4204 S.W. 9th St.
Des Moines, IA 50315
515-244-6215

Idaho

Artistic Skin Illustrations
475 N. Yellowstone
Idaho Falls, ID 83401

Illinois

Electric Pen
435 E. Broadway
Alton, IL 62002
618-462-5548

Bob Olson's Custom Tattooing
1817 N. Lincoln Ave.
Chicago, IL 60613
312-248-0248

Skin Graphics Tattooing
13781 S. Leyden Ave.
Chicago, IL 60627

Southwest Tattoo Emporium
3747 W. 63rd St.
Chicago, IL 60629
312-582-4500

Tattoo Factory
4408 N. Broadway
Chicago, IL 60640
312-989-4077

Jade Dragon Studio
5331 W. Belmont
Chicago, IL 60641
312-736-6960

Chicago Tattooing
922 W. Belmont Ave.
Chicago, IL 60657
312-528-6969

Guilty and Innocent
3105 N. Lincoln
Chicago, IL 60657
312-404-6955

Body Basics Tattooing and
 Piercing
613 W. Briar
Chicago, IL 60657
312-404-5838

Tattooing by George Klauba
6260B N. Hoyne
Chicago, IL 60658

Prairie Tattoo
202 S. Halstead
Chicago Hts., IL 60411
708-709-0319

Dream Illustrations
16918 Krause Rd.
Chillicothe, IL 61523
309-274-2877

Downers Grove Tattoo Works
2051 Ogden Ave.
Downers Grove, IL 60515
708-960-1409

The Ink Spot
P.O. Box 297, Rt. 98
Groveland, IL 61535

Jess's Fine Line Tattoos
905 W. Jefferson
Joliet, IL 60435
815-723-5918

Pat's Tattoo Studio
903 S. State St.
Lockport, IL 60441
815-834-0369

Angel and Poppy's
452 Kendall
Mahomet, IL 61853

RD's Tattooing
208 E. Blvd. St.
Marion, IL 62959
618-997-5259

Living Color Tattoo and
 Novelty
1622 Broadway
Mattoon, IL 61938
217-234-9611

I'm No Angel Productions
2606 W. Farmington Rd.
Peoria, IL 61604
309-673-4930

Breezy's Tattoo Studio
323 S. Century
Rantoul, IL 61866

Tattooing by Jim Delgado
7315 W. 71st St.
Richview, IL 62877

Peter's Tattoo
2447 1st Ave.
River Grove, IL 60171

Goldie's Tattoo Studio
1034 Broadway
Rockford, IL 61125

Kansas

Classic Tattoo Studio
1220 S. National
Fort Scott, KS 66701

Sully's Tattoo Parlor
11015 Frey
Great Bend, KS 67530

East Coast Al's Studio of
 Tattooing
1507 Central Ave.
Kansas City, KS 66102
913-321-1214

Professor Inkslinger
1015 West Santa Fe
Olathe, KS 66061
913-829-8857

Tattooer Mehai Bakaty's inspired tattoo. Tattoo: Mike Bakaty. (PHOTO
© LYNNE BURNS)

Legacy Tattoo's
3121 Fremont
Topeka, KS 66603

Fine Line Tattoo
29th St. and Mass.
Topeka, KS 66605
913-233-8288

Boyd's Tattooing
3024 Chestnut
Wichita, KS 67217

End of the Trail Tattoo
5301 N. Broadway
Wichita, KS 67219

Kentucky

Tattoo Charlie's
289 S. Limestone St.
Lexington, KY 40508
606-254-2174

Tattoo Charlie's Tattoo
1845 Berry Blvd.
Louisville, KY 40215
502-366-9635

Southern Dermagraphics
907 Baxter Ave.
Louisville, KY 40231

Queens of Hearts
829 N. Dixie, Radcliff Plaza
Radcliff, KY 40160
502-351-4800

Ray Smith Tattoo Parlor
759 N. Dixie Blvd.
Radcliff, KY 40160
502-351-6767

Louisiana

Electric Expression
2327 Veterans Hwy., Suite B
Kenner, LA 70062
504-464-0053

Art Accent Tattooing by Jacci
1041 N. Rampart
New Orleans, LA 70116
504-581-9812

American Tattoo Studio
2345 Grimmett Dr.
Shreveport, LA 71107

Maryland

Tattoo Charlie's Place
421 E. Baltimore St., 2nd Fl.
Baltimore, MD 21203
301-244-1160

Port O'Call Tattoo
637 N. Howard
Baltimore, MD 21203

Dark Lady
4825 Belair Rd.
Baltimore, MD 21206
301-488-5422

Jef Kop Fine Art
1509 National Rd.
Baltimore, MD 21237

Personal Art Studio
12505 McMullen Hwy.
Bowling Green, MD 21502

Tux's Electric Tattoo Studio
1 W. 10th Ave.
Brooklyn Park, MD 21233
410-636-5547

Great Midland Tattoo
10746 York Rd.
Cockeysville, MD
301-667-9447

Great Southern Tattoo
9403 Baltimore Blvd.
College Park, MD 20740
301-474-8820

Dragon Moon Tattoo
208 N. Crain Hwy.
Glen Burnie, MD 21061
410-768-6471

Dream Wizard Tattooing
116 N. Potomac St.
Hagerstown, MD 21740
301-739-4904

Gemini Tattoo Boutique
1698 Annapolis Rd., Rt. 175
Odenton, MD 21113
410-551-9808

B. Richmond Dudley
1900 Lyttonsville Rd., #1311
Silver Springs, MD 20910

Little Vinnie's Tattoos
27 E. Main St.
Westminster, MD 21157
410-876-4636

Maine

Elegance Salon
1 Congress St.
Bath, ME 04530
207-442-8081

Loraine's Tattoo Studio
36 Main St.
Lisbon, ME 04250
207-353-7447

Mad Hatters Tattoo Studio
50 Old Orchard St.
Old Orchard, ME 04064
207-934-4090

Michigan

Tattoo as Art
307 E. Liberty St.
Ann Arbor, MI 48104
313-662-2520

Hamlett's Tattoo Shop
1223 Pipestone Rd.
Benton Harbor, MI 49022
616-927-1432

Creative Tattoo
288 E. Maple Rd.
Suite 181
Birmingham, MI 48011

Norm's Chop Shop
10665 S. Dehmel
Burchrun, MI 48415

Grand Rapids Design
442 Bridge St.
Grand Rapids, MI 49504

GR Body Designs
439 Stocking St.
Grand Rapids, MI 49504

Fantasy Tattoo Emporium
2523 Page Ave.
Jackson, MI 49201

A Splash of Color
3519 S. Cedar
Lansing, MI 48910
517-394-2120

Forever Perfect
2820 South Cedar St., Suite A
Lansing, MI 48910
517-887-6966

Eternal Tattoos Inc.
27544 Plymouth Rd.
Livonia, MI 48932
313-425-0428

Whitehouse Tattoo
224 S. Telegraph
Pontiac, MI 48412
313-682-6068

Inkslingers Tattoo Parlor
29961 Gratiot Ave.
Roseville, MI 48373
313-777-6390

American Tattoo Studio
Box 86
Royal Oak, MI 48067

Wonderland
23531 Little Mack
St. Clair Shores, MI 48080

Tattoos by Johnson
25119 Ecorse Rd.
Taylor, MI 48180
313-292-5296

Dragon's Dream Tattoo Studio
20135 Ecorse Rd.
Taylor, MI 48180

Red's Tattoo Style
22216 Van Dyke
Warren, MI 48089

House Tattooing
2525 Wayne Rd.
Wesland, MI 48185

Minnesota

Tatus by Kore
621 W. Lake St., Suite 208
Minneapolis, MN 55408
612-824-2295

Rising Phoenix Tattoo Studio
16 21st Ave. S.
St. Cloud, MN 56301
612-255-7305

Acme Tattoo Co.
1045 Arcade St.
St. Paul, MN 55101
612-771-0471

Rainbow Fantasy
520 Rice St.
St. Paul, MN 55103
612-291-2520

Mystic Moon Tattoo
489 W. 7th St.
St. Paul, MN 57101
612-227-3578

Hy-tone Tattoo
500 N. Robert St., Studio 538
St. Paul, MN 55101
612-646-2847

Tattoos From Grease
839 4th St., #2
St. Paul, MN 57101
612-776-2913

Tiger Lily Tattoo and Piercing
100 Main St.
Stockton, MN 55969
507-689-2953

Missouri

Fay's Tattooing
P.O. Box 325
Crocker, MO 65452
314-336-4376

Majestic Tattooing
404 S. Jefferson
Springfield, MO 65801
417-864-5585

Trader Bob's Tattoo Shop
2529 S. Jefferson
St. Louis, MO 63104
314-776-2307

Craig's Tattoo
341 Lemay Ferry Rd.
St. Louis, MO 63125

Goldenland
8852 St. Charles Rock Rd.
St. Louis, MO 63114
314-423-0530

Tattooing by R. Dippoldt
P.O. Box 18845
St. Louis, MO 63118

Mississippi

California Studio
1610 Pass Rd.
Biloxi, MS 39531
601-435-7436

Jack and Diane's Custom
 Tattoos
1630 Pass Rd.
Biloxi, MS 39531
601-436-9726

Jack and Diane's Kustom
 Tattooing
527 Broad Ave.
Gulfport, MS 39501
609-864-4764

California Studio
1641 Broad Ave.
Gulfport, MS 39501
601-864-7701

Psychedelic Enterprises
1205 Hall Rd.
Nesbit, MS 39531

Montana

Northwest Territory Tattoo
111 2nd St. W
Kalispell, MT 59901

Tracy Stum. Tattoo by Zee. (PHOTO © TOM SANTELLI)

Nebraska

Fantasies in Ink
2229 "O" St.
Lincoln, NE 68510

Tattoo Studio
5433 Sugarberry Ct.
Lincoln, NE 68516

Ricky Do
3310 Carnelian, Apt. 3
Lincoln, NE 68516

American Tattoo
4452 S. 84th St.
Omaha, NE 68127
402-339-9000

Tattoos by Dick Warsocki
4016 S. 35th St.
Omaha, NE 81070
402-734-1481

Skin Art Tattoos
1910 Dakota Ave.
S. Sioux City, NE 68776
402-494-2919

New Hampshire

White Mountain
Rt. 16, P.O. Box 820
Conway, NH 03818
603-447-3262

L.A. East
51 Elm St.
Laconia, NH 03446
603-524-6908

Tattoo America
60 Canal St.
Nashua, NH 03060
603-595-4994

Jim's Tattoo Studio
Rt. 1
Seabrook, NH 03874
603-474-8754

Seacoast Tattoo
Rt. 1
Seabrook, NH 03874
603-474-2133

Juli Moon Designs
P.O. Box 1403
Seabrook, NH 03874
603-474-2250

Tattooing by Scott and Steve
Rt. 286
Seabrook, NH 03874

Sign of the Wolf
Rt. 12A
West Lebanon, NH 03784
603-298-6053

New Jersey

Body Art World
615 Main Street
Asbury Park, NJ 07712

Dan's Tattoo Studio
2807 Atlantic Ave.
Atlantic City, NJ 08401
609-344-1444

Atlantic Tattoos
2014 Atlantic Ave.
Atlantic City, NJ 08401

Jersey Devils Tattooing
1008 Black Horse Pike
Blackwood, NJ 08012

East Coast Tattoos
231 Chambers Bridge Rd.
Bricktown, NJ 08723

Tattoo Factory
94 Main St.
Butler, NJ 07405
201-838-7828

Sailor Eddie
441 Broadway
Camden, NJ 08101
609-966-2772

Tattoo Shoppe
309 Hackensack St.
Carlstadt, NJ 07072
201-933-0037

Lola's Tattoo
675 Palisade Ave.
Cliffside Park, NJ 07010
201-945-9327

Tattoo 46
288 Hwy 46
Dover, NJ 07801
201-366-9772

Ron's Tattooing
607 Westfield Ave.
Elizabeth, NJ 07202
201-289-7876

Shoemaker Mike
260 Morris Ave.
Elizabeth, NJ 07207

Ink Spot Tattooing
345 Morris Ave.
Elizabeth, NJ 07208
908-352-5777

Body Graphics Studio
Plaza 264, Rt. 206
Flanders, NJ 07836
201-927-7315

Tattooing by Mr. Richards
321 Harrison Ave.
Harrison, NJ 07029

Wolf Den's Tattooing
1091 Rt. 9, H & O Shopping
 Center
Lakewood, NJ 08701
201-367-2889

Tattoos by Lola
Palisades Av.
Leonia, NJ 07501
201-945-9327

Ink Spot II
905 S. Wood Ave.
Linden, NJ 07036
908-862-1722

Fusion of Styles
Rts. 40 and 47, P.O. Box 834
Malaga, NJ 08328
609-694-3699

Bob's Tattooing
Rt. 40 and 47 (Old Delsea Dr.)
P.O. Box 834
Malaga, NJ 08328
609-694-3699

Powerhouse Tattoo
545 Bloomfield Ave.
Montclair, NJ 07042
201-744-8788

Tattoo Kenny
US 1 Flea Market
New Brunswick, NJ 08901

Tattoo Studio
300 Main St., Suite 3B
Orange, NJ 07051
201-674-5907

Tom's Tattoo Carnival
P.O. Box 1513
Paramus, NJ 07652
201-652-1134

Body Art World
US Highway 130 South
Pennsauken, NJ 08110

Smokin Joe's Tattooing
712 Blackwood
Pine Hills, NJ 08021
609-435-5269

J & J's Body Exotica
14 Somerset St.
Plainfield, NJ 07061

Pleasantville Tattoo
115 N. Main
Pleasantville, NJ 08232

The Tattoo Castle
207 Rt. 57
Port Murray, NJ 07865

Captain Jack's
91 Rt. 23 South
Riverdale, NJ 07457

Shotsie's Tattoos
1275 Route 23
Wayne, NJ 07470
201-633-1411

Smokin Joe's Tattooing
204 Black Horse Pike
Runnemede, NJ 08078
609-939-9191

Second Skin Body Art
1248 Paterson Plank Rd.
Secaucus, NJ 07094
201-864-3883

Richie's Guideline Tattoo
947 Hwy. 9 Northbound
South Amboy, NJ 08879
908-727-9820

Wallflash Tattooing
1523 Bay Shore Rd.
Villas, NJ 08251
609-889-2422

Tony's Tattoo Shop
158 State Hwy. 36
West Keansburg, NJ 08240
908-495-2305

New Mexico

Fine Line Tattoo
5511 Central, Old Rt. 66
Albuquerque, NM 87108
505-255-3784

Tattooing
P.O. Box 274
Pecos, NM 87552

Nevada

Las Vegas Tattoo
414 Hoover
Las Vegas, NV 89101

Fine-Art Tattoo
2558 S. Valley View
Las Vegas, NV 89102

A Shadow Brite Tattoo
351 S. Wells Ave.
Reno, NV 89502
702-348-8383

New York

Tatu Tony's
33 Columbus Ave.
Auburn, NY 13021
315-252-4123

Tattoos by Joe T.
257 East Main St.
Avon, NY 14414
716-226-8070

Peter Tattoo Assoc.
609 Hicksville Rd.
Bethpage, NY 11714

Tanzer's Tattoo Studio
48–50 Court St.
Binghamton, NY 13901

Tattoos by Wildside
5605 Brockport/Spencerport
Rd.
Brockport, NY 14420
716-637-6633

MacKenzie's Forever Ink
5 Seminary Hill Rd.
Carmel, NY 10512
914-225-4147

Cliff's Tattoo
1446 Middle Country Rd.
Centereach, NY 11721
516-732-1957

Dynamic Tattoo
1825 Deer Park Ave.
Deer Park, NY 11729

Tattoos by Mark
5230 Transit Rd.
DePew, NY 14043

Body Creations
16 W. Main St.
East Islip, NY 11730

S & W Tattooing
P.O. Box 263
East Northport, NY 11731

Peter Tattoo Assoc.
375 Hempstead Tpke.
Elmont, NY 11003

James Collier. Tattoos: Mr. G, Chinchilla and Erno Salsbury. (PHOTO: DEIRDRE LAMB PHOTOGRAPHY © 1993 FORT BRAGG, CA)

Tattooing by Richie
375 Hempstead Tpke.
Elmont, NY 11003

Tattooing by Bob and Pat
27B Shadybrook Dr.
Endicott, NY 13760

Drew's Tattoo Studio
RD 1, Box 784M
Gloversville, NY 12078

Tattoos by Paul
3049 Delaware Ave., Suite F
Kenmore, NY 14217
716-876-6200

D & J Tattooing
Lansing Plaza
Lansing, NY 14882
607-533-7970

Great Northern Tattoo Studio
209 Oswego St.
Liverpool, NY 13088
315-457-6220

Bridge Street Tattoo Co.
22 Bridge St.
Madrid, NY 13660
315-322-4170

Tattoo Tony Marchese
P.O. Box 60
Marlboro, NY 12542
914-236-3451

Fantasy Tattoo
1320 Rt. 9W
Marlboro, NY 12542
914-236-3451

J. C. Fly and Son Tattooing
2628 Rt. 112
Medford, NY 11763

Middletown Tattoo
202 North St.
Middletown, NY 10940
914-343-2972

Skin Images Tattoo Studio
7 South St.
Middletown, NY 10940

Tattoo Tony Marchese
Mahoney Rd., Box 260B
Milton, NY 12547

Big Joe and Sons
P.O. Box 1374, 27 Mount
 Vernon Ave.
Mount Vernon, NY 10550
914-644-9894

Empire State Tattoo Club
 Newsletter
P.O. Box 1374
Mount Vernon, NY 17808

Tattoos by Crazy Joe
60 State St.
Pittsford, NY 14534

Mad Pup Tattooing
26 City Hall Pl.
Plattsburgh, NY 12901
518-561-0798

Tattoos by Bill
20 U.S. Ave. (Rt. 9)
Plattsburgh, NY 12901
518-562-4056

Golden Needle Tattoo Studio
252 Lyell Ave.
Rochester, NY 14608
716-254-9404

Cosmic Rainbow Art Tattoo
157 Park Ave.
Rochester, NY 14692
716-262-6219

Twisted Tattoo
116 Lawrence St.
Rome, NY 13446

Lilly Studio Tattooing
1 Tower St.
Roslyn, NY 11576

Tattooing by George Special
7 Alflo Rd.
Scotia, NY 12302

Selden Tattoo Studio
262A (Rt. 25) Middle Country
 Rd.
Selden, NY 11784
516-732-9585

Willie's Island Tattoo
518 Wm. Floyd Parkway
Shirley, NY 11967

Skin Tapestry
P.O. Box 327
Sugar Loaf, NY 10981

Bruce Bart Tattooing
Main Street
Tannersville, NY 12485
518-589-5069

Peter Tattoo Assoc.
223 Hempstead Tpke.
West Hempstead, NY 11552
516-282-8622

Ink Well
146 River St.
Warrensburg, NY 12885

Dr. Strange's Tattoo Parlor
606 Factory St.
Watertown, NY 13601

Tattoos by Carew
307 Catherine St.
Wilson, NY 14172

Pat's Tats
102 Mill Hill Rd.
Woodstock, NY 12498
914-679-4429

North Carolina

Shorty's Inkworks
1500 Patton Ave.
Asheville, NC 28806

Ricky's Tattooing
13224 Mores Chapel Rd.
Charlotte, NC 28228
704-394-7468

Carl's Tattoo
98 St. Charles Ave.
Concord, NC 28025

Supreme Tattoo Equipment
Rt. 3, Box 157A
Dallas, NC 28034

Tattoos by Bill Claydon
5955 Yadkin Rd.
Fayetteville, NC 28303
919-867-9792

Smoking Guns Tattooing
6109-B Yadkin Rd.
Fayetteville, NC 28303

Skin Fantasies
4325 Bragg Blvd.
Fayetteville, NC 28303

Doc Holliday
101-5 Chaney Ave.
Fayetteville, NC 28540

Snake Tat-2
4725A High Point Rd.
Greensboro, NC 27420

Jim's Tattoos
1830 1st Ave. SW
Hickory, NC 28602

Tattoos by Buzz Jr.
653 N. Marine Blvd.
Jacksonville, NC 28540
919-938-3585

Odyssey Tattoo Studio
304 A South Marine Blvd.
Jacksonville, NC 28540

The Lucky Tiger
740 Court St.
Jacksonville, NC 58401
919-346-1077

Jolly Roger Tattoo
12526C E. Independence
Blvd.
Matthews, NC 28105

Savage & Head
853 W. Morgan St.
Raleigh, NC 27602
919-828-4475

R. C.'s Tattooing
Highway 21 South
Statesville, NC 28677
704-871-8985

Marks of Distinction
5741 A Oleander Dr.
Wilmington, NC 28401
919-392-1123

North Dakota

Sterling Rose Tattoos
123½ Broadway, Suite 4
Fargo, ND 58102
701-232-1744

Ohio

North Akron Tattoo Co.
673 N. Main St.
Akron, OH 44310

Cincinnati Tattoo Studio
4104 Glenway Ave.
Cincinnati, OH 45205
513-921-3308

Designs by Dana
4167 Hamilton Ave.
Cincinnati, OH 45223
513-681-8871

Artistic Tattooing
3160 West Broad St.
Columbus, OH 43204

Tattoos by Glen Scott
3047 N. Main St.
Dayton, OH 45401
513-276-3061

Skin Scribes
330 W. 23rd St.
Lorraine, OH 44052
216-324-4793

Roy's Art Studio
123 West Main St.
Mason, OH 45040

Double Eagle Studio
432 Tuscarawas Ave., N.W.
New Philadelphia, OH 44663
216-339-6100

Tattoos by Norma Sonneville
432 Tuscarawas Ave., N.W.
New Philadelphia, OH 44663
216-339-6100

Toledo Tattoo Co.
2068 Airport Hwy.
Toledo, OH 43612
419-382-8805

Toledo Tattoo Co.
4825 N. Summit St.
Toledo, OH 43611
419-726-3862

Grumpy Bear's Tattoo Studio
721 E. Main St.
Van Wert, OH 45891
419-238-4157

Tattoos by Col. Marty
1322 Hillcrest
Wellsville, OH 43968
216-532-2540

Finest Lines Tattoo Studio
29027 Euclid
Wickliffe, OH 44092
216-943-4008

G & G Tattooing
4126 Erie St.
Willoughby, OH 44094
216-942-3567

Z Tattoo
542 Main St.
Wintersville, OH 43952
612-226-2581

Moving Pictures Studio
321 E. Liberty
Wooster, OH 44691
216-264-8282

Maniac Custom Tattoo
3213 South Avenue
Youngstown, OH 44501
216-788-7200

Artistic Dermagraphics
8384 Market St., Suite C-6
Youngstown, OH 44512
216-726-6677

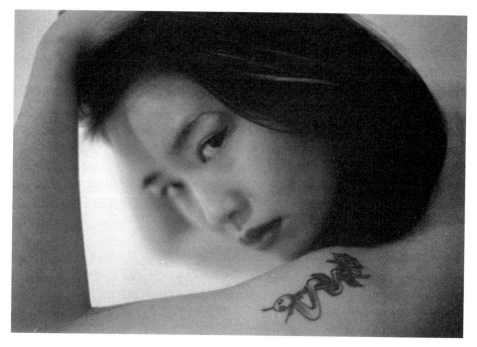

Kammeco. (PHOTO © 1990 SETH GURVITZ)

Tattoo Fanatic
165 Aylesboro Ave.
Youngstown, OH 44512

Oregon

Portland Tattoo
117 NW 6th
Portland, OR 97209

American Tattoo
428 E. Burnside
Portland, OR 97214

Just a Touch of Class
826 S.W. 3rd St.
Portland, OR 97205
503-397-7973

Altered States Tattoo
P.O. Box 308
Willamina, OR 97396

Pennsylvania

Tattooz Inc.
1017 Bristol Pike
Bensalem, PA 19020

Tattoo Odyssey Inc.
Street Rd. and Asbury Ave.
Bensalem, PA 19025
215-639-1166

Skin Designs Tattoo
217 E. 1st St.
Birdsboro, PA 19508

Bernie's Tattooing
2924 West Ave.
Bristol, PA 19007
215-788-6496

Hero Tattooing by Bud
440 N. Duffy Rd.
Butler, PA 16001
412-283-4531

Midnite Rider Tattoos
5th and Locust St.
Columbia, PA 17512
717-684-0765

Skin Flix
125 Chestnut St.
Coplay, PA 18037
215-261-1570

Tattoos by Savini
1215 Highland Ave.
Coropolis, PA 15108
412-264-6757

M & M Tattooing
114 E. Lancaster Ave.
Downington, PA 19335
215-269-0760

Tattooing by Sam Snyder
228 E. Wilkesbarre St.
Easton, PA 18042
215-252-3448

The Southlands
228 E. Wilkesbarre St.
Easton, PA 18042

Skin Images
121 Broadway
Hanover, PA
717-637-5961

Tattooing by Rick
433 N. 22nd St.
Lebanon, PA 17042

Island Ave. Tattoo
707 Island Ave.
McKees Rock, PA 15136

Tattooing by Carl Hess
1129 W. Market St.
Perkasie, PA 19007
215-453-0734

Philadelphia Eddie's Tattooing
& Tattoo Museum
3216 Kensington
Philadelphia, PA 19104
215-426-9977

Tattoo Artists United Inc.
931 Arch St.
Philadelphia, PA 19107

Fine Line Tattooing
131 Brownsville Rd.
Pittsburgh, PA 15210
412-488-7787

Tattoos by Moose
106 Nelbon
Pittsburgh, PA 15219
412-731-3462

Tattooing by Skip
835-1 Heister's Lane
Reading, PA 19603
215-929-9877

Twin Dragons
403 Howes Run Rd.
Sarver, PA 16055

Totem Tattoos
49 Center St.
Shamokin, PA 17872

Tattoo Hugh
118 W. State St.
Sharon, PA 16146
412-347-4198

Tattooing by Cal
35 N. Mem. Hwy.
Shavertown, PA 18708
717-696-3240

C-Bear
115 Pensylvannia Ave.
Shillington, PA 19607
215-796-0320

Ink Inc.
2030 E. College Ave.
State College, PA 16801
814-234-0605

Tattoos by Tiny
1824 Brownsville Rd.
Trevose, PA 19047

C. C. Rider's
53 S. Potomac St.
Waynesboro, PA 17268
717-765-4857

Tattoo You
112 S. Main St.
West Scranton, PA 18504
717-347-8850

Jerry's Tattoo Studio
586 S. Main St.
Wilkes-Barre, PA 18702
717-823-1139

Rhode Island

Tattooing by Color Creations
307 Taunton Ave., Rt. 454
East Providence, RI 02914
401-438-9297

Electric Ink
153 Waterman Ave.
East Providence, RI 02914
401-435-3393

Sailor Ron's Anchor Steam
 Tattoo
2 Collins St.
Newport, RI 02851
401-847-4155

Artistic Tattoo
144 Spruce St.
Providence, RI 02903
401-861-7373

Sin on Skin
2 Main Rd.
Tiverton, RI 02878
401-624-8287

South Dakota

Black Hills Tattoo
1401 W. 10th St.
Sioux Falls, SD 57101
605-335-0832

Tattoos by Vinny
R.R. 1, Box 87
Tabor, SD 57063

Tennessee

Color-U Tattoo
1040 Center St.
Kingsport, TN 37660
615-246-5203

Mountain Tattoo
4117 Airport Rd.
Knoxville, TN 37777
615-970-3307

Guns and Needles Tattoo
5311 Clinton Hwy.
Knoxville, TN 37912
615-689-3519

Mountain Tattoo
Rt. 5, Box 232
Louisville, TN 37777
615-970-3307

Mouse's Custom Tattooing
6079 Hwy. 51 North
Millington, TN 38053
901-353-6250

Mystic Tattoo
1612 Church St.
Nashville, TN 37202
800-552-2407

Forever Yours Tattoo Studio
R. K. Sweeny, Ron Kevie
2807-A Old Hickory Blvd.
Old Hickory, TN 37138
615-847-1153

Texas

River City Tattoo
513 E. 6th St.
Austin, TX 78701
502-476-8282

Tattooing by Dave Lum
4205 Guadalupe
Austin, TX 78751
512-453-2089

Chuck's Custom Tattooing
2440 1H 10 East
Beaumont, TX 77703
409-898-2075

Tattoos by Hack
3603 Parry Ave.
Dallas, TX 75226
214-821-4982

Night Shift Tattoos
3805 S. Buckner
Dallas, TX 75227
214-388-5213

Texas Tattoo
10402 Kingslow
Dallas, TX 75260

Dermagraphics by Lurch
1508 Dowdy Ferry Rd.
Dallas, TX 75260

Pat's Custom Tattoos
9411 Dyer
El Paso, TX 79924
915-755-6627

Creative Tattoos by Dragon
 Lady
551 W. Bus. Hwy. 190
P.O. Box 2387
Harker Heights, TX 76543

World Famous Shaw's Studio
1660 Westheimer
Houston, TX 77001
713-528-1255

Mild Anthony
1845½ W. Alabama
Houston, TX 77001

Tattoo Zone
7008 Lond Drive
Houston, TX 77001
713-645-2756

Tattooing by Adrian
102 A Holder St.
Hurst, TX 76053

Master Tattooing
916 W. Hwy. 190
Killeen, TX 76541

West Texas Tattoo Co.
3501 Avenue Q, Suite C
Lubbock, TX 79412

Bill the Beachcomber
126 Rice Dr.
Portland, TX 78374

Body Art Tattoo
2115 Buffalo St.
San Antonio, TX 78206
512-675-0800

Tattoo Arcade
519 E. Houston St.
San Antonio, TX 78205
512-225-0782

Texas Tattoo
1913 N. Braunfels
San Antonio, TX 78208

Sidewinder Sam's Tattoos
109 E. Gonzales
Seguin, TX 78155

Fat Cat
2810 N. 19th St.
Waco, TX
817-755-8006

Different Drummer Tattoos
4049 BurkBurnett Rd.
Wichita Falls, TX 76306

Design Master
Box 785
Wichita Falls, TX 76307

Utah

Sad Sadie's Tattoo Parlor
Box 164
Cedar City, UT 84720

Artistic Skin Illustrations
1103 S. State
Salt Lake City, UT 84111

Artistic Dermagraphics
1103 S. State
Salt Lake City, UT 84119

Virginia

Cards and Ink
139 South Fairfax
Alexandria, VA 22313

Dr. Who
Rt. 1 Box 254A, U.S. 17
Carrollton, VA 23314

Ancient Art Tattoo
Rt. 1, Box 228A
Carrollton, VA 23314
804-238-3302

Tattoos by Dr. Who
Rt. 1, Box 108, Suite 1-A
Carrollton, VA 23314

T. J.'s Dermagraphics
414 East Main St.
Charlottesville, VA 22902
804-979-7733

Lobo Tatu
704 W. Strasburg Rd.
Front Royal, VA 22630
703-635-8342

Skin Illusions
1708 C-1 Kimbro Lp.
Ft. Belvoir, VA 22060
703-781-0038

Accent Tattoo
P.O. Box 1119
Gloucester Point Shopping
 Ctr.
Gloucester Point, VA 23062
804-642-3993

Temporary Tattoos and Tee
 Shirts
P.O. Box 1923
Grafton, VA 23692
800-344-7752

Modern Marks
9053 Liberia Ave.
Manassas, VA 22110
703-361-0742

Ancient Art Tattoo
2720 Rt. 17 N.
Newport News, VA 23602

Tattoo Al Creamer
7615 Elgar St.
Springfield, VA 22151

Tattooing by Crowe
P.O. Box 1125
Virginia Beach, VA 23451
804-867-8899

Tattoos by Jungle Jim
815-B North Loudoun St.
Winchester, VA 22601
703-667-6305

Washington

Dusted Magic Tattoos
324 N. Callow
Bremerton, WA 98312

Everett Tattoo Emporium
2408 Broadway
Everett, WA 98203
206-252-8315

Ancient Art Tattoo
2408 Broadway
Everett, WA 98206

Skin Sensations
P.O. Box 676
Fall City, WA 98024

Custom Skin Designs
202 E. Columbia Dr.
Kennewick, WA 99336
509-586-0149

Class Act Tattoo Studio
15019 S. Meridian St.
Puyallup, WA 98373
206-845-8503

Skin Print Tattoo
234½ Wells Ave. S.
Renton, WA 98055
216-255-5841

Seattle Tattoo Emporium
1106 Pike St.
Seattle, WA 98101

Tattoo Body Art
15302 1st Ave. S.
Seattle, WA 98166

Tiger Tattoo
E. 2229 Sprague
Spokane, WA 99202
509-535-1003

River City Tattoo
709 N. Monroe St.
Spokane, WA 99201

Wisconsin

Windy City Tattooing
208 W. Madison
Eau Claire, WI 54703
715-834-1917

Green Bay Tattoo
110 S. Broadway
Green Bay, WI 54303

Skin Illustrations
406 W. Walnut St.
Green Bay, WI 54303

Tattoo by Rick
406 W. Walnut St.
Green Bay, WI 54305
414-432-3735

Diamond Ted's Tattoo Parlor
720 Center Ave.
Janesville, WI 53545

Lake Geneva Tattoo Co.
150½ Center St.
Lake Geneva, WI 53147

Ultimate Arts Tattooing
4512 E. Washington Ave.
Madison, WI 53704

Steve's Tattoo
1148 Williamson St.
Madison, WI 53704
608-251-6111

Larry's Tattoo
2302 Atwood Ave.
Madison, WI 53707

Doc's Tattoo
603 S. Park Ave.
Medford, WI 54451
715-748-3558

Ink Well Tattoos
222 Lazy Ace Rd.
Wausau, WI 54401

West Virginia

Charlie's Tattooing
Rt. 2, Box 28
Charlestown, WV 25414
304-725-7861

Animal's All-American
 Tattooing
3019 Main St.
Weirton, WV 26062
304-797-7287

Wyoming

Peter Tat 2 Studio
313 W. 18th St.
Cheyenne, WY 82001

Wales

Dai Tattoo Studio
198 High St.
Swansea West,
Wales (South)

APPENDIX
A LEXICON OF TATTOO LINGO

Now you too can talk just like a tattooist, or like a member of the tattoo subculture. If you want to sound hip and trendy, here are some terms to toss around in your next conversation about tattoos.

Autoclave. A steam-pressure sterilization bath for surgical or tattoo equipment. Your dentist has one; your tattooist should, too.

Blood-borne pathogens. Illness-causing "germs" that are carried from person to person via blood.

Body suit. A tattoo that covers the entire body, usually beginning at the neckline, covering the back and chest, and ending at the ankles. Hands and feet are not tattooed in a full body suit, but arms might be tattooed (see "Sleeved"). The Japanese made the body suit a work of art.

Cockamamies. Lick 'em, stick 'em–style fake tattoos that were popular during the 1940s and 1950s. Not as sophisticated as today's temporary tattoos.

Colors. Red, orange, yellow, green, blue, etc. Whoops. You already know about those colors. In tattoo talk, colors are what bikers wear with pride. They represent the name and logo of the wearer's motorcycle club, stitched, sewn, or embroidered onto clothing or tattooed on a chest.

Cover-up Work. New tattoos that hide an old tattoo. This is done either by incorporating the old design into a new one or by literally covering up the old work with new tattooing. Good cover-up work is quite difficult to detect. It's popular among young men who pledged their love via body art early in their lives.

Dermapigmentation. Called by any name, permanent makeup is permanent because it's a tattoo. And dermapigmentation is just another name for cosmetic tattooing.

Devotion tattoo. Pledging love or devotion to another person, place or thing via permanent body art. "Mom" tattooed on a bicep is a good example of a devotion tattoo; so is having your sweetheart's name permanently inscribed on your tush (see cover-up work). The best devotion tattoo I've seen is on a rock and roller from Brooklyn. He had the name of a girlfriend tattooed. They broke up. He liked the tattoo and didn't want cover-up work. His new girlfriend wanted her mark on his body. He explained, "I wasn't going to get *her* name tattooed on me. I wouldn't make that mistake again. One morning, after she had put on her lipstick, she kissed me, low down on my neck. It looked so good that I went off to my tattooist and had him tattoo a red kiss, right where she had kissed me."

Fine-line. A tattoo outline made with a single needle, giving a very fine line. This style has been popularized through the exquisitely fine, detailed portraiture of Jack Rudy of southern California.

Flash. The sheets of pictures hanging on a tattooist's wall. Flash is sold in sets. The tattooist who buys flash may legally reproduce it onto stencils and templates and bodies.

FTW. An outlaw biker tattoo that's still in fashion. It is always tattooed as FTW, never "F**k the World," which is what it actually stands for.

"Is the Outline Done Yet?" One of the first questions asked when a tattooist takes his or her first break. That's because getting a tattoo

is painful and frightening, and the outline is the first thing that's done. The client, seeking a bit of relief, poses this question. And tattooists have heard it enough times to make jokes about it.

Jailhouse tattoo. Any homemade, handmade tattoo.

Lady Luck tattoo. A popular wartime tattoo icon, meant to bring luck to the owner. A pretty lady coupled with some other lucky signs was the stereotypical image.

Leviticus 19:28. The biblical reference that states: "You shall not make any cuttings in your flesh . . . or tattoo any marks upon you."

Microdermal implantation. Another pretentious name for a cosmetic tattoo.

Memorial tattoo. A tattoo that's in memory of something or someone.

Men's Ruin tattoo. The dark side of Lady Luck. Men's Ruin tattoos depicted the vices that could cause big-time problems for men: dice, cards, booze. The central image was considered to be the major source of trouble: a woman.

Needles. Necessary for dipping into the pigment, then inserting into the skin, if you want a tattoo.

Needle bars. Needles are small. They're soldered to long narrow bars, which are then inserted into tubes in tattoo machines. The needle bars, with the attached needles, move up and down, inside the tube, pushing ink into the skin.

1% tattoo. During the height of outlaw biker hysteria in the mid-1960s, the American Motorcycle Association stated that only 1 percent of the motorcycle owner/riders in the country were outlaws. The other 99 percent were something else. Upstanding citizen? The boy next door? Your boss? The middle-class bourgeoisie? Blue-collar worker? They didn't say. The outlaw biker community, including members of the major motorcycle clubs, were amused by the fact that they were considered to be part of that 1 percent. So they had it tattooed. 1% tattoos are still around, although they're not as prevalent as they used to be. Why? Because the membership of motorcycle clubs now consists of upstanding citizens, boys next door, bosses, blue-collar workers, maybe even some middle-class bourgeoisie.

Outliner. Three to five needles soldered to a bar. Outlines are done first. The tattoo is then colored in.

Pigment. Tattoo inks.

"Property of" tattoo. Back when 1% tattoos were really popular, so were "property of" tattoos. Yes, it's another biker tattoo, but these were tattooed on the women who were the "property" of the clubs. "Property of" tattoos still exist, although they too are becoming increasingly rare. Many women tattooists will not do "property of" tattoos.

Rock of Ages tattoo. Jesus with the cross, on the rock. A substantial, powerful and very popular tattoo image. It has remained such over several decades.

Scratcher. Ugh. Don't go to one. A scratcher is a bad tattooist.

Shader. Configuration of seven or more needles. This is what is used to color and shade in the tattoo, giving it depth and perspective.

Sleeved. Tattoos that cover both arms, as would the sleeves of a shirt. These tattoos do not go past the elbow or wrist. Getting "sleeved" is a substantial tattoo commitment.

Stencil. A template or tracing of the tattoo design that's either been created especially for you or that you've picked out off the wall of flash.

Travel marks. What tattoos were called in the 1940s. They showed you had been around, had some life experience, had "traveled."

Tube. Needle bars are inserted into the tube, which is then inserted into the tattoo machine.

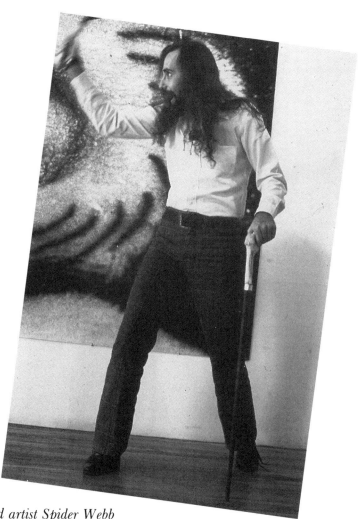

Tattoo and artist Spider Webb during one of his more pensive moments in New York's Chuck Levitan Gallery. Webb used his intelligence and artistic sensibilities along with witty antics to promote tattooing and poke fun at New York City's antiquated health-code violation that bans tattooing.
(PHOTO © SPIDER WEBB STUDIOS)